The Photographer's

Guide to the

Digital Darkroom

Bill Kennedy

ALLWORTH
PRESS
NEW YORK

© 2006 Bill Kennedy

09 08 07 06 05 5 4 3 2 1

Published by Allworth Press
An imprint of Allworth Communications, Inc.
10 East 23rd Street, New York, NY 10010

Page composition/typography by Sharp Des!gns, Lansing, MI
Cover design by Derek Bacchus
ISBN: 1-58115-433-X

LIBRARY OF CONGRESS CATALOGING-IN-PUBLICATION DATA
Kennedy, Bill, 1951–
The photographer's guide to the digital darkroom / Bill Kennedy.
 p. cm.
Includes index.
ISBN 1-58115-433-X (pbk.)
1. Photography—Digital techniques. 2. Photography—Special effects. I. Title.
TR267.K46 2006
775—dc22
 2006001956

Printed in Canada

TABLE OF CONTENTS

PREFACE

This project began several years ago as a series of handouts on digital imaging for my university and workshop students. The handouts were necessary because I could not find a textbook that brought together all the bits and pieces of information needed to work successfully in the digital darkroom. The material available in books, in magazine articles, and on the Internet—ranging from digital capture options to Photoshop procedures and inkjet printing—was often useful but fragmented. Differences in vocabulary were enough to make the information confusing.

I realized that a cohesive approach was important to many photographers and educators as photography continues its inevitable transition from wet to digital darkroom practices. This was brought home to me, in a powerful way, while teaching a digital printing class at the Santa Fe Workshops. Half the participants were teachers (ranging from high school to community college and university) struggling to develop curricula and build digital facilities for their photography programs.

This book is designed to organize the information photographers need to work successfully and efficiently in the digital darkroom. As you'll discover, the text has been organized to present information as conversationally as possible; topics closely related to one another are woven into chapters that progress from introductory to advanced material.

Because the technologies that support the digital darkroom are constantly changing, one aspect of this project was especially challenging: how to write a book that isn't obsolete before it's printed. The approach adopted here is to emphasize two overlapping and complementary ideas: *skill set*s and *workflows*.

Skill sets are a photographer's "knowledge library." If you imagine the digital darkroom as a puzzle, then skill sets are the individual pieces. Skill sets are necessary for digital capture (camera or scanner), processing (using applications such as Photoshop), and output (we'll concentrate on desktop inkjet printers), for example. They tend to be stable over time and evolve as digital darkroom software and hardware evolve.

Workflows are how the puzzle pieces are linked together. What makes the digital darkroom puzzle so interesting (and sometimes confusing) is that the pieces can be linked in different ways. Many workflows can be created, but some are more reliable and useful than others. This flexibility is a significant asset; however, until the techniques supporting the digital darkroom are as transparent as those supporting traditional photography, it is also a liability. Mistakes are easily made. This text outlines a series of workflows that, when used properly, are reliable and adaptable.

There is one additional advantage to emphasizing skill sets and workflows in the digital darkroom: as the technology continues to mature, photographers (and teachers) can develop new skill sets as necessary and modify workflows to accommodate the inevitable changes. This common-sense approach is a bulwark against obsolescence. However, it falls to each photographer and educator to stay informed about changes in hardware and software: the digital darkroom is maturing very quickly.

In formulating this approach I am indebted to many people. Robert "Cowboy" Zolla has graciously and patiently served as my technology mentor (and the author of the "Jones Plot" appendix) from the beginning. His ability to translate the mathematics and science of digital imaging into understandable language is a rare gift.

Scott King shares with Bob a deep love and appreciation of photography, and a keen understanding of how technology is changing the world we live in. His contribution to the information on raster image processor (RIP) software and print workflows has been especially valuable. My many conversations with Bob and Scott have contributed mightily to this text. I cannot thank them enough for their friendship and support. Their time and generosity are woven into this book.

I've had the good fortune of working, for the past twenty-five years, in the Photocommunications undergraduate program at St. Edward's University, Austin, Texas. Numerous faculty development grants and research awards have underwritten my photography, involvement in digital imaging, and on-going curriculum development. I am appreciative of the university's commitment to build a photography program centered on critical thinking and professional development. This book, and much of my teaching, would not be possible without the continuing support of the SEU community.

I've worked with talented and supportive colleagues, most importantly Joseph Vitone and Sybil Miller. Their dedication to photography and teaching, their work ethic, and their commitment to building a student-centered photography program have made my professional life very rewarding. I would especially like to thank Sybil for her thoughtful, diligent, and skillful management of the program. Keora

Norris and Daniel McCoy, our traditional and digital lab managers, have also made my work—in and outside the classroom—rewarding and productive.

While still in graduate school, during the summer of 1979, I was accepted into the Maine Photographic Workshops (MPW) work-study program, and I am appreciative to David Lyman for that opportunity. It was the beginning of a twenty-five-year involvement in workshop teaching. I am deeply indebted to the late Kate Carter for her encouragement, for making it possible for me to become a teaching assistant and, later that summer, to join the resident faculty at MPW. I also want to acknowledge the work of Craig Stevens and Carson Graves; with Kate and others, they developed a photography curriculum at MPW that has stood the test of time (see the Resources appendix for information on Grave's excellent textbooks).

I am also indebted to Reid Callanan, whom I also met that first summer at MPW. In the mid-1980s I worked as the academic program director during Reid's tenure as general manager at MPW. When Reid and his wife, Cathy Maier Callanan, founded the Santa Fe Workshops (SFW) in 1990, I was honored to begin a twelve-year association as teacher and member of the SFW board of advisors. Teaching workshops—and especially making the many wonderful and important friendships during those intense experiences—has formed my approach and philosophy to photography.

I want to thank Paul Roark for providing the tutorial on printing curves and quadtone ink. Paul's contribution to this project is another reflection of his generous contributions to the digital printing community. Paul is a member of a large group of people, tied together by the Internet, who give selflessly of their time and expertise (thanks especially to Tyler Boley, Roy Harrington, Clayton Jones, and the many color experts on the ColorSync e-list).

Abhay Sharma, color management expert and fellow teacher, was a thoughtful reader on this project. I'm grateful for his knowledge and expertise, and for his effort to make the science of color management understandable and accessible. His book, *Understanding Color Management* (Thomson Delmar Learning, 2004) is a valuable resource, which I regularly use in my classroom.

Scott Martin, color management guru, also contributed to my understanding of how RIPs function and the relative value of their features. His insight, like Abhay Sharma's, has hopefully spared me from obvious mistakes (though any that exist are solely mine). Ave Bonar, a gifted photographer and friend of many years, had the dubious honor of proofreading the manuscript while wrestling her Epson 4000 into submission.

Lastly, I want to thank my wife and companion, Melissa Miller, for her patience and good humor. Her support and companionship has meant the world to me. Her art, and belief in the necessity of art, is a continuing inspiration.

INTRODUCTION

It is an amazing time to be a photographer. The technologies for making images by writing with light continue to advance the promise of Joseph Nicephore Niépce's first permanent photographs. He could not have known that the view from his window in 1827 would stretch into the digital age that photographers are entering in the twenty-first century.

Joseph Nicephore Niépce, *View from his Window at Le Gras*. ca. 1827. Heliograph. Gernsheim Collection, Humanities Research Center, University of Texas, Austin.

Many photographers find the transition from film to digital photography a surprising challenge. They discover that technical expertise in traditional photography, while important and helpful, doesn't guarantee immediate success.

The digital darkroom did not evolve from the wet darkroom. Instead, it owes much of its heritage to the prepress industry and, to a lesser degree, the changes brought on by the advent of desktop publishing beginning in the 1980s. This technology is in an adaptive phase. It is maturing quickly, but it does not yet have the transparency and accessibility that photographers enjoy in the wet darkroom.

Photographers today work with a film-based technology that has evolved and become increasingly accessible over the past 175 years. This technology represents billions of dollars in research and development by companies past and present, and it has been refined by the practical experience of many dedicated and talented people. In other words, the *technology* that makes traditional photography possible is complex and impressive, but the *technique* for doing photography has become relatively simple.

A good example of the difference between a technology and a technique is Ansel Adams's Zone System. Adams, along with his colleague Fred Archer, developed a methodology for exposing and developing black/white film to produce predictable silver gelatin prints. They developed a *technique* that tapped into a *technology*—in this case, the science of sensitometry.

This makes it possible for a photographer to learn the Zone System without being a scientist or engineer. Because Zone System technique forms a strong and flexible workflow, photographers can use it to explore any facet of photography they desire. In fact, to borrow an analogy from the digital domain, the Zone System is a user-friendly *interface* with the science of sensitometry.

The Zone System codified the practice of photography, establishing a common *vocabulary* and *methodology*; both are huge advantages that the digital darkroom is just beginning to emulate. By comparison, the digital darkroom is barely a decade old (many photographers would date its beginning from the introduction of the Epson Stylus color printer, circa 1994–5).

Prior to the Stylus, a photographer working digitally might own a dye-sublimation printer (which was expensive and limited in print sizes and paper surfaces) or, more likely, he outsourced printing to a service bureau, a professional lab, or one of the new "digital ateliers" modeled after the pioneers at Nash Editions and Cone Editions. These options could not satisfy a photographer's desire to make *his own images*. Photographers needed a way to produce quality prints easily and at a reasonable cost. The answer would be the inkjet printer (originally intended as a substitute for impact printers and more expensive laser printers). Unlike the expensive IRIS printers used by Nash and Cone, desktop inkjets were affordable and could sit on a desktop.

Just as the personal computer revolutionized the design and publication industry, the desktop inkjet printer changed photography. It is now possible to print photographs on the desktop—with a machine costing less than $100—that

are virtually indistinguishable from those produced with commercial equipment costing hundreds of thousands of dollars. This amazing accomplishment can be misleading, however. There is no technological substitute for technique. It is the foundation of fine craftsmanship.

Digital craftsmanship requires knowledge, practice, patience, and the same "sweat equity" that the wet darkroom has always demanded. The tools to master the digital darkroom are embedded in the software that controls the behavior of hardware (cameras, scanners, displays, and printers, for example). Manufacturers can provide the technology, but the challenge for photographers is to develop techniques and craftsmanship for making fine prints. In short, photographers must learn to use software, and develop skill sets and workflows, to control the computing and printing hardware used in the digital darkroom.

In chapter 1, The Digital Darkroom, we'll outline what is needed to do photography in the digital domain. We'll examine both the hardware and software needed for a digital darkroom. In chapter 2, First Steps in the Digital Imaging Workflow, our apprenticeship begins by defining *workflow*, a concept used throughout the book, and examining how digital files are made. We'll start building a vocabulary to describe the devices and processes used in digital imaging, including Photoshop. We need to understand how digital imaging systems work and how they are controlled.

In chapter 3, Generating Digital Image Files, we'll look at how image files are created by digital cameras and scanners. There will be suggestions for creating the highest quality files for inkjet printing. In chapter 4, Color Management in the Digital Darkroom, we focus attention on the details of color management as it applies to the digital darkroom: what color management does, how it works, and why it's important. Chapter 5, Configuring Photoshop, is dedicated to the important controls and options available for managing color and grayscale image files in Photoshop. Together, chapters 4 and 5 deal with many of the practical "nuts-and-bolts" configuration issues that are important in digital printing.

In chapter 6, Color Printing on the OEM Path, Part I: The Hard Proof Workflow, we'll begin our exploration of printing color images with original equipment manufacturer (OEM) software, inks, and papers. The OEM path is the logical starting point for working in the digital darkroom and, properly managed, can produce excellent prints. You need to learn the OEM path before venturing off of it. We'll outline procedures for making Hard Proof prints, an important part of the digital darkroom workflow.

Chapter 7, Color Printing on the OEM Path, Part II: The Print Profile Workflow, extends our investigation of what can be accomplished on the OEM path. We'll concentrate on what can be done by using printing profiles. The digital darkroom is a challenging puzzle: the pieces can be connected in different ways. There is much to learn and, because each piece is ultimately connected to every other piece, it can be difficult knowing where to begin. The first seven chapters sort out the puzzle and describe the best connections.

In chapter 8, Advanced Color Printing, we'll continue to examine the print profile workflow, concentrating on Photoshop's soft-proofing features. We'll explore the important role that accurate print profiles play in digital printing and the options for printing color off the OEM path.

Chapter 9, Grayscale Printing on the OEM Path, identifies the issues related to printing black/white photographs with an inkjet printer. Many photographers are surprised to learn that printing grayscale can be more challenging than color. In chapter 10, Advanced Grayscale Printing, we'll expand the options for controlling grayscale to include third-party software, inks (including quadtone), and papers. In many ways, chapter 10 is the most complex because grayscale printing, especially off the OEM path, is a rich and diverse topic. As you'll see, there are many options to consider.

Although Photoshop is the primary image-editing software for the digital darkroom, this is not a Photoshop techniques book. Photoshop is capable of many things, some of which have little or no direct bearing on producing beautiful inkjet prints. Those that do apply, however, are truly impressive. Photoshop simplifies and extends the image-processing control of the traditional darkroom by several magnitudes. We've included several excellent Photoshop technique books in the Resources appendix.

If you're already conversant in Photoshop, the workflow suggestions may be more useful than any Photoshop instruction or procedure offered. If you are learning Photoshop, this book should help sort the tools and procedures you need to know *now* from those that can be learned later. Our focus is on the print, and we will explore Photoshop to that end.

Eventually, the technology driving the digital darkroom will become as accessible and transparent as the technology that supports the wet darkroom. Photographers will be able to choose the approach that provides the best fit for their lives and their aesthetic ambitions. Technologies change, but the path to mastery in any printing medium—albumen, gum, platinum, photogravure, silver gelatin, inkjet, or hybrids that combine several approaches—has always required an apprenticeship to an ideal. This apprenticeship is based on acquiring *skill sets*: the knowledge one needs to master the technology used.

Lastly, by focusing on *workflow,* you can build skill sets that do not become obsolete with each new generation of digital equipment. This is particularly important with inkjet printers. The rate of change inherent in digital equipment (which has no equivalent in traditional photography) makes *device-dependent expertise* less valuable than in the past.

With traditional darkroom equipment—an enlarger, for example—learning how to operate one brand or type was a good initiation into using all brands and types. This is less true for the digital darkroom, especially when using third-party inks, papers, and software. The principal reason for this has more to do with the software that drives the printer than with the hardware. If you venture off the "OEM" path, *and eventually most will,* only a reliable workflow will keep you moving toward the goal of making beautifully crafted and aesthetically compelling prints.

It is ironic, but wonderful, that the immense creative potential made possible by applying ink to paper has finally reached the working photographer. It appears that Niépce was trying to invent what we now call *photolithography* when he accidentally completed those first photographs.

Niépce was trying to use the power of the sun to add images made with ink to the printed page—almost four hundred years after Johannes Gutenberg invented movable type. Niépce called his process *heliography*, or "sun writing." Nearly two hundred years later, digital imaging has finally moved the printmaking process out of darkrooms and into the light.

CHAPTER 1

The Digital Darkroom

If you're assembling a digital darkroom, or have been investigating the possibilities, this chapter can serve as an annotated checklist and guide. We'll outline the hardware and software needed to begin on the right path. In the process, we'll also begin to build a working vocabulary for the digital darkroom.

It doesn't matter if you use an Apple or PC, but we refer most often to Apple's operating system (Mac OS) and focus the discussion of image-processing software on Photoshop CS2. If you're using a PC, or different software to process digital image files, the issues and procedures can be adapted to the computing platform and graphic editing program you're using. As we'll discover, it's how Photoshop and the *print driver*—the software that controls the printer—work together that is critical to understanding how photographs are made by applying ink to paper.

The Right Stuff

Leaving cost aside for the moment, a basic digital darkroom would include the following hardware and software:

- Inkjet printer (including ink and paper choices, and the print driver software)
- Computer and display
- Display calibration and profiling kit
- Viewing light

- Software to process and archive images
- Hard drives and CD-R/DVD drives for storing and archiving image files
- Digital camera or scanner to produce image files

The Printer

There is an amazing range of inkjet printers available for the digital darkroom, with printer models coming and going at a dizzying pace. This is especially true on the consumer and prosumer level, where new printers are introduced every month or two (the market in professional printers is relatively more stable). To simplify choosing a printer, we'll consider three criteria: print size, software, and ink.

PRINT SIZE

The desktop inkjet printers many photographers begin with fall into two size categories, which are based on the width of the carriages: 8.5 inches and 13 inches. The carriage width determines how wide a print can be, but not how long (print length is determined by the print-driver software). Eight-and-a-half inch inkjet printers are versatile machines. They are small, about the size and weight of a kitchen appliance, and remarkably inexpensive considering the technology embedded within them.

You'll find that small printers fall into two categories—general office use (including the many multi-functional units that combine the printer with a scanner, memory card readers, and other features) and photo printers. The office machines are capable of producing good prints if used properly, but the photo printers will have features that a photographer will appreciate, as we'll see later. Photo printers in the 8.5-inch and 13-inch categories will generally use a six-color (or more) ink set instead of four (which improves the color that can be reproduced by a printer and can help smooth tonal transitions in prints) and the software may include more print profiles and features, like borderless printing.

FIGURE 1.1 Epson C86 and R800, 8.5-inch printers.

FIGURE 1.2 Epson 2200 and R1800, 13-inch printers.

A 13-inch printer can cost four to almost ten times as much as an 8.5-inch printer, but the cost, compared to wet-darkroom equipment, is still a bargain. Working with a high-resolution scan from a 35mm film original, for example, you can make a 12" × 18" image on a 13-inch printer. This is equivalent to printing the same image on 16" × 20" paper in the wet darkroom. A smaller image can always be printed on a 13-inch printer, making it a good choice if budget allows. By the way, to use an inkjet printer for 12" × 12" scrapbook pages, you'll need a 13-inch carriage printer.

A 17-inch printer, by comparison, is substantially larger and weighs much more than either the 8.5- or 13-inch machines (the Epson 4000 or 4800, for example, weighs over 80 pounds). These printers can fit on a desktop, provided the desk is large and sturdy. The 17-inch and larger printers are professional models. Generally, this means that the overall quality on the larger printers, including the print heads, is more robust. It also means they cost much more. You can purchase an 8.5-inch photo printer for under $100.00. The Epson 4000 currently retails for just under $1,600.00 and the newer 4800 for under $2,000. Inkjet printers larger than the 17-inch carriage size fall into the wide- and large-format categories (24-inch, 44-inch, and beyond).

FIGURE 1.3 Epson 4000 and Hewlett-Packard Designjet 130, 17-inch printers.

PRINTER SOFTWARE

Beyond the obvious, that you can make larger prints with larger printers, there can be a substantial difference in the software designed to drive the printer. This may not be immediately apparent by looking at the user interface—the various dialog boxes that you must navigate through in order to send an image file from Photoshop to the printer. The OEM (original equipment manufacturer) interface for a small printer may appear very similar to that of a larger one. The important differences are 1) the print profiles that are automatically added to the computer system when print-driver software is installed, and 2) options for controlling the printer that are typically embedded within the print-driver's control panels.

The print driver is responsible for managing the printer's mechanical functions and how the information in an image file is translated into droplets of ink. This transformation, called "ripping" (raster image processing), will be examined in detail in later chapters. The main software advantage of photo inkjet printers is the quality of the installed profiles.

A print profile contains the information the computer's operating system uses to match the color space of one device, like a display, to the color space of another device, like an inkjet printer. We'll explore color spaces in detail later but, for the moment, imagine a color space as a box of crayons; some color spaces, like boxes of crayons, are larger than others.

```
▲
. .
Nikon Apple_CPS 4.0.0.3000
Nikon Bruce RGB 4.0.0.3000
Nikon CIE RGB 4.0.0.3000
Nikon ColorMatch RGB 4.0.0.3000
Nikon MacMonitor 4.0.0.3000
Nikon NTSC RGB 4.0.0.3000
Nikon sRGB 4.0.0.3001
Nikon WinMonitor 4.0.0.3000
NTSC (1953)
PAL/SECAM
Pro4000 Archival Matte
Pro4000 Enhanced Matte
Pro4000 Photo Qlty IJP
Pro4000 Premium Glossy
Pro4000 Premium Glossy 250
Pro4000 Premium Luster
Pro4000 Premium Luster 250
Pro4000 Premium Semigloss
Pro4000 Premium Semigloss 250
Pro4000 Premium Semimatte 250
Pro4000 Proofing Semimatte
Pro4000 Singleweight Matte
Pro4000 Smooth Fine Art
Pro4000 Standard
Pro4000 Texture Fine Art
Pro4000 Velvet Fine Art
Pro4000 Watercolor - RW
ProPhoto RGB
ProPhoto RGB
ROMM-RGB
SMPTE-C
SP2200 Enhanced Matte_MK
SP2200 Prem.Luster 1440.icc
SP2200 Prem.Luster 2880.icc
SP2200 Prem.Semigloss 1440.icc
SP2200 Prem.Semigloss 2880.icc
SP2200 Standard_MK
SP2200 Velvet Fine Art_MK
SP2200 Watercolor - RW_MK
sRGB Profile
Stylus C83 C84 Standard
Wide Gamut RGB

2200 1440v EnhanceMatt MK.icc
2200 1440v EnhanceMatt PK.icc
2200 1440v H_PhotoRag188 MK.icc
2200 1440v H_PhotoRag308 MK.icc
2200 1440v PremLuster MK.icc
2200 1440v PremLuster PK.icc
2200 1440v PremSemiGlos PK.icc
2200 1440v VelFineArt MK.icc
2200 1440v WaterColor RW PK.icc
2200 1440v WaterColor RWMK.icc
2200 1440vs PhotoPaper PK.icc
▼
```

FIGURE 1.4 A portion of the profile list that can be viewed in Photoshop's Proof Setup. Notice the single generic profile for the Epson C86 printer; also listed are the default print profiles for an Epson 2200 and other devices.

The color space that describes human vision is called LAB, and all other color spaces are referenced to it. LAB is the "master set" of colors, or crayons, we work with in the digital darkroom. The color space created by an Epson C86 printer, DuraBrite inks, and DuraBright paper is a smaller box of crayons than the color space created by an Epson 2400, UltraChrome inks, and Epson Premium Luster paper. But all the colors in both examples fit within LAB's master set.

The higher the quality of a print profile—the more accurately it describes the color space—the better are the chances that a print will match what you see on a calibrated and profiled display. Small office inkjets typically ship with a single, generic profile, which may produce an acceptable color print but will not perform well for grayscale (black/white) printing.

In chapter 6, we'll introduce the Hard Proof printing workflow, which doesn't rely on printing profiles and will produce good results with all inkjets, including office printers. However, to achieve the best photographic results from these machines, custom profiles must be made or purchased for them. We'll discuss profiles in chapter 4 and how custom profiles are used in later chapters.

The 8.5-inch photo printers and the 13-inch printers usually install a set of default print profiles for the media (paper) the manufacturer wishes to market for that printer. Generally, these profiles are tailored to the paper, and the result, when used properly, is a more accurate print.

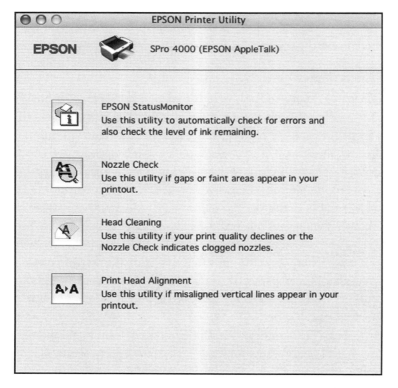

FIGURE 1.5 The printer utility panel for an Epson 4000 printer.

All inkjet print-driver software share certain features, including a set of *printer utilities* that you'll use on a regular basis. (For example, see Figure 1.5 on previous page.) The printer utilities are used to keep the print head clean and properly aligned to the printing stock. We will examine the printer utilities in chapter 6. Monitoring a printer's performance will help you know when it is time to repair or replace it with a new one. You might keep one enlarger for a lifetime, but an inkjet printer is a different animal: its life span has to be measured in "ink years."

You should consider the "digital darkroom learning curve" before choosing a printer size. You can start with a small printer and have the occasional large print made at a professional lab. Consider using the savings to purchase a display calibration/profiling kit (if you haven't purchased one already) and lots of ink and paper to learn with. If you do opt for a larger printer, make certain you have high-quality image files that are large enough for producing bigger prints.

You can work with any brand of printer. There are more options in third-party software and inks available for Epson, but Canon and Hewlett Packard also make inkjet printers that are competitive with Epson in price and features. Used properly, all brands can produce beautiful prints. Once you choose a printer, check for a user group on Yahoo (*www.yahoo.com*) and subscribe. User groups are a terrific way to stay informed about the equipment you use.

DYE INK VERSUS PIGMENT INK

An inkjet printer will use either dye ink or pigment inks. Although the difference in performance between dye ink and pigment ink grows smaller with each new generation of printers, many photographers choose to work with pigment ink due to archival considerations. Good dye ink/paper combinations can produce prints that are currently predicted to last twenty-plus years if displayed properly. Good color pigment ink/paper combinations can match or exceed the life span of the best color prints made in the wet darkroom (sixty-plus years). Visit *www.wilhelm-research.com* for estimates on ink and paper longevity.

All inks, dye and pigment, are fugitive, and eventually the image will lose density and shift color balance as the inks fade (as will color prints made in the wet darkroom). Some ink and paper combinations resist color shift and fading much better than others. As a general rule, dye-ink prints tend to last longer if the ink and paper are made for each other.

Beyond archival considerations, choosing between dye ink and pigment ink is an important aesthetic issue, because ink choice is directly related to the paper you'll want to print on. Pigment inks do not work well—at least not yet—with most glossy surface papers. Some glossy and semigloss surfaces do not absorb pigment inks well. On

these papers, pigment inks may dry poorly and/or be easily scratched or abraded.

The paper-and-ink combination may also be prone to *bronzing*: the ink is absorbed into the paper surface unevenly, creating an odd reflective sheen that is especially obvious when the print is viewed at an angle. Some photographers routinely spray their prints to protect the surface and to camouflage the bronzing. The third generation of Epson's pigment-based UltraChrome inks (K3) is designed to minimize this effect.

Dye inks can print well on all papers, from high gloss to matte or watercolor (although on matte surfaces, they perform best when the paper is coated for inkjet printing). Dye inks generally have a larger color gamut. To understand color gamut, let's revisit the crayon analogy for a moment. Larger color spaces provide more "digital crayons" to work with, but a given print may not use all the crayons in the box. A landscape image may use more blue and cyan crayons in sky areas; a head-and-shoulders portrait may not require these crayons at all. You can think of gamut as the crayons used to form a given image. Image files exist in a color space; prints have gamut; and, generally, dye inks have a larger gamut than pigment inks.

Dye inks also achieve a deeper black, or maximum density (Dmax; Dmin, or minimum density, is the white of the paper). They can replicate more colors, particularly vivid hues, compared to pigment inks (although this, too, is changing with new and improved ink sets).

The aesthetic of gamut and paper surface is part of the digital darkroom learning curve. Some photographers, for example, process images in Photoshop but outsource their printing to labs that can output image files onto traditional Type-C color-printing paper. They simply prefer the look and feel of a traditional wet-process print. There are many choices for printing digitally and, as your experience deepens, the aesthetics of the fine print will become increasing clear.

Consider prints you've made or seen and identify the characteristics you most enjoy. If a high-gloss surface is important, for example, a dye-ink printer may be

FIGURE 1.6 Kodak 8500 and Olympus 440, 8.5-inch dye-sublimation printers.

the best choice. If luster or matte surfaces are preferable, and you're concerned about archival issues, a pigment-ink printer would work well. Either way, it pays to do a little research up front and select a printer and an ink set that resists color shifts and fading with the paper you prefer.

Lastly, one of the great strengths of the digital darkroom is the potential for making prints that *do not mimic* those made in a wet darkroom. Expand your aesthetic horizons by looking at prints made with non-silver emulsion processes (albumen, platinum/palladium, or gum, to name just a few), as well as photolithographs. Once you've mastered the basics of inkjet printing, the range of aesthetic choices is limited only by your imagination.

Ink, incidentally, is not the only way to print in the digital darkroom. There are thermal and dye-sublimation printers that can produce excellent photographs (Kodak, Sony, and Olympus, among others, market these—see Figure 1.6 on page 9), but you'll be limited in print size and paper surfaces compared to inkjet printers, and the initial cost relative to print size can be much higher. Dye-sublimation printers can be a good choice for high-volume production and are a favorite of event, portrait, and wedding photographers.

The Computer

There are many considerations when choosing a computer for the digital darkroom: processor speed, internal architecture (also related to speed), hard drive size; memory, or RAM; and connectivity (how equipment like printers are plugged into the system). "Larger" and "faster" will always have advantages for photographers.

If the printing size is limited to an 8.5-inch printer, and you won't be producing large image files initially, a computer configuration can be modest. To print larger, or work with larger image files, the computer system must grow to accommodate this. When purchasing a computer, consider its ability to grow with you. Internal bays for hard drives and the slots available for RAM are important considerations (several current Apple G5 computers can accommodate up to 8 gigabits of RAM, for example).

Speed is directly related to performing Photoshop work, but it also affects how quickly files can be transferred between the various devices that make up a digital darkroom. This may not be an issue unless the files are large and you want to make big prints. Computer equipment is becoming less expensive and more powerful. You can purchase an excellent computer, configured for the digital darkroom, for about the same cost as a high-quality sheet-film enlarger setup for a wet darkroom.

Hard drives and RAM have dropped significantly in price. If your computer is an older model, consider upgrading the hard drive space and RAM. You cannot have too much of either. A USB/firewire card can be added if the computer has the internal space. Working with smaller files makes CD-R a reasonable choice for storing/retrieving image files. Large files may dictate DVD or additional hard drive

space. All three options—CD, DVD, and hard drives—can be added to an existing computer as external devices.

It is possible to set up a digital darkroom using a laptop computer. A display calibration and profiling kit is still necessary, and an external mouse is a good idea. An external hard drive and/or CD-R/DVD drive, depending on the laptop, may be necessary. Some photographers use a laptop connected to a large external display. Photographers who travel may want to add a laptop as an addition to their desktop system. It can be used on location and work as a second monitor in the digital darkroom. However, a desktop digital darkroom is less expensive to build, and it is easier to expand and upgrade, than a laptop-based one.

THE DISPLAY

Choosing a good display is important. It is the one purchase for which you should budget adequately. You should consider the display, the video card that drives the display, and a display calibration and profiling kit to be a single, unified decision. All three components combine to produce the on-screen image.

You can choose between cathode-ray tube (CRT) and flat-screen, liquid crystal display (LCD) displays in different sizes. A 17-inch CRT display is an economical starting point, but 19- to 22-inch displays are more useful because they allow on-screen images to appear larger. There are CRT displays sold with dedicated calibration and profiling packages. (Sony, Barco, and LeCie have loyal followings, but these are becoming more difficult to find as the computer industry continues to move to LCD technology.)

FIGURE 1.7 Sony Artisan CRT display with calibrator and Apple Cinema LCD display.

Many photographers find that a dual-display setup works well. You might have one high-quality display to work on images, and a less expensive one used to place Photoshop tool palettes and panels. This is a relatively inexpensive way to increase display "real estate" (provided, of course, that you also have a large enough desk for two displays).

If you already have a display and want to upgrade, consider using the old display as a second screen. Displays have a life span and, if keeping one calibrated and profiled is difficult, it may be time to replace it. Depending on the computer, it may be necessary to install a second video card for a dual-display setup. This card can also be less expensive than the one needed for your primary display.

The best choices in a CRT allow internal calibration of the individual red, green, and blue (RGB) scan guns. You may not find this feature on inexpensive displays. If the display allows access to the RGB channels from a control panel or set of buttons on the front, it will usually allow internal calibration. If you're not sure about a display, check with the manufacturer. If internal calibration is not possible, the video card in the computer must be calibrated, and this will compromise the color gamut. It is best for the video card to deliver all the image file information to an internally calibrated display. One consequence of calibrating an inexpensive CRT display through the video card can be reduced screen brightness.

An LCD display saves space on the desk and generates less heat. Many photographers are moving to high-quality LCDs (the Apple Cinema and the Eizo displays are gaining a reputation for color accuracy). Calibrating and profiling an LCD is now as easy as doing the same with a CRT, and the image on the screen is crisp and bright. Calibration, however, must be performed through the video card. If you choose an LCD, be sure to have a high-quality video card installed in the computer.

Avoid inexpensive LCD displays. They tend to manage color poorly, which can require severe adjustments to the video card, and the illumination across the screen's surface may be noticeably uneven. You'll also find that inexpensive LCD displays have a restricted angle of view. Unless you're positioned directly in front of the screen, the image will appear dim and the color rendering can shift dramatically. Inexpensive LCDs may be terrific for the checkout line at the grocery store, but they will only cause heartache in the digital darkroom.

THE VIEWING LIGHT

The brightness of a display raises an interesting point about setting up a digital darkroom: you'll need a reliable viewing light under which to examine prints. Evaluation is more accurate if the brightness and color temperature of the viewing light matches, or is very close, to those of the display. Since a display's brightness is established when it is calibrated and profiled, you will need to adjust the brightness of the viewing light to match it.

The best viewing lights are in the color-viewing booths commonly used in the prepress industry. They are quickly becoming part of the digital darkroom. GretagMacBeth, GTI, and Just-Normlicht manufacture viewing booths suitable for a small office. These range in price from under $500 to $2,500 (there is an excellent PDF article by Dan Reid on color-viewing booths that can be downloaded from *www.rpimaging.com*). These lights are carefully calibrated to either the D-50

FIGURE 1.8 GTI and Just Normlicht viewing booths.

FIGURE 1.9 Ott-Lite and Solux track-lighting fixtures.

or D-65 color-temperature viewing standards. The better models allow the illu-
mination to be adjusted to match display brightness without sacrificing accurate
color temperature (the best reason to budget for a viewing booth). Some include
calibrated light boxes for viewing film.

The Ott-Lite, which does not conform to the strict ISO standards of viewing
booths and is not as versatile, is an inexpensive alternative. The Ott-Lite is a small,
color-balanced lamp that can be purchased at local computer and electronics stores,
or readily found on the Web. Another good alternative is a Solux lamp. There are
fewer models to choose from, compared to Ott-Lite, but the quality of the Solux
light is quickly gaining popularity among digital printers. These desk lamps can be

positioned so that you can physically raise or lower it to match the display brightness. If there is a wall in your digital darkroom that can be used as a viewing space, the Solux track-lighting kit is an excellent choice of illumination. A well-lit viewing wall is especially handy if you intend to make large prints.

A digital darkroom should be set up where the ambient light can be controlled. With a good display and viewing light working at about the same brightness level, the ambient lighting should be dimmed to reduce color contamination and flare. Overhead lighting on a dimmer switch, or low-wattage desk/floor lamps, work well. Window light can be a problem. If the ambient lighting is too high or harsh, the display image will be washed out and mistakes about density, contrast, and color balance are inevitable. If you profile a display in poor ambient-light conditions, the profile will, most likely, be inaccurate.

With either a viewing booth, Ott-Lite, or Solux fixture, do not allow the light to spill onto the display. Many viewing booths have accessory side panels, or you can simply tape black cardboard to the sides.

SOFTWARE

The hardware for a digital darkroom is important, but nothing happens until the software is installed and configured properly. A digital darkroom will need:

1. A current, up-to-date operating system (OS). Updated driver software for the printer and any other peripherals you might have (Zip, CD-R, DVD drives, scanners, and digital cameras)
2. A graphic-imaging program, like Photoshop
3. Information-management software (Acrobat Reader, QuickTime, and StuffIt, for example)
4. A digital-asset management program to keep your files organized and readily accessible
5. Accurate profiles for your monitor, printer, and scanner (if you have one)

THE OPERATING SYSTEM

A new computer should come with the latest version of the manufacturer's operating system software. Major updates must be purchased, but minor updates are usually free and readily available. Updates can be checked over the Internet, and you should make this part of a monthly maintenance plan to keep the digital darkroom running smoothly. This is also true for the driver software for all peripherals. Driver software is code that allows the peripheral—a printer or CD-R drive, for example—to communicate with the operating system.

When operating systems are updated, it may be necessary to update the drivers. This is almost always free and can be done over the Internet. A CD-R or DVD drive will probably come with the software needed to burn files to media. If not, or if the free software is clunky or slow, Adaptec's Toast is an excellent choice.

PHOTOSHOP

Photoshop is the de facto standard for image-editing software in the digital dark-room (although there are other programs available for both Apple and PC). Your choice is between the professional version of Photoshop (currently CS2), retailing for around $650, or Photoshop Elements, for under $100. Photoshop Elements, or the older LE version, is a useful program (and it is sometimes included free with a printer or scanner), but you will want the professional version sooner rather than later.

The color-management capability of Photoshop CS2, and the improved print-ing path through the Print with Preview feature are worth the cost alone. CS2 also incorporates an improved version of the Adobe Camera Raw plug-in software that gives users the ability to work with the Raw image files captured by digital cam-eras (check the Adobe Web site to see if your camera is currently supported), and Bridge, the newest version of Adobe's image browser. When the utility of these two applications is considered, the cost of Photoshop CS2 is very reasonable.

Photoshop CS2 and the Adobe Creative Suite 2 are available for purchase by students and instruc-tors at a very substantial discount (you'll need to verify enrollment/employment, but this can be done online). Many other companies, ranging from Apple to Hasselblad and Mamiya (for camera equipment), also offer student/instructor discounts. If you aren't a student, consider enrolling in digital classes at a local community college or university. The tuition is money well spent, and you'll recover all, or most of it, by making discounted purchases.

Information Management

The Internet is a bountiful resource of information for the digital darkroom. You'll discover that much information, ranging from manufacturers' brochures to magazine articles and helpful tutorials, can be downloaded as portable document format (PDF) files. To open a PDF file requires Acrobat Reader, a free utility from Adobe, which is available in both Apple and PC versions. You may already have this software installed on your computer. If not, simply visit *www.adobe.com* and download a copy.

PDF is a very powerful program that makes it possible to format digital docu-ments using a very wide range of software, convert those documents to PDF files and post them on the Internet for downloading, and then open them without the software used to create them. All that is needed, instead of the original application, is Adobe Acrobat Reader. PDF has greatly simplified the entire process of sharing information electronically—*making information portable*—and it is creating new opportunities for publishing that photographers can take advantage of.

You'll also discover that many Web sites and some software programs require QuickTime, a free utility that is included with Apple's Macintosh OS. If you don't have it, or if you need an updated version, visit *www.apple.com* and download a

FIGURE 1.10 PDF, QuickTime, and StuffIt software utilities.

copy for either an Apple or PC. Like PDF, QuickTime is powerful software for au-thoring multimedia content (including text, video, and animation into a single project, for example). Both programs are becoming universal standards, and you'll need these free utilities to take best advantage of Internet resources.

If the material you wish to download from the Internet is large, or contains more than one item, it may be compressed into a "Zip" file (not to be confused with Zip *drives* which use rewritable cartridges to store data). Once downloaded, Zip files must be decompressed before they will open. This requires another free soft-ware program called StuffIt. This utility is also preinstalled on Apple computers. If you need a copy, or want to check for updates, visit *www.allume.com* or *www.stuffit.com*. The PC versions of this software are PKZip (*www.pkware.com*) and WinZip (*www.winzip.com*) and, if they are not already on your system, can be purchased for a small fee.

Acrobat, QuickTime, and StuffIt are also available for purchase in professional versions that allow you to author and share digital content. You may find these pro-grams useful for presentations or to build a Web site and share your work.

Digital Asset Management

Managing files is often overlooked, but it is an issue that can quickly gridlock a digi-tal darkroom. As digital files are brought into the computer, either by download-ing from a camera or by scanning, they are stored on the hard drive until archived on other media (CD-R/DVD or an external hard drive, for example). You'll create folders to store the files, and this is a good first step in staying organized.

Label every file and folder with an appropriate name for easy identification lat-er. Including the date in file and folder names can be useful, as well. Naming should be descriptive, but you will need to be clever: the computer's software, especially on a PC, will limit how many characters can be used.

You might organize folders by project, place, or subject matter. There is power-ful digital asset management software available for creating catalogs of your work

FIGURE 1.11 Digital asset management software.

(Extensis Portfolio, *www.extensis.com,* and Canto Cumulus, *www.canto.com*). Think of catalogs as sophisticated digital contact sheets; these programs can handle image files, digital video, sound files, desktop publishing projects, and more. They allow attaching keywords to files, making it easy and efficient to find what you're looking for (a CD-R cannot be held up to a light the way a sleeve of negatives can). If you've already mastered software programs like Excel or FileMaker Pro, it is possible to create your own digital asset management system.

It is well worth the time to establish a digital asset management routine. Limited versions of this kind of software are sometimes packaged free with printers (check the installer disk that came with your printer). Photographers working with Photoshop CS2 and Apple's Mac OS X operating system already have on their computers two programs for managing digital image files: iPhoto, part of the Apple's iLife application suite, and Bridge (the Photoshop CS2 browser).

iPhoto isn't as powerful or fully featured as professional applications but it is easy to use, free, and a good way to stay organized until a more powerful solution is needed. It's integrated into Apple's iWork application suite, which includes Pages and Keynote. There are three iPhoto features worth noting. First, the size of thumbnail images can be increased in the iPhoto panel by using the slider in the bottom right corner. Use this feature to identify, compare images, and make selections. Second, in iPhoto Preferences select Photoshop as the "Double-click Open" option. Once thus set, double-clicking on a thumbnail will automatically open the image file in Photoshop, a terrific time saver. Thirdly, iPhoto incorporates a Keyword feature (Image>Keyword) that can greatly simplify searching for images.

Bridge, the newest version of Adobe's image browser, is a stand-alone application that integrates seamlessly with all the components of the Adobe CS2 package. It can simplify workflow while helping with the chores of building image catalogs and conducting searches. If you use a digital camera, Bridge's ability to show the metadata attached to image files can be especially important. Metadata (which literally means "data about data") will show exactly how the image file was captured,

FIGURE 1.12 Apple's iPhoto application.

FIGURE 1.13 Photoshop CS2 Bridge is a very flexible file browser that integrates seamlessly into all Adobe Creative Suite applications (including Photoshop's Camera Raw processor).

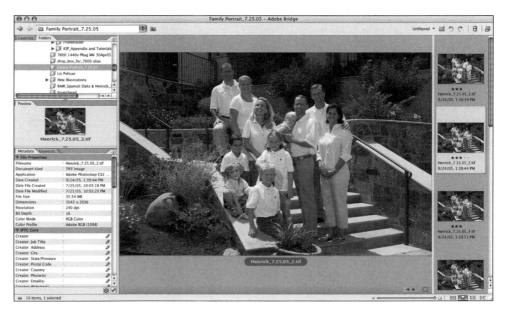

along with any processing steps applied to the image, either by the camera or by Raw conversion software.

Like iPhoto, Bridge allows keywords to be assigned to images, words that can, when used regularly, greatly simplify searching for files. Bridge also includes the ability to "flag" and "rank" files. This gives you the option of grouping files into categories (like "bests," "seconds," and "rejects"). If you use the browser to edit camera files, and tend to shoot a lot, categorizing files up front can save a great deal of time and effort later.

Lastly, Bridge has many configuration options. You can set it up to view lots of images simultaneously or just one at a time. You can save configurations and use the appropriate one for the job at hand. There are two excellent resources for more information about Photoshop's browser: Bruce Fraser's *Real World Camera Raw with Adobe Photoshop CS2* (Peachpit Press, 2005), and Deke McClelland's *Adobe Photoshop CS2 One-on-One* (O'Reilly Media, 2005).

CD-R and DVD Storage

As folders accumulate image files, you'll want to transfer them to a dedicated hard drive (either internal or external) or burn them to a CD-R or DVD. You can then remove the folders from the computer's main hard drive and free the space.

Currently, a CD-R will hold about 700 megabytes of data and a DVD will hold just over 4.5 gigabits. If your image files are moderate in size, CD-R can be a good choice. Fast CD-R drives have become remarkably inexpensive, and the highest quality blank CD-Rs are a bargain. As your image files grow larger or begin to accumulate, a DVD recorder may prove a better choice. Some drives will burn and play both CD-R and DVD.

DVD drives are slower than CD-R, and blank DVDs are more expensive compared to CD-R, but the storage capacity is an advantage for archiving large files or folders (and DVD capacity will increase in the near future). DVDs are also less prone to damage, as compared to CD-Rs, because the recording layer is located in the middle of the disc structure. The recording layer on CD disc is just below the surface *of the label side.* The proximity of the recording layer to the label is reason to not write on the surface with anything harder than a felt-tip marker. Be sure to use a marker that is designed for this purpose. It will ideally have a permanent water-based ink. The safest place to write on a CD or DVD is on the center hub or within the "mirror band" that surrounds the hub.

Some photographers routinely burn duplicate CD-R or DVDs. They archive one set as a safeguard and work from the other. *This is a good strategy.* Some photographers will burn CD-R or DVDs but also add an extra hard drive to their system dedicated to storing duplicate image files. When the drive fills, it is removed, archived, and a new drive is added to the system.

Because hard drives have dropped significantly in price, the cost of using an extra hard drive to archive image files is about the same, measured in megabytes, as using DVDs. Either way, if the work is important you must create a system to backup and archive image files. You court disaster if this is not routinely done. An archiving strategy, used with digital asset management software, will make the digital darkroom safer, more productive, and efficient.

Blank CD-Rs and DVDs can vary considerably in quality. You can use inexpensive media for temporary storage, but for archiving it is imperative to use the highest quality discs available. These will be more expensive and probably harder to find over-the-counter (the MAM-A brand CD-R and DVD discs, formerly known as Matsui, enjoy a good reputation and can be purchased online).

It is important to handle and store your archive CDs and DVDs properly. Protect the discs from excess heat and humidity, particularly direct sunlight. Protect all surfaces from scratches, smudges, and fingerprints. Fingerprints can adversely affect the performance of a disk more than slight scratching. Lastly, file your archive discs vertically in plastic "jewel cases." Do not store them horizontally as, over time, they will flex and the recording surface can be distorted. For the same reason, when removing or placing discs in cases, be sure not to flex them more than necessary.

In the next chapter, we will focus on generating digital files. We'll examine hardware and software but also discuss options and choices that can affect the quality of the files you generate. Making beautiful prints in the digital darkroom requires high-quality image files, and our emphasis will be on developing strategies to accomplish this.

CHAPTER 2

First Steps in the
Digital Imaging Workflow

The term "workflow" has migrated into photography's vocabulary from digital imaging. It's a subtle but powerful illustration of how traditional and digital systems for making photographs are merging and complementing each other.

The Zone System is an excellent example of a traditional photographic workflow. It's a mature and adaptable technique for learning the craft of photography. One of Adams's protégés, Minor White, understood the concept of "work flowing" better than most. His melding of the Zone System with eastern mysticism brought the Tao concept of flow, or *wu wei*, into play.

Creative work should flow. That's the promise of mastering one's craft. Properly used, the Zone System offers photographers a workflow that focuses on complementary ideals: producing accurate image information to make quality prints. Traditionally, Zone System photographers use film and paper curves to map image density to print tonalities. Some photographers use densitometers to build film and paper curves; others prefer the level of control achieved by eye.

In the digital darkroom, photographers learn to read the *histogram* of an image file. Like film and paper curves, the histogram helps you understand how *image information* organized into pixels ultimately translates into the *tonal quality* created by ink in a finished print. We'll examine Photoshop's histogram later in this chapter.

The advantage of learning the printing craft in the wet darkroom is that the "stuff" can be held and touched. It is a very tactile workflow. Digital photographs, by comparison, exist behind the hard, objective surface of a computer display. The image tends to feel abstract and untouchable until printed. Building good workflows

FIGURE 2.1 Kodak Tri-X film curves. Kodak technical data/black-and-white film, No. F-4017.

FIGURE 2.2 A grayscale image file with Photoshop's Histogram window.

for the digital darkroom will help overcome this sense of disconnection.

In this chapter we'll examine a number of basic concepts that, working together, create a foundation for the digital darkroom. We'll explore how digital information is created and organized, and how that information is used and edited in Photoshop for inkjet printing.

Workflow and Skill Sets

Skill sets and workflow are complementary concepts. Skill sets are *what* you know about the tools you use (hardware and software, for example). Workflows are the processes that depend upon skill sets; they are *how* you put what is known into practice.

Digital darkroom skill sets are analogous to those used in traditional photography and the wet darkroom. There are skill sets for digital capture using a scanner or digital camera, for example. You'll learn skill sets for inkjet printers and the OEM printer driver, and perhaps RIPs for printing off the OEM path. And, of course, there are many Photoshop skill sets. Skill sets vary from one device or application to another but share characteristics with traditional photography: you'll never outgrow them, there is always something new to learn, and mastery requires practice.

Workflows are routines that take advantage of skill sets. Good workflows tend to share certain characteristics, as well: they are flexible, adaptive, and efficient. For example, you'll develop as many workflows for inkjet printing as the work requires; they'll change as printers, inks, and papers change. A reliable workflow should account for:

- Computer hardware/software
- How your digital files are generated (digital camera or scanner)
- Level of digital processing expertise (usually Photoshop)
- Intended output (color or grayscale, inkjet or other)

Later in this chapter we'll examine the factors that determine how large image files need to be to make the prints you desire. Considering file size is a good way to measure and evaluate the equipment needed for a digital darkroom. Making 8.5" × 11" or smaller prints requires less investment compared to a system that supports larger prints. The skill sets and workflows learned from a modest system can then be used to produce larger image files and make larger prints, as a system is upgraded.

The Digital Image File

We'll begin with a working definition of the *digital image file* made with cameras and scanners. To understand digital files, we'll use examples in Photoshop to build a working vocabulary. You may want to open image files in Photoshop to compare with examples in the text.

Unlike conventional film images, which are composed of silver grains or dye particles, digital image files are composed of numbers (binary code). If you're uncomfortable with math, take heart. The computer's binary system is elegantly simple: it uses only two values, 0 and 1. Each discrete level of information in a digital file is represented by a string of 0s and 1s. Longer strings, having more 0s and 1s, contain more information. The length of a binary string is the *bit depth* ("bit" is a contraction of "*bi*nary digi*t*"). Bits are the smallest piece of information used by a computer.

Typically, the image files that photographers work with range from 8-bit to 16-bit. Depending on a digital camera or scanner's software, and the way it is configured, files created at 10-, 12-, or 14-bit are automatically interpolated downward to 8-bit for processing in Photoshop; or the bit depth is conserved and the file opens as if it were a 16-bit file (conserving bit depth is the best option for inkjet printing).

Bit information is organized into *pixels* ("pixel" is shorthand for "picture element"). Each pixel in a 12-bit file, for example, represents twelve discrete levels of information. Pixels are mathematical constructs often confused with *photodiodes*, the physical devices arrayed on the sensor of a digital camera or scanner. The confusion is understandable; manufacturers (or at least the good folks who market what manufacturers make) prefer the word "pixel" to "photodiode." A "megapixel camera" feels more comfortable than a "megaphotodiode" one.

FIGURE 2.3　In the digital darkroom, binary numbers replaced analog grain.

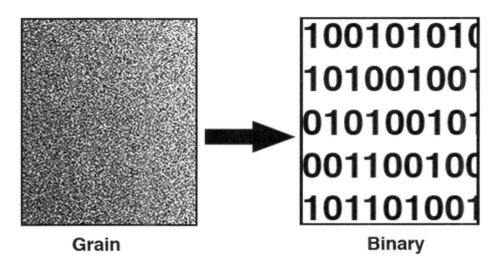

Grain　　　　　　　　　　　　　　　Binary

Pixels

Pixels are the smallest pieces of information that photographers access and manipulate in the digital darkroom (unless they write computer code). They are the building blocks of the digital darkroom. Scanners and digital cameras create and then organize bit information into pixels, displays show information in pixels, and Photoshop is designed to work on the pixel level. How they are created, used, and ultimately translated into droplets of ink determines the quality of an inkjet print.

The technology that makes this possible is truly impressive. Digital cameras create the data to form pixels by *sampling* the light transmitted through the camera's lens during exposure. Scanners have an internal light source but also work by sampling exposure.

A digital capture begins, as with film, when an exposure is made. Film-based photography uses silver-halide emulsions to record light. Digital devices use an entirely different technology: a sensor covered with rows and columns of photodiodes. Most digital capture devices use either a charge-coupled device (CCD) or a complementary metal-oxide semiconductor (CMOS) image sensor.

Imagine standing on the sensor's edge in a digital camera. Stretching before you in a vast, orderly array are photodiodes in the shape of buckets (millions of buckets). If rain were to strike the sensor, these sophisticated buckets would collect and measure the water falling into them. Substitute photons (discrete packets of electromagnetic energy) for raindrops and you begin to understand what a digital sensor does. It uses photodiodes to collect and measure photonic energy.

Each photodiode has a red, green, or blue color filter placed over it, forming a pattern that is often referred to as a *stripped array*. The most common configuration is called the Bayer pattern, using a Green, Red, Green, and Blue (GRGB) array.

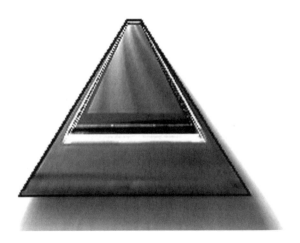

FIGURE 2.4 A CCD or CMOS image sensor is composed of millions of individual photodiodes, each producing the mathematical information to form a single pixel.

There are twice as many green sensors as red or blue (the human eye is most sensitive to green light). Without filters, the photodiodes would record only luminance values, ranging from black (no exposure) to white (a full bucket). Color filters alter these values, allowing the photodiode to record information that represents red, green, and blue values. A full-color image is possible when all the information is combined. This principle, by the way, was demonstrated in 1861 by the Scottish physicist James Clerk Maxwell.

You may have wondered why an image file created by a 6-megapixel camera opens at about 18 megapixels in Photoshop. If the camera has 6 megapixels (and we now know that each pixel is responsible for encoding a specific color), where do the additional 12 megapixels come from?

After the original exposure (the photodiodes have collected the photonic information), the image sensor generates the additional pixels by having each photodiode sample its neighbor. A green-filtered photodiode will sample the information from a neighboring photodiode. This information is used to generate the full complement of pixels in an image file. A very sophisticated form of interpolation (performed by in-camera demosaicing algorithms) is used to generate a total of 18 megapixels from a 6-megapixel camera. The Foveon X3 "direct image sensor" offers a unique approach to color filtering. Each photodiode collects red, green, and blue data during the analog exposure, instead of sampling neighboring photodiodes, thus mimicking color-film technology.

In practice this works very well. The information is then sent to the analog-to-digital (A/D) converter for further processing in-camera. There is an elegant illustration of this at *www.dpreview.com* (see the glossary for excellent tutorials by Vincent Bockeart).

All digital files begin as electromagnetic energy that is transformed into voltage signals by the image sensor. These signals are transformed into binary information when they reach the camera's A/D converter. It is the A/D converter's job, not the image sensor's, to turn analog information into bits. The image sensor, the photodiodes (including the colored-filter array), and the A/D converter—and software that controls this amazing set of hardware—play important roles in the quality of the digital information in an image file.

For example, "noise" can be an important issue in digital capture. Always present in electronic systems, noise can be minimized by using high-quality hardware and software. Physically larger photodiodes, for example, tend to generate less electronic noise. Most photodiodes are square, but some are rectangular. Most are arranged in rows and columns (like bricks in a wall or a stack of toy blocks), but the Fuji sensor has square photodiodes oriented at a 45-degree angle.

Bits and Bytes

A 1-bit image file is only capable of depicting information as either black or white. This represents very little information. To store more image information in each pixel, the string of 0s and 1s needs to be longer (often referred to as "increasing the bit depth"). Increased bit depth, composed of longer strings of 0s and 1s, can represent more information in each individual pixel of the image file.

Bit depth has important implications for photographers because the math is exponential; each increase in bit depth raises the information in a pixel to the second power. For example, a 1-bit file has just two possible combinations of 0 and 1 (01 and 10), but a 2-bit file has four combinations. A 4-bit file will have sixteen possible combinations. With 8 bits of information, a computer can achieve 256 different combinations of 0 and 1. With that much information, the illusion of continuous-tone image is possible.

FIGURE 2.5 Increasing bit depth increases information.

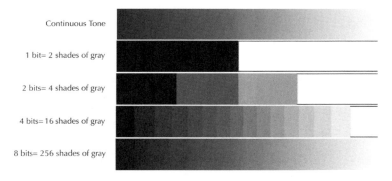

FIGURE 2.6 An 8-bit file has enough information to create the illusion of a continuous-tone image.

1-bit 2-bit 8-bit

Increasingly, photographers are using image files larger than 8-bit. A 16-bit image file is twice the size of an 8-bit file (increasing the need for storage space on either hard drives or removable media, processor speed, and RAM). But an 8-bit file has only 256 levels ($2^8 = 256$) of information to work with, whereas a 16-bit image file has 65,536 combinations of 0 and 1 ($2^{16} = 65,536$). If all the binary information in an 8-bit file were to fit perfectly on one page, a 16-bit file would be a 256-page book.

You should know that some consumer graphic-editing applications do not support working with 16-bit files. Photoshop CS2 isn't completely 16-bit enabled, but it has all the 16-bit processing features typically needed in the digital darkroom.

In the digital domain, 8 bits of data are a *byte* ("byte" is shorthand for "binary term"). Small image files are measured in *kilobytes* (KB, or thousands of bytes). One kilobyte equals 1,024 bytes, or 8,192 bits of information. Larger files are measured in *megabytes* (MB, or millions of bytes). One megabyte of data equals 1,048,576 bytes, or 8,388,608 bits of information. A 20-megabyte image file would contain 20,971,520 bytes or 167,772,160 bits of information.

Numbers that large can seem overwhelming, but they illustrate two important points. First, it takes a lot of digital information to create the illusion of a continuous-tone photograph. Small image files are actually preferable for some uses, but megabytes of information are needed for inkjet prints larger than wallet size. A

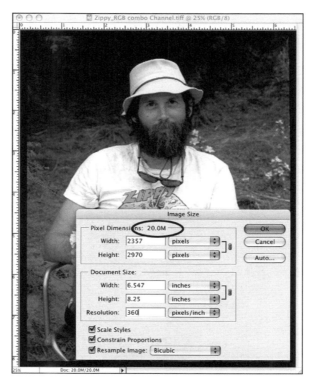

FIGURE **2.7** **We can examine the file size in Photoshop's Image Size panel. It provides a wealth of informa-**
tion, ranging from pixel dimensions to height, width, and resolution.

PHOTOGRAPHER'S GUIDE TO THE DIGITAL DARKROOM

20-megabyte RGB image file contains enough information to produce high-quality color inkjet prints 8" × 10" to 12" × 16" (depending on the subject matter). We'll discuss how file size is translated into printing resolution later in this chapter.

Second, all this information must be highly organized to be useful. To help accomplish this, the bit information contained in the pixels of an image file is organized into *channels*. The creation device—for example, a digital camera or scanner—manages the organization of this information, but we can use Photoshop to better understand how channels work.

Channels

Let's revisit the 20-megabyte file to explore how images are represented in Photoshop. The data that forms an RGB image is organized into red, green, and blue *channels*. Channels can be viewed in Photoshop (Window>Channels). The Channels palette lists individual channels for each color, along with a composite channel (the default selection when a file is opened in Photoshop).

Open the Channels window and click on the individual Red, Green, and Blue channels. You'll discover that color information is encoded in grayscale. This can seem coun-

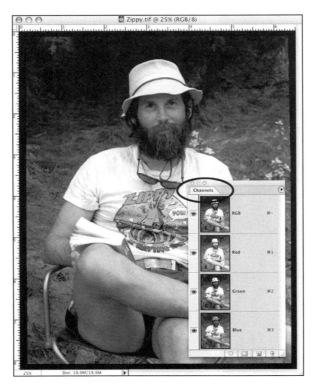

FIGURE 2.8 Photoshop's Channels palette showing an image in RGB mode (one composite channel plus additional channels for red, green, and blue image information).

terintuitive: why would color be represented in grayscale? The answer is in the math. The information in an image file is binary, *including the color information created by the filters on the image sensor.* Each channel contains instructions that an application (like Photoshop) and a device (a display or inkjet printer) use to create the illusion of color.

Photoshop can create illusions in eight modes (Image>Mode). A CMYK file will display five channels (one each for cyan, magenta, yellow, and black information, plus a composite channel). A grayscale image file has a single channel. In LAB mode, almost all the data containing details and texture is organized into the Luminance channel, and color information is organized into the A and B channels.

Channels are the digital equivalent of color separations used to produce offset printing plates. As the information on one plate is added to the next, one layer at a time, the finished image is created on the press. Each plate, like the channels in Photoshop, includes information used to construct image detail and color. Other printing technologies used by artists and photographers—lithography, intaglio, silkscreen, dye transfer, and carbon printing, for example—work in a similar fashion.

Each technology has a *medium* for storing and using image information. The medium can be a metal or plastic plate, wood, stone, plastics, or fabric (to name just a few). The idea is to transfer information stored in the medium to *media.* Channels are the medium used in the digital darkroom and, most often, the information is transferred to paper media. There are other possibilities. A digital file can be printing on plastic, for example, to produce a negative for contact printing in the wet darkroom.

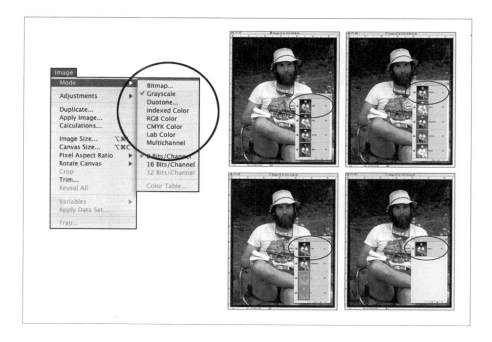

FIGURE 2.9 **Photoshop offers eight modes for displaying and editing image files. Photographers typically use RGB and grayscale.**

Remember, it is the capture device (digital camera or scanner) that organizes all those bits and bytes of information into pixels, and the pixels into respective channels. Photoshop simply displays the information present in the file and provides a sophisticated tool kit for editing it. (See Figure 2.10, below.)

The Histogram

You can actually see the distribution of information in an image file by accessing Levels (Image>Adjustment>Levels) or opening the Histogram window (Window> Histogram). The graphic display is called a *histogram*. It is a mathematical "snapshot" of the information in the file.

Histograms are a valuable tool in the digital darkroom. They organize image information into 256 levels (0-255) regardless of the file size (files exceeding 8-bit will also display in a 256-level histogram). The Histogram window presents a wealth of statistical information about an image file, including how many pixels exist in each level (move the cursor across the graph and the information will display below it). You can also simultaneously view the histograms for each channel in a color image.

FIGURE 2.10 The histogram of an image file can be viewed in Levels or in the Histogram window, which can be kept open as you edit and image file. The Histogram window is dynamic; it will change to reflect the edits made.

Levels and Curves

The Levels panel provides a powerful tool set for editing files. You can, for example, edit the black point, white point, and gamma of the image by moving the respective pointers located immediately below the histogram. Some photographers may be more accustomed to the word "contrast" than gamma. If you change the gamma point in Levels, the effect, seen in the on-screen image, is a change in image contrast. Editing these settings can make a considerable difference in an image file's density, contrast, color balance, and tonal quality. Each channel in the image can be individually edited through a pop-up menu.

Some photographers prefer Curves (Image>Adjustment>Curves) for image editing instead of Levels. You'll want to experiment with both. The Curves panel does not include a histogram, but the Histogram window can remain open while editing in Curves. The histogram window is dynamic; it will change to indicate the effect of an edit in levels or curves.

As you might have guessed, when using Levels or Curves to edit an image, file the "behind the scenes" processing is mathematical. Open Curves (and click the button in the lower right corner to enlarge the panel). Notice the straight diagonal line in the graph and Input/Output fields directly below. The straight line indicates a default one-to-one relationship between Input and Output values. Move the cursor over the

FIGURE 2.11 Individual channels can be edited in Levels.

FIGURE 2.12 Some photographers prefer to edit image files in Curves, which also provides access to individual channels.

FIGURE 2.13 The default curve for an image file will have a straight diagonal line moving from black (lower left corner) to white (upper right corner). By editing the curve (in this example, two editing points were created by clicking on the line and dragging them to new positions) we can see that the relationship between input and output values are changed.

graph and these fields change. Click anywhere on the graph, or click and drag the diagonal line, and the relationship between input and output values changes.

Input and output values are an important concept in the digital darkroom. Manipulating the relationship between them is the basis for color management and image file editing. They are also used when sending a file to an inkjet printer. The software that drives the printer treats every pixel in the image as a set of input values. It will map, or translate, those values into output values that determine how the inks are applied to the paper. Profiles contain the instructions that the applications, like Photoshop and the OEM print driver, use to translate input values into output values. The more accurate the profile, the more accurately input values are translated into output values.

Photoshop internally organizes input and output values into look-up tables (LUTs). We'll return to LUTs in chapter 4, when talking about the important role profiles play in the digital darkroom.

Device Resolution

Because photodiodes are mechanical/electronic devices, they can be counted, providing an accurate measure of optical resolution. However, pixel count is often used to indicate the resolution of digital cameras and scanners. Technically, the resolution should be stated in *samples per inch* (spi), but *pixels per inch* (ppi) is commonly used, and the terms have become interchangeable.

The resolution of digital cameras and scanners is stated in different ways. Camera resolution is measured in *megapixels* (millions of pixels). For example, the CCD sensor in a Nikon D100 camera measures 23.7×11.5 mm in size. Photodiodes are arranged in rows and columns measuring 3008×2000 ($3008 \times 2000 = 6,016,000$, rounded to 6 million, or 6 megapixels). By comparison, the Kodak SLR/n camera has a 36×24 mm CMOS sensor (which corresponds to the format size of 35mm film) with 4500×3000 photodiodes. The result is a 14-megapixel file.

Scanner resolution is not measured in megapixels. Instead, it is stated as a pair of numbers: 1200×2400 or 1800×2400, for example. Standing on the edge of a scanner's sensor, you'd see photodiodes arranged in a linear array, not the field array of a CCD or CMOS censor used in a digital camera. Some scanners have a single row of photodiodes; others have several.

The first number indicates how many photodiodes per linear inch exist on the sensor row. If a flatbed scanner is 8.5 inches wide, for example, the sensors are aligned across that dimension. If the scanner's optical resolution is 1200 ppi, there are 1200 individual photodiodes per linear inch (the photodiodes in a flatbed or film scanner, like those on the sensor of a digital camera, also have color filters). This number is the *optical resolution* of the scanner; it represents the number of samples, and therefore real pixels, generated by the scanner. The linear photodiode

array in a film scanner remains stationary, and a stepper motor moves the film across the array. The second number indicates the discrete mechanical steps the sensor array can make. If the number is 2,400, for example, the stepper motor will move the sensor array to 2,400 positions as it incrementally travels the long dimension of the scanning field.

The scanning field for film scanners is stated by film-format sizes. The most popular (and affordable) film scanners are designed for 35mm and smaller film. There are also medium-format and large-format film scanners (which, all other things being equal, are proportionally more expensive). Most film scanners use film holders to position and transport film. The mechanical quality of these holders, as well as the transport and optical system used by the scanner, are important factors in a film scanner's overall quality.

When comparing scanners, it's important to know the measured optical resolution instead of any ability the scanner has to create *interpolated resolution.* Interpolated resolution, as we will see in a moment, is a completely different digital animal. Interpolated numbers are often published to enhance the marketing of a scanner and, for all practical purposes, should be ignored.

There is one additional explanation of the term *bit* that begs clarification. An 8-bit RGB device is sometimes called a "24-bit" device. This refers to the 3 channels an RGB device generates (each channel having 8-bits). A 16-bit RGB device will be called a "48-bit" device (3 channels x 16-bit = 48-bit).

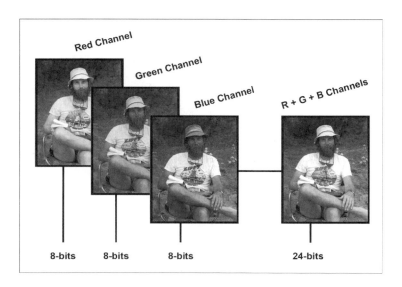

FIGURE 2.14 Digital nomenclature can lead to a confusing vocabulary. Bit depth is directly related to channels. An RGB image, having three 8-bit channels, is often referred to a "24-bit image."

Referring to capture devices in this manner is technically correct, but it can be confusing. These descriptions are related to digital cameras and scanners that do not have a 16-bit option but can produce image files that exceed 8 bits per channel. For example, a camera or scanner capturing 12 bits of image information for each red, green, and blue channel will produce a 36-bit file (3 x 12 bits = 36 bits). If a camera is formatted for Raw capture, all 36 bits of information are preserved by the software. The image, opened as a Raw file in Photoshop, retains the information. If the camera is formatted for a TIFF or JPEG capture, the software will *downsample* the 12-bit capture to 8-bit. The excess information is permanently discarded.

Scanners do not have Raw capture and will downsample files to 8-bit automatically. The assumption is that downsampling produces a higher quality file (because there was more information to begin with). Generally, this process does result in better image files. Of course, the transformation from a higher bit depth to a lower bit depth will depend, in large measure, on how well the software performing the downsampling works. The better solution is to scan in 16-bit.

Image File Size:

It is relatively easy to identify factors that contribute to the size (measured in pixels or megabytes) of an image file:

- The bit depth
- The number of channels
- The optical resolution of the imaging device
- The size of the original image (film or print) when using a scanner

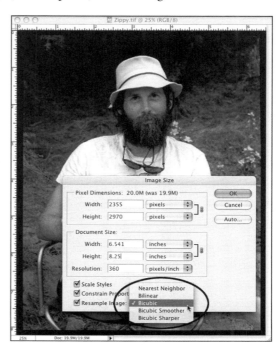

FIGURE 2.15 Photoshop's Image Size panel also provides access to five types of interpolation.

However, size isn't everything. "Large" doesn't necessarily equate to "quality." We already know, for example, that pixels are not created equally. There is one additional factor in the creation of image files to consider: *optical density range* is often overlooked. Optical density range does not affect file size; rather, it's the ability of a scanner or camera to capture information in the low end (shadows) and high end (highlights) of the image's tonal scale. We'll examine optical density range in more detail in chapter 3.

Let's take a closer look at the resolution of our 20-megabyte image file. We can use Photoshop (Image>Image Size) to illustrate how the variables of image size and resolution can be measured, or altered, in both pixels and inches. (See Figure 2.15 on previous page for example.) If we decrease or increase any variable, the size of the image file will change accordingly. The Image Size dialogue panel illustrates the relationship between pixels, resolution, and document size.

Interpolation

Notice that Resample Image is at the bottom of the Image Size dialog panel. This is Photoshop's *interpolation* menu. In this example, the file was interpolated to a slightly larger size (the new, added pixels have been "invented" by Photoshop interpolation. There are limits to how much new information can be created before it becomes detrimental to the finished print. Interpolation should always be performed on a *Working* copy of an image file, never the *Master* file. We'll discuss Working and Master files in chapter 4.

We can also ask Photoshop to interpolate the file downward, requiring Photoshop to subtract pixels from the file. How Photoshop performs interpolation depends on the selection in the Resample Image menu. Photoshop CS2 has five methods for performing interpolation. The three Bicubic options—Bicubic, Bicubic Sharper, and Bicubic Smooth—are the best choices for the digital darkroom.

You should test all three on an image file. Bicubic Sharper is designed for interpolating a file upward: Bicubic Smoother is for downsampling. The standard Bicubic operates between the two. As with many Photoshop options, the subject matter in an image file is the final criteria.

Print Resolution

Resolution is a complex topic, in part because of the vocabulary used to describe how different devices work. We describe the resolution of displays in pixels, and the resolution of digital cameras and scanners in samples per inch (but, often, pixel count is substituted instead). We should also consider the resolution of output devices, especially inkjet printers.

When a file is sent to an inkjet printer, pixel information—is translated into extremely small droplets of ink, a process controlled by a raster image processor (RIP). RIPping a file is performed by print driver software (either the OEM driver that came with the printer or a third-party RIP). The print driver typically needs 240–360 ppi (pixels per inch) of image information to create a high-quality print. More pixels per inch can be sent to the printer, but it is unlikely you'll notice an improvement in print quality.

Keeping the file size constant using 360-ppi produces a smaller print size than one made at the lower 240-ppi printing resolution. Try printing at both resolutions and see if there is a noticeable difference in the prints you make. Dropping lower than 240 ppi with an inkjet printer is risky.

The pixels-per-inch resolution of image files has nothing to do with the resolution of an inkjet printer. A common printing resolution for inkjet printers is 2880 × 1440 dpi (dots per inch). The printing resolution numbers work like those for flatbed scanners. Printer resolution indicates how many individual droplets of ink the print head produces per linear inch. A 240- to 360-ppi file is transformed, as part of the RIP process, by the printer into 2880 × 1440 droplets of ink per inch. Pixels per inch and dots per inch describe very different things.

When outsourcing printing, it is important to know the file resolution needed by the printer. You can have a file printed at a professional lab, a mini-lab (your local drugstore or food market, for example), or by e-mailing files to Internet vendors. Always ask what resolution they require and, while you're at it, which file format is preferred. Some custom labs charge a setup fee if they must alter the resolution or format of an image file. For example, at 300 ppi, you need a 6 MB file to make a 4" × 6" print; a 17 MB file to make a 7" × 10" print; and a 34 MB file to make a 9" × 14" print.

Information and Illusion

When looking at a continuous tone image on a display, you may *experience* details and colors but, in reality, this is simply information composed of *bits* that have been organized into *bytes* and stored precisely in *channels*. If done properly, the math and organization are invisible, and a compelling illusion—*a photograph*—is the end result.

The essential technical challenge of making photographs, with film or digital media, is to understand and control how *one kind of information becomes another kind of information*. With conventional photography, for example, light is recorded on film at the moment of exposure. Radiant energy produces an electrochemical response in the silver-halide molecules embedded in the film emulsion. A latent image is formed that will be chemically amplified through development. In this process, radiant energy *becomes* silver density (and, with color films, the silver density will be translated into dye particles as part of the film-development process). The image information is stored or, to use a term from the digital domain—*encoded*—in the film density.

Printing the image is a transformation of film density into print density. The information stored in the film becomes information stored in a print, essentially a refinement on the negative-to-positive processes invented in the 1830s by William Henry Fox Talbot. To print in the digital darkroom, we use the binary information stored in an image file. We can use a scanner to transform analog film or print information into binary code, or use a digital camera to create image files.

The image eventually seen on a display may be composed of tens of thousands of individual pixels, each mathematically defined, forming a matrix below the perceptual threshold. Each pixel displays a small portion of the information in the digital file. This is a finely controlled electronic illusion that mimics those created by film grain or the halftone reproduction process used in most publications, including this book.

In each case, the illusion is believable if the discrete pieces of information that compose the image stay below the perceptual threshold. By enlarging the digital image file in Photoshop (Command + will incrementally increase the file magnification to a maximum of 1,600 percent; or, you can use Photoshop's Zoom tool), we can see the film's grain structure. Eventually, at full magnification, we can see that the apparent grain structure is actually composed of pixels.

When the image file is sent to an inkjet printer, pixel information is transformed by the print-driver software into millions of ink droplets. Done properly, the illusion remains intact. In chapter 4 we will examine the scanning process in more detail and relate resolution and bit depth to another important concept, optical density range. For now, keep in mind that increased resolution allows analog information to be translated into more pixels. By increasing the bit depth of each pixel, the amount of information stored in an image file is significantly increased. Mostly importantly, increased bit depth translates into finer gradation of image values. This helps create and preserve the illusion of a continuous-tone photograph.

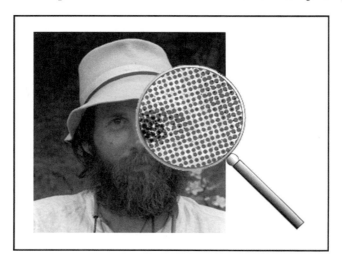

FIGURE 2.16 Continuous-tone images, in any medium, are carefully controlled technological illusions.

Generating Digital Image Files

Photographers with wet-darkroom experience understand how important a good film original is to the printing process. Image files created by a digital camera or scanner are equally important. With either traditional or digital photography, the path to a finished print begins at the moment of exposure and is affected by the decisions made at each step in the processing of the image.

We'll discover that the digital workflow, compared to the wet darkroom, requires new ways of thinking about how images are created and processed. Photoshop provides a level of processing control that is far beyond what can be accomplished in the wet darkroom. To make things more interesting and challenging, there is usually a range of options for accomplishing the same goal: the trick is to assemble the puzzle into a coherent picture.

The Digital Capture Workflow

Let's begin with a brief overview of the decisions photographers make with film-based photography and fine printing. The four basic technical variables in wet-darkroom printing are:

- *Density* (how light or dark the image is overall)
- *Contrast* (the relative difference between areas of differing tonality, also called *gamma*)
- *Color balance* (when printing color images)
- *Tonal relationships* (when printing black/white)

Beyond these four variables, there are many things that affect the *character* of a finished print: film type and format, film development (including dilution, temperature, and agitation), paper type (including surface, Dmax, and base tint), paper developer and development, tonal manipulation (dodging, burning, masking, flashing, and bleaching, for example), toning with black/white printing, print size and finishing, and much more.

The aesthetic success of a print is the accumulation of all the decisions embedded in a photographer's wet-darkroom workflow. Photographers can spend a lifetime refining these choices.

As outlined in the last chapter, both film-based photography and digital capture begin with an exposure. Unlike with film, where exposure produces a latent image that is chemically amplified through development, a digital camera literally segments the exposure into very small individual units (based on the number of photodiodes on the image sensor). The analog information is transformed to digital information by the A/D converter in the camera. The information leaving the A/D converter is binary data organized into pixels. All of this happens before an image is viewed on the camera's LCD panel or the image file is opened in Photoshop.

The electronic journey of an image file continues after the A/D converter. It will be processed by the camera software, based on menu selections, before it is stored in memory (usually on a removable memory card—Compact Flash, Smart Media, or Microdrive, for example). The image file is eventually downloaded to the computer for processing in Photoshop.

A film or print image must be scanned to translate analog information into digital information. You can make the scan yourself or outsource it (an option we'll examine later in this chapter). The file created by a scanner also begins as analog information converted to binary data by the scanner. Digital cameras and scanners both offer an impressive (and sometimes confusing) range of menu options that affect how an image file is processed before it is viewed in Photoshop.

How extensively an image file is processed *before* Photoshop is an important issue. The decisions made through the menu choices on a digital camera, or in the scanner software, can have a substantial effect on the image file. Digital craftsmanship is very important! The idea that it can be "fixed in Photoshop" is one of the most pernicious misconceptions in digital imaging. You cannot pay too much attention to the way digital files are created, processed, and archived.

Image files are composed of numeric information, and *processing digital files alters this information*. Sometimes, the changes are so minor that they don't affect print quality; the changes exist below the visual threshold and cannot be perceived. Sometimes, however, so much information is modified during processing that it becomes very difficult, if not impossible, to make a fine print. Any digital printing workflow should be designed to *conserve and protect information*.

File Names

Before taking a closer look at image files produced by digital cameras and scanners, let's build a working vocabulary for the file names that have special meaning in the digital darkroom:

- A *Raw* file, made with either a digital camera or scanner, captures the *largest and least manipulated digital image file possible*. It is the first choice for most digital captures and it is the default starting point in the digital darkroom.
- A *Master* file is a duplicate of the Raw file that has additional processing applied to it. For example, you may want to do chores like "dust busting" or other remedial retouching to an image file only once to save unnecessary, repetitive work.
- A *Working* file is a duplicate of the Master file. When you are ready to process a file to print, it is good practice to duplicate the Master file to make a Working file. Generally, this is the file for any given image that you will spend the most time in Photoshop working on.
- A *Print* file will contain all the image information that is sent to the ink-jet printer. Usually, it will differ from the Working file in two ways: it is sized and sharpened for printing.

You may wonder if it is necessary to save image files four times. Probably not, but it depends on the workflow you want to create. If there are no "chores" to perform on a Raw file, for example, it is the Master file. If there are important differences between the Raw and Master file, you'll want to save both (the downside to this strategy is that more data must be archived and a reliable file naming and cataloging routine is imperative).

It may not be necessary to save both the Working and Print file, provided the only difference between them is sizing and sharpening. The Working file can always be resized and resharpened for printing in the future. In this case, the Print file needs to be saved long enough to make multiple copies or pull an edition of the print.

My preference is to open Raw files and perform basic Photoshop chores before archiving the image as a Master file. In this workflow *the Master file becomes the digital equivalent of the film original*. The chores usually include:

1. "Dust busting" the file. I only want to perform this chore once. I'd much rather archive a clean file than one that needs to be retouched every time it is printed.
2. If basic density adjustments are needed—perhaps the scanned file is from a film original that was overexposed or developed incorrectly, for example—I want to

make adjustments before archiving. This also applies to color corrections. If you are new to Photoshop spend time experimenting with Levels (Image⋯⋰Adjustments⋯⋰Levels) or Curves (Image⋯⋰Adjustments⋯⋰Curves). These are basic image edits that would have to be made every time the file is printed, not aesthetic choices (like fine-tuning density, contrast, color balance, or tonal relationships to produce a fine print).

3. Converting JPEG files to TIFF for archiving.
4. Hard Proofing the Master file.

I archive a Master file and pull a Hard Proof for every important image. Because the Hard Proof process is nondestructive (the pixel information in the Master file is not altered in any way), I can return to the Master file and create copies any time. We'll explain the Hard Proof in chapter 6.

Fine-art photographers are typically concerned with individual images, or a suite of images that work together. Pulling Hard Proofs from these Master files makes sense: it enhances the editing process and provides a means for making physical contact with the image.

A commercial or event photographer, on the other hand, may routinely produce hundreds of images (if not more) at a time. Pulling Hard Proofs on each would be counterproductive. A better workflow may involve pulling selected Hard Proofs when desired, but relying most often on a high-quality image browser to not only maintain order but replicate, as much as possible, the advantages of a Hard Proof.

FIGURE 3.1 Adobe Bridge's Compact View mode is a useful editing tool.

Most photographers archive image files on CD-R or DVD disks; the advantage is that a copy is automatically created each time a file in opened in Photoshop (the original, permanently written to the CD-R or DVD, remains unchanged). This works nicely. An automatic copy is not generated when the file is opened from a hard drive. You'll need to duplicate the Master file and work on the copy.

The idea behind establishing a reliable naming and archiving scheme is to manage the proliferation of image files on your system and avoid repetitive work. In most cases, archiving the Master and Working files for a given image will be adequate. There are three things to keep in mind:

- Do not trash a Raw scan unless you're certain that the Master file represents the starting point for an image in the future.
- Make sure that the Working file contains all the aesthetic choices and decisions you've made.
- If the difference between the Working and Print file is limited to sizing and sharpening, archiving the Print file is optional.

There is one more consideration. You need to back up your image files regularly. Any important file should be duplicated and stored separately. One set can be stored on the hard drive of the computer, for example, and another on an external hard drive or CD-R/DVD media. The truly obsessive will make two backup copies, storing one set in a different physical location (home versus office, or a bank deposit box, for example). The idea is to avoid disaster (sooner or later, if important files are not backed up, you'll regret it). CD-Rs and DVDs can be lost or damaged, and hard drives will eventually fail.

Digital Camera Files

Many digital cameras have a Raw capture option. A camera may also offer a TIFF and several JPEG file formats. Explore the menu options on the camera to see what choices are available.

A Raw capture retains the largest resolution and highest bit depth the camera is capable of. It is processed as minimally as possible by the camera's software. A Raw image file allows decisions about density, contrast, color balance, or tonal relationships to be made in the RAW file converter or in Photoshop.

The fact that Raw files open in Photoshop at full bit depth is a substantial advantage. If the camera captures a 12-bit file, the entire bit depth is preserved for processing and printing (Photoshop will open the file in 16-bit mode rather than downsampling to 8-bit mode to preserve the 12-bit depth). Creating JPEG or TIFF image files with a 12-bit camera results in data that is downsampled by the camera software to 8-bit *before it opens in Photoshop*.

There are trade-offs to shooting in Raw format. Not as many files can be saved on a given memory card, for example. Depending on the camera, it may take substantially longer to process and store files to memory between exposures. Both of these factors, by the way, also apply to TIFF files. Lastly, and perhaps most important, Raw format for a given camera is *proprietary*. You'll notice, in Figure 3.2, that Nikon's Raw format is NEF (Canon's is CRW or CR2; Olympus is ORF, and so on).

Software that can read the proprietary information is needed to open and process a Raw image file. This software is sometimes provided with the camera, or it can be purchased separately. There is also third-party RAW converter software available. Proprietary Raw formats are a by-product of digital evolution, but they are inherently limiting.

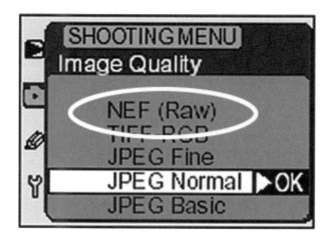

FIGURE 3.2 Nikon D100 file format menu.

Fortunately, Photoshop includes a Camera Raw converter plug-in that recognizes and processes many Raw formats. A better solution to this issue is Adobe's new Digital Negative (DNG) initiative. DNG is a proposed universal format that would standardize Raw capture. If digital camera manufacturers adopt DNG, the compatibility issues currently related to Raw capture will be greatly simplified. Incidentally, if the Adobe Camera Raw converter does recognize your camera's RAW format, the files can be opened and saved in the DNG format.

Raw conversion is analogous to compatibility issues that photographers have dealt with forever. Proprietary lens mounts, for example, keep a Nikon shooter from using Canon lenses. Photographers have the ability to influence this issue by purchasing products that support DNG and other initiatives that standardize the hardware and software necessary for working successfully in the digital darkroom.

Film photographers naturally think of *shooting* and *processing* as two connected but separate steps in the creative process (with the exception of Polaroid). When using a digital camera this paradigm is changed. You actually begin the *processing of the image in the camera.*

Digital capture is a two-step process. The image file is processed first by the device (camera or scanner). The second stage begins after the file is downloaded to the computer and opened in Photoshop. The quality of the capture, regardless of capture mode, can vary between cameras. An image file captured in Raw or JPEG mode with one camera may not be as good as another. We tend to look for specific features or compare resolution when evaluating digital cameras, but *the camera software responsible for how digital files are processed and stored is as important as the hardware.*

FIGURE 3.3 Photoshop's JPEG Options panel allows control over the compression applied to the image.

In practice, you may discover that there is little observable difference between working with images in TIFF versus JPEG Fine modes. It depends on the prints you want to make. For many photographers, including professionals, JPEG is a versatile choice. It includes a compression scheme that allows the camera to store files using less memory.

JPEG files are actually compressed *twice*. The first compression results in a permanent loss of image information through a sampling process; the second compression further reduces the file size, but information is not lost. If a JPEG file is opened but no changes are made, it will close without further loss of information. Any change, *however small*, starts the compression cycle over. This often results in eventual image-file degradation that photographers find distressing. The solution, when archiving a JPEG image file, is to save it as a TIFF after the initial opening.

Photoshop automatically launches a panel that allows you to select the compression setting when saving to JPEG format. The highest quality setting, 12, uses minimal compression and, in many cases, results in a file that has not been substantially altered. You'll want to use this setting when repurposing files sent to a lab, for example. Lower compression settings are typically used for e-mailing image files or preparing them for use on the Web.

If you prepare JPEG image files for the Web, be sure to take advantage of Photoshop's Save for Web panel (File···⟩Save for Web). It is an extremely useful, but little known, feature that includes a live preview (Save for Web, incidentally, can also be used to improve the quality of JPEG images for e-mailing).

Trust Your Eyes

If using a digital camera, compare a few images to see which capture mode works best for the prints you wish to make. Make identical captures in Raw, TIFF, and the largest JPEG mode available on the camera. Examine the files in Photoshop and make identical prints. There are several criteria worth paying careful attention to:

- The size of the print can matter a great deal. An accurate practical test is to make prints at the largest size you envision. Small prints can hide problems that may become glaringly obvious at larger sizes. Remember that in the future, to print larger, there may be issues that will be difficult, if not impossible, to solve. This is the principal reason why RAW is the default file format in the digital darkroom (it is also the reason why some photographers are willing to pay more for digital SLRs that can capture larger image files).
- Subject matter is an important variable. The sampling performed in JPEG format to compress an image file can create digital *artifacts* that are most obvious if the image has fine detail with lots of edges or,

conversely, there are large areas of continuous tone or color. There are two kinds of artifacts associated with JPEG compression: jagged edges (which compromise the illusion of smooth lines and curves) and pixel blocks (where image detail and texture are obscured). A photograph that includes a clear blue sky, tree branches, or a sign with crisp lettering is a good practical test. Artifacts will also become increasingly noticeable as the print size increases. If working in Photoshop CS2, familiarize yourself with the new Remove JPEG Artifact feature built into the Reduce Noise filter (Filter>Noise>Reduce Noise). This is a quick and easy way to improve JPEG files that have been compressed too often.

The debate over file formats is akin to the much older argument over film formats. Choosing to shoot 35mm, for example, offers portability and spontaneity, but you accept the "look and feel" of prints made from film that is smaller than medium or large format. These differences tend to become more noticeable as the print size increases. Ultimately, as you climb the learning curve of the digital darkroom, preferences and desires will dictate the kind of working habits, including the choice of file formats, needed to produce prints that are a mature expression of your personal vision and aesthetic.

If you do shoot JPEG, archive the image files as TIFFs. You can always duplicate the archived file and *repurpose* the copy to JPEG when necessary (for example, to send a file over the Internet, use it on a Web site, or have prints made at a lab that requests JPEGs).

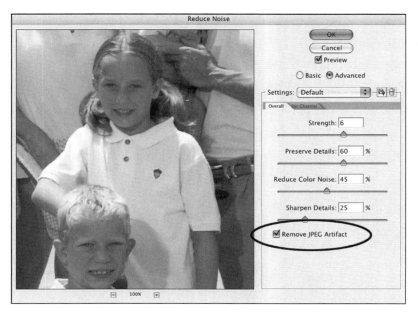

FIGURE 3.4 Photoshop CS2 offers a much improved Reduce Noise filter that includes an auto-correction option to deal with JPEG artifacts.

Scanners

When scanning a film image, you want to produce the closest equivalent of the digital camera's Raw file. Unfortunately, this is easier said than done. Consumer scanner software is not designed for this. The controls to produce Raw scans, or the closest equivalent, are usually scattered among the options in the software interface, and they vary by name depending on the manufacturer.

This can lead to confusion and poorly made scans. Typically, scanning software offers a range of controls for editing image density, contrast, color balance, and tonal range. Unless you're working with professional scanner software, Photoshop offers a much better tool kit for performing these tasks. In fact, *if you've been making significant image edits with scanner software, there is a good possibility that the files do not reflect what the scanner is capable of.*

A scanner should capture all the image information possible and deliver it to the computer in the least altered or manipulated state. *There are important exceptions to this general rule,* depending on the quality of the scanner hardware and software being using (we'll examine these in a moment). There are three basic variables that determine how much image information a scanner can produce:

- *Optical resolution.* This is measured by how many actual samples the sensor in the scanner can produce. Interpolated resolution doesn't count.
- *Bit depth.* Ideally, a scanner will produce true 16-bit-per-channel image files. If so, the scanner specifications may indicate this as "48-bit"—16 bit × 3 channels (RGB) = 48 bit. Any number smaller than 48-bit means the scanner delivers less image information in the file. Bit depth is controlled by the software, not the hardware. Third-party software, if it upgrades the scans from 8-bit to 16-bit, may substantially improve the performance of a scanner (see the Resource appendix for information on SilverFast and VueScan).
- *Optical density range* indicates the ability of the scanner to discriminate and record image information in the shadow and highlight areas of an image. Unfortunately, there is no industry standard for measuring optical density range, and manufacturers have a tendency to use criteria that often inflate their figures. Keep this in mind when you compare the specifications of scanners.

As with digital cameras, there is a tendency to compare scanners based on optical resolution; but the optical density range and the bit depth are equally important. These three factors, working together, determine how much textural detail and tonal information can be rendered from the film original or print.

Optical Density Range

Digital cameras and scanners have an optical density range that is analogous to the tonal range of film. Experienced photographers know that negative film for a given format has a tonal range that is about two full stops greater than slide film. With proper exposure, negative film captures more tonal variation and image detail in both the shadow and highlight areas of a scene or subject, as compared to transparency film.

Photographers traditionally describe the tonal range of film in stops, or, if they know something about sensitometry, as logarithmic points on a film curve. A logarithmic number (3.2, 3.6, or 4.2, for example) is also used to indicate the optical density range of digital capture devices. This information is not always available. Scanner manufacturers typically publish an optical density range but digital camera manufacturers do not. Since a 0.3 difference represents the equivalent of one full stop in tonal range, a small difference can impact how much detail and texture is captured.

Photographers simply want to know how much information can be captured in an image (and they'd like to know this *before* buying a camera or scanner). Because no industry standard exists for measuring optical density range, published figures must be taken with a grain of salt. The best option is to compare the tonal range and detail a digital camera can produce to that of film. Most digital cameras, excluding the high-end digital backs used by professional photographers (ranging from about $10,000 to well over $30,000), have an optical density range roughly analogous to slide film. This equates to about five stops, from fully textured shadow to fully textured highlights.

Better digital cameras may stretch this range to six or seven stops, provided the photographer uses good metering technique to carefully control exposure, learns to read the image histogram, and uses Raw capture format. By the way, one reason high-end digital backs cost so much is their ability to exceed the tonal range of conventional negative film. Look for SLR digital cameras to have better optical density ranges in the near future.

Ideally, you'd like to compare image files captured with different cameras before making a purchase. This may be hard to do unless you have access to a "user-friendly" camera store. There are helpful resources on the web (*www.dpreview.com* or *www.luminous-landspace.com, www.bythom.com*, for example). Use Google to search for information on cameras you're interested in. Look for independent reviews, not the public relations material provided by manufacturers.

To push the digital-to-film analogy further, photographers shooting slide films have typically preferred to expose for highlight detail (rather than for the shadows). Overexposing slide film obliterates highlight detail by pushing the exposure too far

up the shoulder of the film curve. Once detail is lost it cannot be recaptured. This is true, as well, for digital cameras.

Photoshop's Camera Raw software is an important exception. It can retrieve trace amounts of highlight detail by recovering pixels from single channels. This can be a real advantage, especially when shooting in high-contrast situations. There is a limit to how much information Photoshop Raw can recover. It will vary from about a quarter to three-quarters of a stop, depending on the camera.

Exposure control is critical if recovering Raw information is important. Some digital cameras have two useful features for evaluating exposure: a histogram and a "highlight warning." If available, both are activated through the camera menu options and are observable on its LCD display. The histogram displays image information as a bar graph representing 256 levels, as does Photoshop's histogram.

The highlight warning is designed to help avoid overexposure (especially important when shooting JPEG format); however, it must be used thoughtfully. When shooting Raw, there may be recoverable information in the blinking areas. Look closely at the LCD display to distinguish between highlight areas that need detail and texture and specular highlights (reflections from metal or water, for example) that should be rendered as a pure white.

Experienced photographers know the "expose for the shadows, develop for the highlights" mantra that is associated with the Zone System. Digital capture introduces a new paradigm: expose for the highlights, preferably in RAW, and process the image file for the shadows.

Optical density range is important when scanning film. By comparison, making high-quality scans from prints is relatively straightforward. The tonal range of a black/white or color print rarely exceeds a 2.0–2.2 density range, well within the optical density range of even inexpensive scanners. The density range of film, however, is a different issue. The range of a black/white negative or a color transparency can easily reach 3.6.

Digital cameras typically do not provide a direct means for altering optical density range (look for improvements in the near future; the Fuji S3, for example, does incorporate a similar feature). A digital camera's optical density range is determined, for the most part, by the quality of the photodiodes arranged on the sensor, the A/D converter, and the camera's software.

One technique for expanding the optical density range of images made with a digital camera is to bracket a series of exposures on a tripod. The idea is to produce a set of identical frames, some favoring the shadow information in the scene/subject, the others for the highlight information. The images are then combined in Photoshop. CS2 incorporates a new HDR (high dynamic range) feature that makes combining bracketed exposures much easier.

FIGURE 3.5 The Tool Palette for a Nikon 9000 scanner offers controls for adjusting the analog gain and multi-sampling of a scan. These controls, especially when used together, can be useful for harvesting information from image areas of very low or very high density.

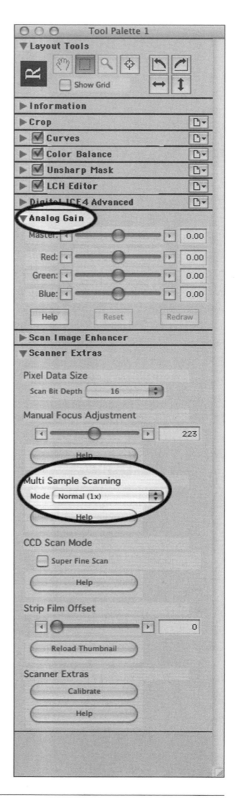

Scanner software may include a method to manipulate the optical density range by increasing the *gain* on the voltage signal generated by the sensor before it is sent to the A/D converter.

There is a limit to how useful analog gain can be. Amplifying the signal does not guarantee more usable image information: noise is also amplified and must be subtracted to arrive at an accurate measurement. Nonetheless, the "information-to-noise trade-off" may be important with some images.

Some scanner software also includes a multi-sampling feature that can be combined with analog gain to increase the information harvested from an image. Multi-sampling directs the scanner to make a number of passes over the image (anywhere from two to sixteen). The information is compared and combined into an image file that has more detail and less noise than a one-pass scan would produce. You may find these controls useful, particularly when trying to extract subtle detail from dense portions of the film image. This will, however, significantly slow the scanning process.

"Scan with the scanner, process in Photoshop" (SSPP) is a workflow designed to *capture and conserve* as much image information as possible when scanning film originals or prints. It is the scanning equivalent of digital camera Raw capture mode. It is designed to exploit the optical resolution, bit depth, and optical density range a scanner is capable of.

Outsourcing

If you are trying to stretch an equipment budget, consider having scans made at a lab. You can skip the expense of a scanner purchase and concentrate on developing Photoshop and printing skills. There are many alternatives for outsourcing.

The Kodak Picture CD scanning service is inexpensive—well under a dollar per scan if purchased at the same time the film is processed—and provides 1024 × 1536 pixel files (4.5 mg of information). These files are large enough for 4" × 6" or slightly larger inkjet prints (depending on the subject matter). The files are placed on a CD that contains the software needed to open the files on your computer (Apple or PC). The Picture CD service is only available for scans from 35mm or APS format color-negative film.

Kodak also offers Photo CD and Pro Photo CD services. Both use a proprietary file format called Image Pac, which provides five resolutions for each scanned image. The largest file size on the Photo CD is 2048 × 3072 spi (18 MB), enough information for 8" × 10" or slightly larger prints. By comparison, an 18-MB image file is equivalent to RGB image files captured by a 6-megapixel digital camera.

Pro Photo scans include a sixth resolution sized at 4096 × 6144 pixels (or 72 MB of image information). This is a large file size, which allows for large prints. All the Kodak scans, from the inexpensive Picture CD to the Pro Photo CD, are currently written in 8-bit depth. The Pro Photo file size is certainly an advantage, but with all 8-bit files, practice good workflow habits that conserve image-file information.

Pro Photo scans are more expensive than Picture CD or Photo CD, ranging between $12 and $20 each, but are an excellent value. Labs will also charge a creation fee for either the Photo CD or Pro Photo CD, but images can be continually added to the disk until it is full. A lab can make Pro Photo scans from 35mm/APS to 4" × 5" film, color or black/white. Both the Photo CD and Pro Photo CD require special software, called an Acquire Module, to open files in Photoshop. The software can be obtained from the lab or downloaded from Kodak's Web site.

Most professional labs will offer the Kodak service or an in-house alternative. If you use an in-house service, ask questions. The scanner used, for example, will determine the optical density range and optical resolution. Specify the scans to be made in the RGB color space, saved as TIFF files, at 16-bit depth.

There are excellent scanning resources available over the Internet (West Coast Imaging, Cone Editions, and Nancy Scans, to name just a few) if a local source isn't

FIGURE 3.6 The Kodak Picture CD, Photo CD, and Pro Photo CD scanning services, or the equivalent, are available through many camera outlets, labs, and service bureaus. This is an excellent option for photographers who do not want to make their own scans.

available. Custom scanning starts at around $25 and can climb to well over $100. Generally speaking, larger film sizes and large file sizes increase the cost.

Archiving

Image files will quickly become a significant investment in time and money. Experienced photographers know the value of properly processing, storing, and handling film originals and prints to maintain archival standards. Working in the digital darkroom requires the same commitment, but the workflow issues, because of the technologies and media employed, are not the same. Digital archiving requires another change in the way photographers think.

Photographers working with analog materials rarely consider the difference between *media* that contains the information (usually film, but it could also be paper, glass, metal plates, or any other substrate that can be coated with light-sensitive emulsions) and *information* (the unique deposits of silver grain or dye that build density). Replicating analog information invariably results in a degree of distortion and a measurable loss of information. Photographers making duplicate negatives or transparencies are aware of the issues. With analog technologies, an inevitable loss of information occurs as image information moves from one generation to the next.

Digital image files are usually archived on removable media (CD-R or DVD) and hard drives. The digital information can be *replicated*, with a higher degree of accuracy than can analog information, and it is *portable*. Done properly, image-file information can be duplicated as many times as necessary, stored on various media, and read by different devices. The digital advantage for archiving image information lies in the ability to accurately move information into new media.

A good digital archiving strategy has two parts: a provision for *redundancy* and a plan for information *migration* to new media, as it becomes available. Redundancy involves duplicating files to have a backup copy of important information (ideally stored in a separate location). Migration is connected to organization. If a cataloging system is implemented early on, preferably with digital asset management software, you can easily find and duplicate valuable image files to new archiving media as they appear.

It is also important to note that there is not a single definition for what *archival* means in photography or, for that matter, in any of the arts. Henry Wilhelm, an expert in the field of photographic preservation, has noted that the concept of an archival print dates to Ansel Adams's original publications. No one knows just how long a traditionally made wet-darkroom print will last. Photography is still too young.

We do know that color photographs (slides, color-negative film, and prints), which became widely available after World War II, deteriorate. This deterioration is accelerated by exposure to light, heat, and humidity. Current research indicates that color inkjet photographs made with dye inks matched to a high-quality paper can last as long as contemporary wet-darkroom prints. Inkjet prints made with pigment inks on high-quality paper are projected to exceed traditional color materials. The combination of specific ink to a specific paper is a critical factor if longevity is important.

Current testing indicates that grayscale inkjet prints may enjoy a longer life span than color prints, due primarily to the increased amount of black ink used and a corresponding decrease in other colors. Grayscale inkjet prints made with pigment quadtone ink sets, on high-quality paper, should last much longer. In fact, the life span of the paper may be more of a factor than the inks. We'll examine quadtone printing in chapter 9.

Color Management
in the Digital Darkroom

Often the first epiphany for experienced photographers transitioning to digital photography, especially those working in black/white, is that *the digital darkroom is a color darkroom*. Inkjet printing, color or grayscale, requires a working knowledge of how digital color information is produced and managed (black/white is called grayscale in the digital darkroom; see chapter 9 for details). In this chapter we'll examine the overall structure and process of color management as it relates to working in the digital darkroom. In the next chapter we'll see how color management is implemented and used in Photoshop.

Piecing together the digital darkroom puzzle would be difficult at best without a method for making digital devices "play well together." That's what color management is about: giving photographers a reliable method for moving information through a computer system, device to device, as accurately as possible. Photographers need to know that an image viewed on a display is an accurate representation of the pixel information in an image file. If it is, the image can be evaluated and edited properly. Second, they need to know that the file will be accurately translated into ink on paper when printed.

Color Management

Every device used in the digital darkroom—camera or scanner, display, and inkjet printer—is typically a red-green-blue (RGB) color device. Grayscale images, for example, are viewed on the same RGB displays as color images. The gray tonalities are a mixture of red, green, and blue pixels.

Just as every individual experiences color differently, *each digital device renders color differently*. As mentioned in chapter 1, the unique color "signature" of a digital device is called *gamut*. Gamut is a measure of how many colors a device can create. If a color space describes the colors that *can* exist in the image file, gamut is a measure of the colors that *do* exist.

Photographers will find this concept similar to the idea that color films have a color signature. Dissimilar devices can generate significantly different color, just as different color films will produce different shades of color. You can think of an inkjet *print* as a device, too. It has a unique gamut defined by the printer/ink/paper combination used.

Photographers are often encouraged to "think outside the box," but it helps to think *inside* the box to understand digital darkroom color management. Imagine that every device is connected to the computer by a virtual pipeline. Pipe size is determined by the system's hardware and software (the Apple G5 has "bigger pipes" than a G4, for example). Some pipes, like those connecting a scanner to the computer, or the computer to an inkjet printer, are one-way. Information flows from one device into another. The pipe connecting the computer to the display is two-way. Information flows to the display where it can be seen and manipulated. It then flows back to the computer for storage or, perhaps, to an inkjet printer.

FIGURE 4.1 **Digital darkroom devices connected to the computer's color engine. Image files flow into the system from input devices (cameras and scanners) and out to output devices (inkjet printers, for example). The display is both an input and output device.**

PHOTOGRAPHER'S GUIDE TO THE DIGITAL DARKROOM

The pipes used to transport image files connect to the computer's *color engine*. The color engine is part of a computer's operating system (OS) and is designed to process color information entering and exiting the system. Two OS color-engine components are especially important to the digital darkroom: the Color Management Module (CMM) and Profile Connection Space (PCS).

Image files, flowing into the color engine from a digital camera or scanner, typically have a *source profile* attached to them that can be read by the PCS. Profiles are instructions that identify the information in an image file, including the gamut and color space the file was saved in. This information, arranged in either look-up tables (LUTs) or Matrixes, makes it possible to numerically identify the discrete color of every pixel in the image file.

These are *input values* that are matched to standard reference values encoded into the CMM. Reference values are based on the LAB color model. When the image file leaves the CMM, en route to a display, for example, the PCS attaches a *destination profile* to it. The destination profile contains instructions the display uses to accurately present the image file on-screen.

This arrangement has two advantages. First, it greatly simplifies how information moves through the system. Lacking this open architecture, every device would need to connect directly to every other device (a digital plumbing nightmare). This was, incidentally, how many of the proprietary closed-loop digital systems used in the prepress industry were originally designed.

Second, the CMM and PCS function together like a universal translator, allowing devices—each speaking a different "color language"—to communicate accurately with each other. The open architecture of color management becomes increasingly transparent as manufacturers' implement industry standards. Standardized color spaces, such as the Adobe RGB (1998), and the International Color Consortium (ICC) profiles are examples of this. We'll look at ICC profiles later in this chapter, and the Adobe RGB (1998) color space in the next chapter.

To better understand how color management works, we'll focus on the two questions most important in the digital darkroom: how are colors from the real world reproduced digitally (including black, white, and shades of gray); and how can this process be controlled?

Color Models

The answer to the first question is LAB, a color model of human perception dating from 1931. The LAB model defines how a *standard observer* (you or me) typically experiences color. Color models are mathematical descriptions of the color we see, or the color data generated by digital devices. LAB is a *reference color model* used by a color engine for comparing and reconciling the two.

Human perception is a complex subject, and many models have been developed (over several centuries) to explain *how* we see *what* we see. For more information

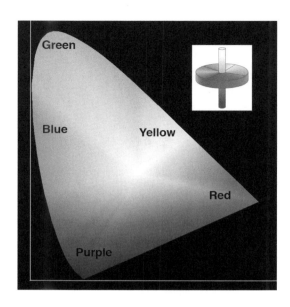

FIGURE 4.2 Three models of the LAB color space.

on color models, *www.colorcube.com* is an excellent resource (be sure to download ColorCube's "Color Model Timeline Gives Birth to New Gem," by Winston Wong).

ColorSync is Apple's color engine; the PC equivalent is Windows ICM. Both use LAB as a reference color space. These engines manage the majority of information seen on a display: the desktop, charts and graphs, word processing, and Internet Web pages, for example. Some software applications, like Photoshop, can use a variety of color engines. We'll use the default Adobe ACE color engine in the digital darkroom (Edit>Color Settings) to control the way image files are rendered on-screen.

LAB is sometimes written as "L*a*b" or "CIELab." The L*a*b abbreviation signifies that LAB organizes image information into three channels: a lightness channel (containing luminance values from black to white and most of the textural detail in the image file), the A channel (green-to-red colors), and the B channel (blue-to-yellow colors). The second abbreviation, CIE Lab, refers to the Commission Internationale d'Eclairage (International Committee on Illumination), the organization that established and continues to improve the LAB model.

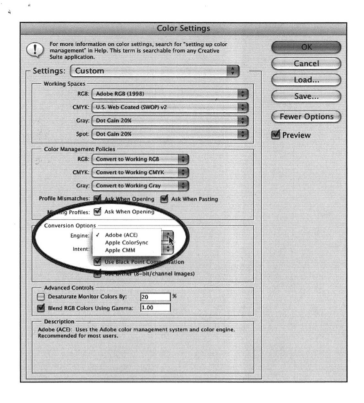

FIGURE 4.3 Photoshop's color-engine selections, located in the Color Settings panel.

LAB is one of eight Image Modes available for displaying and editing image files in Photoshop, but photographers typically work in grayscale or RGB mode. The information in the channel(s) of a grayscale or RGB file makes editing intuitive and relatively easy to learn.

Try this experiment: select an RGB image that has a good range of color and detail. Duplicate the file and open both in Photoshop. Convert one file to Lab (Image···⁝Mode···⁝Lab). Next, perform any color balance, density, and contrast changes you deem appropriate to the unconverted RGB file.

Try to duplicate these changes in the LAB file. It can be done, but you'll likely discover that RGB editing is easier because the textural and detail information is fully integrated with the color information. In LAB mode, most of the textural and detail information is isolated in the L (luminance) channel.

Photoshop makes it easy to transform an image file from one mode to another. Keep in mind, though, that transformations—like all Photoshop edits—impact the distribution of pixel information in the file. Thoughtless editing will often produce poor prints. The transformation from RGB to LAB and back is relatively benign;

FIGURE 4.4 Photoshop's Image Modes

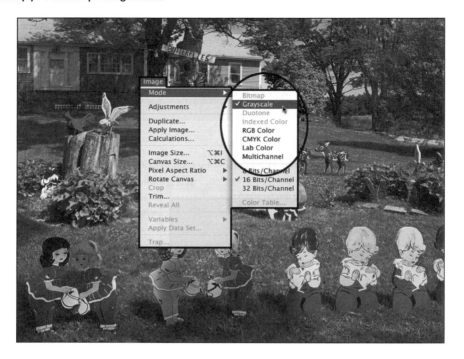

but, as a general rule, do not transform image modes unless necessary.

Another good reason to work in RGB or grayscale is the OEM print-driver software. It is designed to process only grayscale and RGB information. A printer typically uses CMYK inks, but the print driver is designed to make the machine function as an RGB device. A third-party RIP is necessary if you need to send CMYK image files to an inkjet printer.

As inkjet printers have evolved, the number of inks used in some machines has increased. Many small printers, particularly those for home and office use, still use a traditional four-ink set: Cyan, Magenta, Yellow, and Black (CMYK). Printers marketed for photography often include two additional inks—a light cyan (c) and a light magenta (m)—to create a six-ink set (CcMmYK). There are also printers, like the Epson 2200 and 7600, that include a light black ink (k), bringing the total to seven (CcMmYKk).

The Epson 4000 includes three black inks: Photo Black for printing on glossy papers, and Matte Black for other papers, plus Light Black. The Epson 4800 has a different configuration: it includes a fourth very light black ink (called Light Light Black) to improve grayscale printing, but you must use it in combination with either Photo Black or Matte Black (you can't use all three).

Expanded ink sets reflect the technology used in the prepress industry, where professional large-format inkjet printers may have twelve or more inks. There are two additional prepress techniques that have filtered down to the desktop: The first is printers that combine CMYK with other

inks, such as blue and red. The second is printers that have a non-ink channel, which applies a "gloss optimizer" to eliminate the bronzing issue associated with using pigment inks on glossy and semi-gloss papers. The Epson R series inkjets incorporate these refinements. It is likely in the near future that inkjet printers will include more black ink options to improve OEM grayscale printing and, perhaps, additional options for coatings.

The OEM print driver uses proprietary methods, locked away in the driver's "black box," to convert RGB image files into CMYK information. If a LAB or CMYK image file is processed through OEM print drivers, the information is automatically converted to the printer's CMYK space before printing. A CMYK file sent from Photoshop to the print driver will be converted first to a generic RGB color space and then to the print driver's proprietary CMYK color space. Since you have no control over these conversions, and they can produce unfortunate consequences, working in RGB or grayscale is a better workflow for the digital darkroom.

There are exceptions to this workflow. Graphic designers and art directors often prepare print projects for an offset press and may elect to edit images in CMYK mode. It is possible to send CMYK files to an inkjet printer without destructive conversions if the OEM print driver is replaced with a third-party RIP (raster image processor). We'll talk more about RIP software in chapters 7 and 9.

The answer to the second question—*how can this process be controlled*—leads to the important role *calibration* and *profiles* play in the digital darkroom. We already know that source and destination profiles play an important role in moving image information accurately through a computer system. In order for profiles to do their job properly, a digital system must be calibrated.

FIGURE 4.5 Inkjet printers typically use CMYK ink sets, but they function as an RGB device. The translation of RGB information into ink is controlled by the software that drives the printer.

Calibration

Calibration is the process of returning a machine or device to a known state or standard (like calibrating a car by having it tuned, aligning a wet-darkroom enlarger, or having shutter speeds adjusted). Digital equipment is calibrated for the same reason photographers calibrate meters, perform film speed/development time tests, or test the color response of film. Digital devices, *especially displays*, are notorious for drifting from standard settings and should be calibrated regularly. Calibration ensures accuracy.

Desktop calibration is accomplished with software that controls hardware behavior (software is the "hammer that drives the nail"). When using a display profiling kit, for example, the display is first calibrated and then a profile is authored to describe its color gamut. The calibration insures that the profile is accurate and usable.

Inkjet printers can also be calibrated. Called *linearization*, this process adjusts how much ink is used in each channel. Authoring linearized print profiles requires professional hardware (a spectrophotometer) and software. Printing with linearized profiles requires a RIP instead of OEM print drivers. This represents a significant investment of time and money, but it offers the highest level of control. We'll examine printer linearization in more detail in later chapters.

The process of calibrating and profiling displays, on the other hand, is inexpensive and easy. There are free software utilities for calibrating display but *using them is not a good idea*. These programs require adjusting by eye (the Apple Macintosh OS utility is located in Preferences>Display>Color>Calibrate >Display Calibrator Assistant). See Paul Roark's tutorial, Using Curves, for an alternative visual calibration and profiling methodology for grayscale printing.

A trustworthy display is the first step in color management. Display calibration and profiling kits typically first adjust the setting for brightness and contrast (called gamma). Apple displays use a 1.8-gamma setting; PCs use 2.2 gamma. This can be a source of frustration for Web designers, who must produce Web pages for all displays, but it's less of an issue for inkjet printing. Unless there is a good reason to do otherwise, standardize on the 1.8-gamma setting for working on an Apple computer and the 2.2-gamma setting for Windows machines, and adjust the brightness of your viewing booth to that of the display (a highly recommended practice).

You'll also select a color temperature to set the display's white point. Professional photographers know that color temperature, measured in degrees Kelvin, describes illumination color. Since displays are light sources, they also have a color temperature that can be adjusted. I recommend D50 (5000 degrees Kelvin) for the digital darkroom. However, if you've purchased a viewing booth with a D65 light source, by all means use this setting. Comparing the two, D50 will appear warmer and a bit flatter. However, as with the gamma setting, your eye will adjust to either D50 or D65.

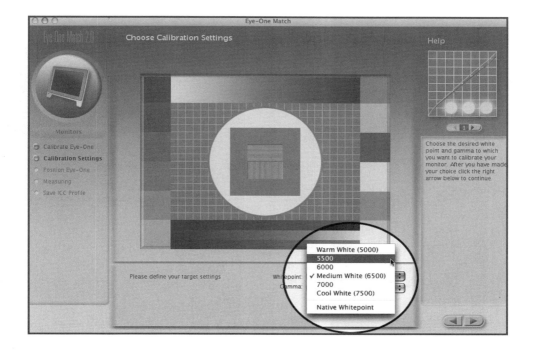

FIGURE 4.6 A display calibration-and-profiling kit will use a "wizard" interface to prompt you to make choices for gamma and white-point settings before calibrating. It will build a profile after the calibration process is complete.

Selecting a display gamma and color temperature is part of the display-calibration process, and there are no right or wrong choices. Inconsistency is the only real mistake.

I use a 1.8 gamma and the D50 white point to calibrate and profile my LCD displays. I prefer the contrast of 1.8 and use D50 because that is the color temperature of my viewing booth. Had I purchased a viewing booth calibrated to the D65 white point, I would use that instead.

It's easy to build display profiles with different combinations of gamma and white-point settings. You can then compare them with a variety of images, on display and under a viewing light. Experimenting with display profiles, since they are easy to author, can improve your understanding of color management in the digital darkroom.

Don't let experimentation contaminate your workflow. Make choices and use them consistently until you have a good reason to change.

Following the initial calibration, the second step is to author a profile that characterizes the display's color gamut. The kit's software will show how the color meter or spectrophotometer (sometimes called a *puck* or *spider*) should be positioned on the display. Follow the instructions carefully. Never attach hardware to an LCD screen with suction cups (it can permanently damage the surface). With the

hardware in place, the software will display and measure a series of color patches of known value. The software compares these readings to the LAB values for each color and then creates a profile.

Less expensive display kits use a color meter to measure the display's color; more expensive packages use a spectrophotometer (capable of measuring more spectral data than a color meter). Additionally, a spectrophotometer (with appropriate software) can also be used to author printing profiles and curves.

Profiles

An image file can be imagined as a "package of pixels" containing all the binary information necessary to create a photograph. This includes luminance values (black, white, and all shades of gray) and color values (hue and saturation). Profiles are detailed "labels" attached to the package containing instructions describing the relationship between input values (data coming into the system) and output values (data moving through the system).

Understanding input and output values can help eliminate much of the confusion that shrouds color management. In its simplest form, an image file is a highly organized set of input values. These values are understood and processed by the color engine. They can be viewed on a display, edited in applications like Photoshop, and are affected by other applications in the imaging chain (the print driver, for example).

There are various kinds of profiles designed to do a wide range of tasks in the digital domain. There are two general types used in the digital darkroom, source and destination profiles. As mentioned earlier, source profiles describe the input values generated by the *capture device* (usually a digital camera or a scanner). Destination profiles describe output values and are used to send image file information to *output devices* (displays and inkjet printers, for example). The better the profile, the more likely the "package of pixels" in an image file will display and print properly. Profile instructions use LUTs and Matrixes to keep input and output data organized.

LUTs organize binary information in a relatively simple way. They establish one-to-one relationships between input and output values. Photoshop's Curves and Layers are examples of LUTs. Matrixes organize data in a more complex and dynamic way, allowing the relationship between input and output values to change when necessary. For example, a printing profile using Matrixes allow adjustment to the color space by the Rendering Intent selected in Photoshop's Color Settings (we'll examine Rendering Intents in the next chapter).

Profiles are automatically installed when device software is added to the computer. Depending on the computer and operating system, profiles are located as follows:

Operating System ICC profiles are installed here:

Mac OS X	Users/Users Home Folder/Library/ColorSync/Profiles
Mac OS 9	System Folder/ColorSync Profiles
Windows XP	Windows/System32/Spool/Drivers/color
Windows 2000	WinNT/System32/Spool/Drivers/Color
Windows NT	WinNT/System32/Color
Windows Me	Windows/System/Color
Windows 98	Windows/System/Color

In Mac OS X, the profiles in a system can be viewed by accessing the ColorSync Utilities panel (Applications>Utilities>ColorSync Utility). A list of profiles installed on your system can also be viewed through Photoshop's soft proofing feature (View>Proof Setup>Custom).

The number of profiles loaded into the system may surprise you. The list includes profiles for the display and also for every camera, scanner, and printer/ink/paper combination that has been installed. An important step in building a reliable

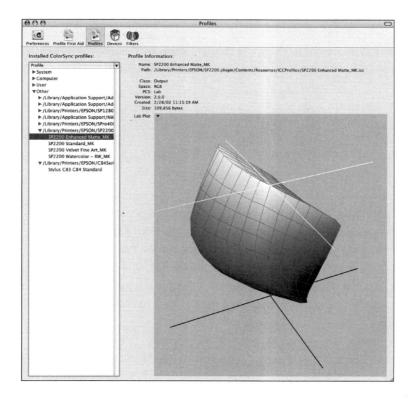

FIGURE 4.7 Use Apple's ColorSync utility to view many of the profiles on your system. This is a print profile that describes the color gamut, in LAB space, for an Epson 2200 printer, UltraChrome inks, and Epson's Enhanced Matte paper. It has been authored to ICC standards and can be used for soft proofing in Photoshop.

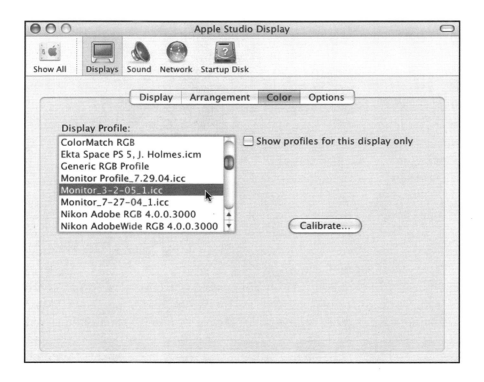

FIGURE 4.8 Apple's display panel is accessed through System Preferences. In this example, the display profile was authored on March 2, 2005, using the i1Photo spectrophotometer and software.

digital darkroom workflow is learning to manage how the computer and the application software use these profiles.

For example, when a display profile is authored, it is automatically added to the other profiles in the system. You should check that the profile is selected through System Preferences (System Preferences>Displays>the Color tab). This instructs the system software to use the profile to display image files.

Profiles, color engines, the CMM and PCS, and LAB are parts of the overall architecture of the digital darkroom. The components for managing color are built into the operating system of the computer and, for the most part, work automatically.

Profiles are the most powerful tool photographers can control. As we will see in the following chapters, color management is a system that works best with accurate ICC profiles.

The ICC

Until the early 1990s, digital color management was virtually opaque to most working photographers. It was part of the "voodoo" of the prepress industry. In 1993, fortunately, a group of industry leaders tackled this problem by forming the

International Color Consortium (a short history of the ICC is available in Abhay Sharma's *Understanding Color Management*.)

Standardization has always been important in photography, and the adoption of *ICC profile standards* was as important to the digital darkroom as the creation of standard aperture and shutter speed scales on cameras. In fact, the ICC performs a role in digital imaging similar to that of the ASA, ISO, and DIN organizations that create standards and certify film and paper speeds. It took traditional photography more than fifty years to begin standardizing shutter speeds and apertures, but, luckily, the process is moving much faster in digital imaging.

Using ICC profiles makes it possible to accurately manage how color information moves between digital devices. Used properly, they allow us to view an image on-screen that can closely match the photograph we'll make with an inkjet printer. The soft-proofing feature in Photoshop, for example, an important part of a digital darkroom workflow, is designed to use ICC profiles.

In the following chapters, we'll continue to examine how ICC profiles are used. But, for the moment, keep in mind that the job of an ICC profile, working with the CMM and its components, is to ensure that image information is accurately translated between devices. Initially, you want to learn how to manage and use the profiles that were added to the system when the device software was installed.

CHAPTER 5

Configuring Photoshop

efore processing image files in Photoshop, we'll configure the color management settings of this deeply structured and powerful application for the digital darkroom. Photoshop can be configured in many ways for a wide variety of tasks. We want to use settings that are appropriate for editing image files for inkjet printing.

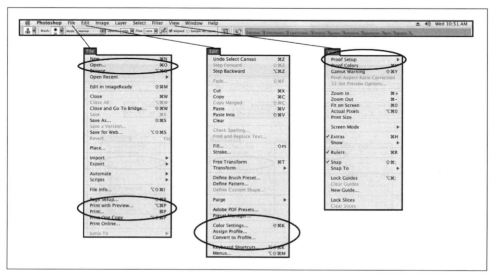

FIGURE 5.1 Photoshop's color management options. This illustration is adapted from *Understanding Color Management*, by Abhay Sharma. Chapter 10: Color Management in Photoshop, is recommended reading.

Photoshop CS2 organizes color management under the File, Edit, and View menus. These include the Open command, Print and Print with Preview, Color Settings, Assign and Convert to Profile, and Proof Setup. Color Settings is "command central" for color managing the digital darkroom. We'll use the options in Color Settings to create a working environment for inkjet printing. In this chapter, we'll concentrate on the choices made in the Color Settings sub-panels and, in the process, discover how the other color-management options work (the Print with Preview panel, which is especially important, will be discussed at length in the remaining chapters).

Color Settings

Open the Color Settings panel in Photoshop (Edit>Color Settings on an Apple or PC). Click the More Options button to expand the panel and access all the options. The top three sub-panels in Color Settings are the most important for editing files and inkjet printing: Working Spaces, Color Management Policies, and Conversion Options.

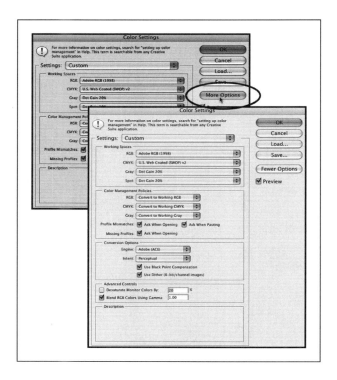

FIGURE 5.2 Photoshop's Color Settings panel. Click the More Options button to access the full range of options.

PHOTOGRAPHER'S GUIDE TO THE DIGITAL DARKROOM

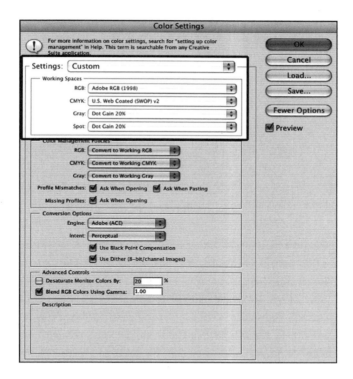

FIGURE 5.3 In Color Settings, select a Working Space profile for color and grayscale image files. These choices will become the default working environments until there is a good reason to change them.

WORKING SPACES

In the Working Spaces sub-panel, you'll select profiles that become the default color spaces for viewing images on-screen and for editing image files. These selections determine the *working environment*, an important step in establishing reliable printing workflows.

There are two important Working Spaces for inkjet printing: RGB and Gray. Click on either menu and you'll discover many profiles to select from. I recommend using Adobe RGB (1998) for color images and Dot Gain 20% for grayscale. These are proven starting points for creating working environments in the digital darkroom. For editing images in CMYK, a default profile describing the output device—a printing press, for example—is usually selected. The Spot Working Space is primarily for graphic designers preparing color separations and for our purposes can be ignored.

Adobe RGB (1998) is a reliable color space for inkjet printing because it is a good match to the color gamut of most desktop inkjet printers. It is neither too small—which would restrict the number of colors available for editing and printing—nor is it excessively large—which would require many out-of-gamut colors to be mapped back to the printing color space (we'll examine this issue in more detail in a moment, when investigating Intents). Adobe RGB (1998) has become the default standard for

many professional labs making prints from digital files. It's also a good source profile choice when making scans or creating image files with a digital camera.

Dot Gain is terminology that has migrated from prepress to the desktop. It is designed to simulate how much a droplet of ink spreads when applied to a surface (either by a desktop inkjet printer or a offset press). The Dot Gain 20% is a midrange setting. For grayscale images being viewed on-screen, lowering the Dot Gain setting causes the image to appear lighter, whereas raising it causes the image to appear darker. As we'll see in later chapters, this can be a useful tool for editing grayscale image files.

Many photographers choose a gamma setting, usually Gamma 1.8 or 2.2, instead of Dot Gain, to match the choice they've made when calibrating and profiling their display. Gamma can certainly be used as a grayscale Working Space. In fact, there are no wrong choices, as long as you know *why* you have chosen a given profile and work consistently.

I prefer to work with Dot Gain 20% when processing grayscale image files in Photoshop. In practice, it has proved to be a reliable match between grayscale images on-screen and the prints I make using a variety of inks, papers, and printers. It is also easily manipulated. We'll discuss the advantages of this in chapter 8, when exploring the workflow for making grayscale prints (Paul Roark also addresses this in the tutorial, Using Curves).

As you gain experience, there may be good reasons to choose a default profile other than Adobe RGB (1998) and Dot Gain 20%. For example, just as some photographers prefer to use a gamma profile for grayscale instead of Dot Gain, some favor ProPhoto or ColorMatch RGB for their color Working Space. Both have a larger gamut compared to Adobe RGB (1998) and can be excellent choices, provided you have accurate printing profiles to work with.

It is a bad policy, however, to switch back and forth. Be thoughtful when configuring Working Spaces. Choose a color and a gray Working Space and stay with them until you have a good reason to change. Consistency is an important part of establishing a reliable workflow.

COLOR MANAGEMENT POLICIES

As mentioned in the last chapter, image files are tagged with a source profile by the creation device (typically a digital camera or scanner). Photoshop's color engine, Adobe ACE, will read the source profile before the file is opened. Image files open automatically in Photoshop if the Working Space profile matches the source profile.

If there is a mismatch, the choices made in the Color Management Policies subpanel tell Photoshop to manage image files tagged with a source profile that does not match the Working Space profiles. I recommend keeping all the options clicked on.

If Photoshop discovers a mismatch, it automatically launches the Embedded Profile

FIGURE 5.4 The Color Management Policies panel is used to program Photoshop to handle image files that are tagged with a color space different from those you've selected in the Working Space menu. As a rule, you'll want Photoshop to convert image files into the Working Spaces you've selected.

FIGURE 5.5 The Embedded Profile Mismatch panel is automatically launched when Photoshop opens an image file that has a profile that does not match the selections made in Color Settings. This is a handy color-management feature, allowing you to make good choices on how files should be represented in Photoshop.

Mismatch panel before the file opens. This will tend to slow down the opening of image files, but it is a handy safeguard. You may have a variety of files saved with different source profiles (and some inexpensive digital cameras only provide one color space, usually SRGB, a profile designed for display devices, including televisions). Unless you have a reason to open and work with an image file in a color space different from the one selected in Color Settings (perhaps the file belongs to someone else), use the Embedded Profile Mismatch panel to convert the image profile to the Working Space.

CONVERSION OPTIONS

The Conversion Options sub-panel is an extension of Color Management Policies: it presents options for how files entering Photoshop are processed. There are two menus in the Conversion Options sub-panel, Engine and Intent, and buttons to turn on/off Use Black Point Compensation and Use Dither.

Black Point Compensation is the digital darkroom equivalent of proper proofing in the wet darkroom, where a contact sheet is made by using the minimum exposure to achieve print black through the film base plus fog. In Photoshop, Black Point Compensation maps the image file's black point to that of the color space selected in Working Spaces. Keep this option clicked on.

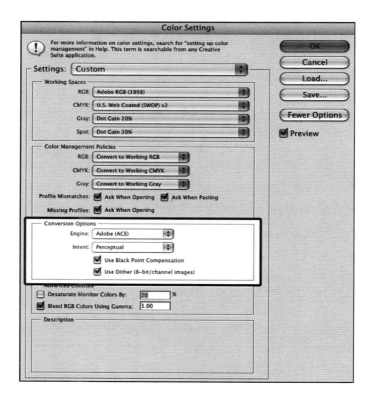

FIGURE 5.6 The Conversion Options sub-panel has two important menus, Engine and Intent, and two buttons. Keep both buttons clicked on.

Dither is a form of interpolation that Photoshop uses to simulate missing color information in 8-bit files. It is helpful for smoothing tonal transitions and for minimizing contouring, which is the visible banding of similar tonalities that can be seen on-screen and in the print. Minimizing contouring is particularly important in areas of graduated tonality—clear blue skies and subtle skin values, for example. Photographers mistakenly refer to contouring as "posterization," a defect that occurs when adjacent tonalities in an image are lost or minimized through file editing.

The Photoshop Help menu warns that using Dither can increase the size of image files. This may be an issue when saving and compressing in JPEG format for use on the Web. The size differential, however, is small, and I have not found this to be a concern. Keep this option clicked on, as well.

The important role of the color engine was introduced in the last chapter. On an Apple computer, the default color engine, ColorSync, works in the background with all the applications on the computer (unless programmed otherwise). It can also be used for inkjet printing (you'll find a ColorSync option listed in OEM print drivers; see chapter 7 for more details). However, for processing image files in the digital darkroom, we'll use Photoshop's powerful color engine, Adobe ACE. You'll find it is the default selection in the Conversion Options sub-panel.

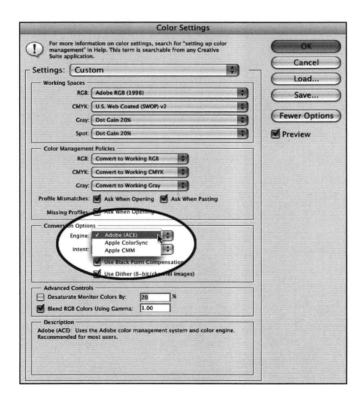

FIGURE 5.7 Computers may have a number of color engines. In Photoshop, select Adobe ACE as the working color engine for the digital darkroom regardless of the computer platform you're working on.

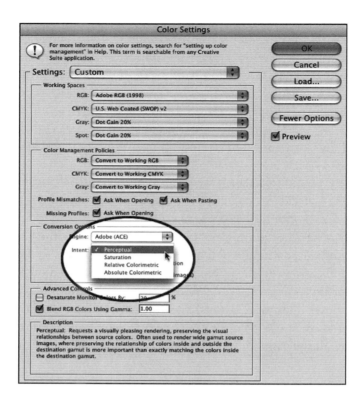

Advances in digital color management over the past decade have standardized Rendering Intents for Perceptual, Saturation, Relative Colorimetric, and Absolute Colorimetric. Photographers working in the digital darkroom typically use Perceptual or Relative Colorimetric. We'll use Perceptual and, in later chapters, examine when Relative Colorimetric makes sense.

The Intents menu opens another important window into color management. Rendering Intents control how an image file's hue, saturation, and luminance values are rendered, or mapped, into a Photoshop Working Space or destination profile (a printing profile, for example). Since every digital device has a unique gamut, specific colors may not reproduce accurately from one device to another. A color may exist in the image file that falls outside of the Working Space default profile or, more commonly, outside the gamut of a print profile.

The most common color gamut issue is colors that can be displayed but not reproduced by a given printer/ink/paper combination (we'll examine using print profiles in chapter 7). There may be a specific green or red that exists in an image file and can be viewed on-screen, for example, but cannot be reproduced in the print.

Rendering Intents addresses this issue. Rather than simply lose out-of-gamut colors, Rendering Intents provides options for mapping them to the color space defined by destination profiles (whether the destination profile is a display or print profile, or a profile for some other output device). The mapping performed by Intents can occur in one of four ways: Perceptual, Saturation, Relative Colorimetric,

and Absolute Colorimetric. All Rendering Intents are designed to address the same basic issue—out-of-gamut color—but each offers a different solution.

A graphic designer, for example, must be certain that a corporate logo color is accurately depicted ("Coca-Cola red" or "IBM blue") and may choose the Saturation intent. It will preserve a specific color at the expense of others. Absolute Colorimetric preserves color relationships that are within gamut but ignores any color that falls outside of the destination gamut. Neither Saturation nor Absolute Colorimetric will try to map a missing color to the gamut of the inkjet printer. Using these Rendering Intents can cause colors to be "clipped," or eliminated, in an inkjet print.

All Photoshop Rendering Intents have a purpose, but the two most useful in the digital darkroom are Perceptual and Relative Colorimetric. Perceptual is designed to preserve, as much as possible, the relationship between colors. When an out-of-gamut color is mapped into the destination color space using Perceptual Intent, all colors shift their relationships accordingly. Imagine that an out-of-gamut color is a late arrival for dinner and the table is a color space. Every guest at the table (the in-gamut colors) will shift positions slightly, making more-or-less equal room for all guests. Every color changes positions, but their relationship to each other remains more or less constant. Generally, the human eye will readily accept this kind of color correction, though it is not as numerically accurate as Relative Colorimetric.

Relative Colorimetric maps out-of-gamut colors differently. It is a two-step process. First, Relative Colorimetric identifies the brightest highlight information in the image file (white) and maps it to the highlight value in the destination color space. Second, out-of-gamut colors are mapped to the nearest corresponding value in the destination color space, whereas all in-gamut colors maintain their original relationship—at this dinner party, some guests remain comfortably seated while others must share their chairs!

I recommend Perceptual as the initial default choice in Photoshop's Color Settings. It is appropriate for the printing workflows we'll examine in chapters 6 and 7. As we investigate advanced printing workflows and Photoshop's soft proofing features, we'll explore why Perceptual might be changed to Relative Colorimetric when desirable (Relative Colorimetric is often the choice of photographers who have purchased or authored accurate printing profiles).

ADVANCED CONTROLS

In the fourth panel from the top, Advanced Controls, you'll find two additional Color Settings options, Desaturate Monitor and Blend RGB Colors. The Desaturate Monitor option provides a means for adjusting the appearance of one color space to another by manipulating the display of color information in an image file. I do not recommend using this option: it will change the display behavior and can lead you down a path of false color.

The Blend RGB Colors option, like Use Dither in the previous sub-panel, may help camouflage some of the image editing issues that can occur, particularly with 8-bit image files. Keep Blend RGB Colors clicked on (and use the default 1.0-gamma setting).

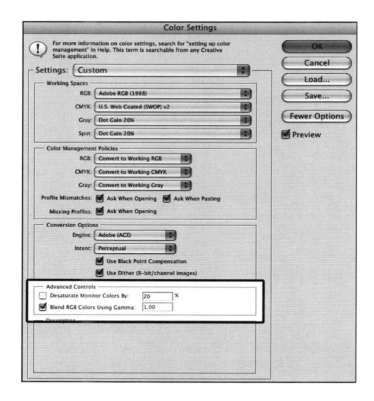

Color Settings

⚠ For more information on color settings, search for "setting up color management" in Help. This term is searchable from any Creative Suite application.

Settings: Custom

Working Spaces
RGB: Adobe RGB (1998)
CMYK: U.S. Web Coated (SWOP) v2
Gray: Dot Gain 20%
Spot: Dot Gain 20%

Color Management Policies
RGB: Convert to Working RGB
CMYK: Convert to Working CMYK
Gray: Convert to Working Gray
Profile Mismatches: ☑ Ask When Opening ☑ Ask When Pasting
Missing Profiles: ☑ Ask When Opening

Conversion Options
Engine: Adobe (ACE)
Intent: Perceptual
☑ Use Black Point Compensation
☑ Use Dither (8-bit/channel images)

Advanced Controls
☐ Desaturate Monitor Colors By: 20 %
☑ Blend RGB Colors Using Gamma: 1.00

OK
Cancel
Load...
Save...
Fewer Options
☑ Preview

FIGURE 5.9 In the Advanced Controls sub-panel, keep Blend RGB Colors on and use the default Gamma 1.0 setting. Do not click on Desaturate Monitor!

When you've configured Color Settings for the digital darkroom, be sure to save them for future use. If you want to use Photoshop for other tasks, beyond inkjet printing, Color Settings can be configured differently for each: you can save as many combinations as desirable. Be sure to give each a descriptive title (and remember to load the correct one when doing inkjet printing).

The combination of Working Space profiles and Rendering Intents is very important. When you've calibrated and profiled the display, and configured the Photoshop's Color Settings correctly, image files can be viewed and edited with confidence. There is a succinct description of Intents in the Photoshop Help menu (Help>Photoshop Help), an extremely useful Web site that you should use liberally. It contains a wealth of clearly written information.

Managing Profiles

Using Apple's Mac OS X software, profiles installed on the system can be viewed with the ColorSync Utility (Applications>Utilities>ColorSync Utility). There are third-party applications that not only display profiles, often in very interesting and

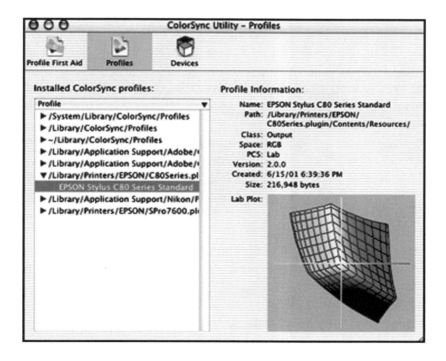

FIGURE 5.10 Apple's ColorSync Utilities offers a limited, but very useful, range of information on many of the profiles installed on the computer. This includes a thumbnail LAB plot that shows the profile's color space.

enlightening ways, but also allow you to access and edit them (see the Resource appendix for details). *Never manipulate profiles unless you know what you are doing.* This is an expert color-management skill that you may never need to learn.

Over time, as new devices are added to your system, dozens of profiles can accumulate on your computer. There will be profiles for displays, scanners, digital cameras, and many printer/ink/paper combinations. The installation of device profiles is usually automatic: it happens when device software is installed.

Although convenient, this can also be confusing and lead to mistakes. Make a point of becoming familiar with the profiles on your computer and, as you work through various digital darkroom tasks, be certain that the right profiles are loaded in the proper places. This is easy to do once you've become aware of it; it simply becomes an integral part of the workflow (you've already loaded several profiles into Photoshop by configuring the Working Space selections in Color Settings).

It's also possible to *assign* or *convert* an image-file profile in Photoshop after it is opened (Edit>Assign Profile or Convert to Profile). Assigning a profile to an image file is temporary; if the file is saved, it will still be tagged with its original profile. Soft proofing (View>Proof Set-up>Custom) is an excellent example of using assigned profiles in Photoshop. Soft Proofing is a powerful tool in the digital darkroom; it assigns a printer/ink/paper profile to the image *as it is viewed on the display*. Essentially, this allows the display to mimic output values.

During conversion, one profile is literally substituted for another. If saved, the image file will be tagged with the new profile. Converting may be necessary when repurposing an image file for something other than inkjet printing, for example. You may want to send a file to a lab or service bureau that requires a profile that is different from your Color Settings defaults. Preparing image files for use on the Web may also require a different profile.

One word of caution: *never repurpose a Master file*; always work on a copy.

In the next chapter, we'll begin printing by using the Hard Proof workflow. This initial printing path allows Photoshop to communicate the default Working Space profile and Intent to the OEM print driver. The driver converts the image file's input values to output values, which are then transformed into droplets of ink on paper. In chapter 7 we'll discover that Photoshop can be programmed to send a print profile (default or custom) with the image file to the OEM print driver. Making prints using both methods will begin to illuminate the range of choice available in the digital darkroom.

It's important to realize, as we move forward, that an image viewed on-screen will never completely match a print (the laws of physics won't allow it). Our subjective experience of an image viewed by transmitted light (display) compared to reflective light (print) can be substantially different. Configuring Photoshop's Color Settings appropriately for the digital darkroom, and learning how to manage and use profiles properly, establishes a foundation upon which many successful print workflows can be built.

CHAPTER **6**

Color Printing on the OEM Path, Part I: The Hard Proof Workflow

You now have image files for printing, a calibrated and profiled display, and Photoshop's Color Settings configured for the digital darkroom. The pieces of the puzzle are beginning to form a coherent picture. In this chapter we explore how pixels are transformed into droplets of ink with the Hard Proof, the first OEM printing workflow to master.

Working on the OEM's path is an excellent way to become more familiar with the fundamentals of color management, learn more about the role profiles play in the printing process, and polish Photoshop skills. Depending on the work to be done, the OEM path may provide all the control you'll ever need.

To print on the OEM path, the print-driver software, the inks made for the printer, and paper matched to the inks are used as an integrated system. Inkjet

FIGURE **6.1** **The Epson C86 inkjet printer is designed for DuraBrite inks and paper.**

FIGURE 6.2 **The Media selection menu in the printer driver will list OEM papers for a printer. The Epson 9800, upper left, has more options than the Epson C84.**

manufacturers devote considerable effort to matching inks to specific papers, and printer hardware/software are designed to work with these combinations.

The documentation that comes with a printer will list appropriate papers (this information is also available on the manufacturer's Web site). Many Internet vendors organize paper types by printer (see *www.atlex.com*, for example). As we explore the print driver later in this chapter, you'll find that OEM papers are listed in the Media Type menu of the print driver.

You'll want to purchase and use an OEM paper as we work through the remaining chapters (and be sure to have enough ink on hand, as well). For example, Enhanced Matte is a good first choice if you're using an Epson 1280, 2200, or 2400 printer. It prints well with both dye inks and pigment inks. By comparison, an Epson C86 uses DuraBrite ink, so DuraBrite paper is a better choice for that printer.

If using a Hewlett Packard, Canon, or other inkjet printer, check the documentation and select an OEM paper to print with. Avoid the temptation to experiment with non-OEM papers for the moment. They can be added to the workflow later, with more control and less confusion.

Getting Started

Working in the wet darkroom has always involved a ritual of sorts: setting up trays and mixing chemicals, switching on the safelight, and preparing the enlarger and easel for making the first print. Photographers develop routines to ensure consistency and predictability, but also to bridge the gap from "real world" distractions to a darkroom mindset. Some photographers prefer music in the darkroom, mingling with running water and the hum of the enlarger. Even familiar smells can play a role in centering a photographer's attention on the task at hand.

PHOTOGRAPHER'S GUIDE TO THE DIGITAL DARKROOM

The wet darkroom has the advantage of being highly tactile and secluded. It engages the body and mind, and it encourages focused but relaxed concentration.

There is a good chance that your initial digital darkroom will be built around the same computer system used for other tasks: surfing the Internet, shopping, paying bills, e-mail, or preparing projects for home or office. You may share the system with other family members and it may be located in a less-than-private area. My preference is to deliberately create an atmosphere in the digital darkroom that emulates the atmosphere I associate with fine printing.

I recommend creating a digital darkroom ritual. Begin by turning on the computer and display (it should be warmed up about twenty minutes before performing any color-critical work). Adjust the illumination in the room to avoid any contaminating influence or glare on the display (shutting doors for privacy, if necessary, and eliminating or reducing window light). Organize the area around the computer, putting away things that might remind you of other tasks. The idea is to create an oasis of concentration, so you can focus on the pleasure of making prints.

Before printing an image, you'll want to assess the "general health and well-being" of the file when first opened in Photoshop. My assessment always includes:

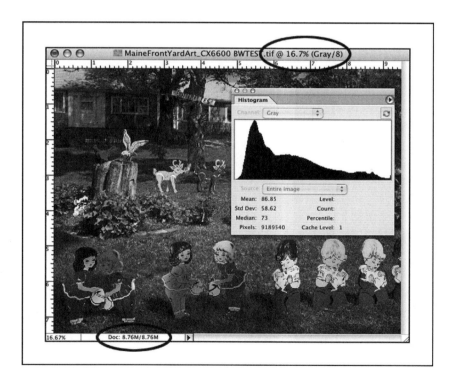

FIGURE 6.3 Use Photoshop's Standard Screen mode and the Histogram window to quickly gather image-file information. We can see that the image is an 8-bit grayscale TIFF file; it is 8.76 megabytes in size and the histogram is healthy (there are no spiked black lines or white gaps).

- What is the size and bit depth of the file? How many pixels do I have to work with, and how much information is stored in those pixels?
- What is the subject matter of the image? Is it simple or complex? Is there lots of important detail in the shadow and highlight areas? Am I missing information that I wish I had?
- What is the Image Mode of the file? Grayscale, RGB, or something else? Do I need to convert the file from one mode to another (from RGB into grayscale, for example)?
- What can the histogram tell me? I check the histogram by opening the Histogram window or launching the Levels option. The Histogram will show exactly how the pixel information in a file is distributed among Photoshop's 256 levels.

Editing an image file alters the distribution of pixel information in the file. Making color balance, density, or contrast edits affects the distribution of information, and this can lead to print-quality issues (especially when working with 8-bit files). It is a good idea to keep the Histogram window open when editing an image file to monitor these changes.

Printer Chores

Before sending an image file to an inkjet printer, there are a few preliminary routines that need attention. If you're new to inkjet printing, check the machine's documentation for paper-feed options. There will be an auto-feed position, a top slot

FIGURE 6.4 **The Histogram window in Photoshop CS2 will show the effect of image edits. In this example, relatively minor edits in Levels have degraded the file slightly. Notice that the pixel count did not change: pixels weren't removed from the file, they were redistributed by the edit. Use this feature to monitor the health of your image files, and to develop Photoshop techniques that are less destructive.**

PHOTOGRAPHER'S GUIDE TO THE DIGITAL DARKROOM

or paper tray, and perhaps manual-feed options used for thick paper stock.

The printer will have a lever, typically found under the top hood or on the back, that adjusts the platen gap for paper thickness. Most desktop inkjets have two settings, distinguished by a page symbol and an envelope symbol. Use the page setting for most OEM papers and the envelope setting for thick paper stock (thick papers may also require that you use a manual-feed slot). On some inkjet printers, like the Epson 4000 and 4800, the platen gap is controlled by software adjustments made through the LCD menus on the printer itself or in the Paper Configuration panel under the Copies & Pages menu in the print driver.

It's a good idea to use the printer utilities to perform a nozzle check and align the print head for the thickness of the paper if necessary. Printer utilities are automatically added to a system when the print driver is installed. In Apple's Mac OS X, the utilities are accessed through the Printer Setup Utility (Applications>Utilities> Printer Setup Utility).

The nozzle check prints a pattern that will show clogged or misfiring jets. If there are issues, follow the on-screen instructions to clean the head. The alignment procedure adjusts the gap between print head and paper surface. Alignment is especially important for printing on thick paper stock, or when switching between papers of varying thickness.

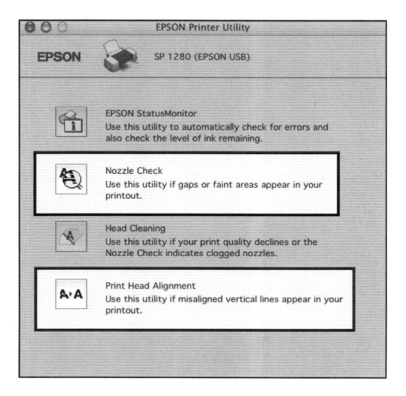

FIGURE 6.5 The Printer Utility panel for an Epson 1280 inkjet printer.

GO TO···⟩Tutorial···⟩Printer Utilities

Printing Workflows

Printing workflows are designed to move image file information from Photoshop to the software that drives the printer. In the process, image-file values are transformed into print values (droplets of ink on paper). There are two aspects of this transformation that we need to understand.

First, how is color managed in the print workflow? Either Photoshop or the print driver must color manage the printing process, but never both. Errors and poor print quality are inevitable if both applications are programmed to color manage printing. Because there are so many options available in Photoshop and the OEM print driver, it's easy to make mistakes. In our first printing workflow, the Hard Proof, the OEM print driver color manages the process.

Second, how is the mechanical behavior and performance of the printer controlled? Having investigated how Photoshop should be configured for the digital darkroom, we need to understand how an inkjet printer should be configured and managed. An OEM print driver is essentially a "black box" application. It can be manipulated to a degree but cannot be opened; instead, we'll look for ways to control its performance with the choices and options available through the application interface.

The primary job of an OEM print driver is to manage the *functionality* of the printer, but it also provides an important set of *features* designed to make the printing process easy and productive. Distinguishing functionality from features makes it easier to understand how a print driver works.

The feature set needed in most digital darkrooms is relatively small. We're typically concerned with making one print at a time, as accurately as possible. However, enhancing speed and productivity can become important issues, especially when the "single print" method becomes a limitation. Some photographers eventually invest in a third-party RIP specifically for workflow features not available in OEM print drivers (including the ability to print multiples or to gang print many images at once, for example; we'll examine RIP feature sets in the later chapters).

OEM workflow features vary by printer. Some offer borderless printing, automated roll-paper cutting, or templates for printing picture packages. There are also features having nothing to do with the digital darkroom but are useful for other tasks (like converting a file to PDF for e-mailing, a handy alternative to JPEG).

Functionality is the primary job of a print driver. It manages all the mechanical operations of the printer (controlling the print head and paper feed, for example). It will color manage the printing process when programmed to do so—applying default print profiles, determining print resolution, and control the amount of ink used (ink limiting), all based on selections made in the application's interface.

Most importantly, the print driver controls the *raster image processing* of an image file. The bit-mapped data in an image file is "RIPped" into a stochastic screen, the pattern of ink droplets laid down on the paper by the printer. OEM manufacturers, and those that make third-party RIPs, use proprietary stochastic screening. You're generally not aware of the pattern created by the screen, unless you view the print with a loupe, because it exists below the visual threshold. Inkjet printers that produce small ink dots also contribute to the illusion of continuous tonality and detail. Raster image processor, by the way, is the origin of the acronym RIP, used to identify third-party print drivers (RIPs).

The Hard Proof

The Hard Proof is the first printing workflow to master. It is a quick, easy, and reliable method for producing reference prints from Master files, and it provides *tactile contact* with the printed image. It transforms the image from the abstract into paper and ink. The binary information in an image file becomes an object that can be held in the hands.

Hard Proofs mimic the "proof prints" photographers make in the wet darkroom. Their utility lies in how faithfully they match the image on-screen. If a reasonable match is achieved, the Hard Proof, like the wet-darkroom proof print, is a road map to more advance printing workflows.

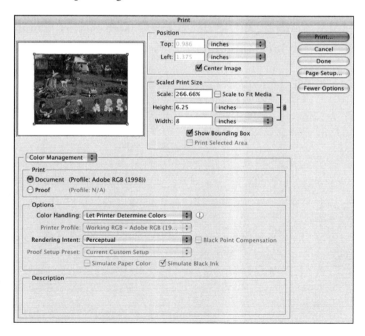

FIGURE **6.6 Print with Preview in Photoshop CS2 is one of the most important application panels in the digital darkroom. Clicking on More Options provides access to the Options and Color Management sub-panels.**

PRINT WITH PREVIEW

To Hard Proof a Master file, launch Photoshop's Print with Preview panel (File>Print with Preview). This is arguably one of the most important panels in the digital darkroom. The upper portion of Print with Preview contains a thumbnail image on the left, two sub-panels (Position and Scaled Print Size), and a set of buttons (Print, Cancel, Done, Page Setup, and More Options) stacked on the right edge. Click More Options to expand the panel, because you'll need access to the Options/Color Management sub-panels.

Click the Center Image button in the Position sub-panel and examine the thumbnail. It will show the orientation of the image on the paper. Click the Page Setup button if the orientation or paper size is wrong. Use Page Setup to select a printer and image orientation and to check the paper size. To print on a paper size not listed in the Page Size menu, click the Settings button and select Custom Page Size. Follow the on-screen instructions.

Select a printer under the Format menu. The Scale setting (default) will be 100 percent. Do not change this. We'll use the better scaling feature in Print with Preview to size the Hard Proof. With Page Setup configured properly, click OK and return to Print with Preview.

The thumbnail should show the proper relationship between the selected paper size and the image. Check the Scaled Print Size sub-panel. Make sure the Show Bounding Box is clicked on. This will place a black line box around the image area with small squares on each corner. Click and drag on a square to size the print; the information in Scale, Height, and Width changes accordingly.

These three functions are linked unless the Scale to Fit Media button is clicked on. My preference is to leave this button unclicked and simply enter the height or

FIGURE 6.7 **Use Page Setup to select a printer and image orientation and to check paper size; or create a custom paper size with custom print borders. Do not use Scale, however; Print with Preview has a better tool kit for scaling the Hard Proof.**

PHOTOGRAPHER'S GUIDE TO THE DIGITAL DARKROOM

width of the Hard Proof I want to make. Change either and Photoshop automatically calculates the other, keeping the image proportionally correct.

The Center Image option will not accurately center a print when a default paper size is selected. The printer has default margin spaces built into the driver (top, left, and right margins are equal but the bottom margin is larger). Center Image positions the print within that predetermined area. You can check the default margin spacing by selecting Custom Paper Size from the Settings menu in Page Setup. There are two work-arounds for this if accurate margins are needed:

1. Make the first print with Center Image clicked on. Measure the borders and determine how much the image needs to be shifted. Click off Center Image and enter the change you've computed into the Top or Left functions.
2. Return to the Page Setup control panel, select Custom Page Size, and create a page size with even margins. It would be tedious to do this every time, so save the Custom Page Size settings for future use.

I'm usually not concerned about exact margins, preferring to print Hard Proofs with as little fuss as necessary. It is important, however, for the print to closely match the on-screen image as faithfully as possible. To accomplish this, click the More Options button to reveal a pop-up menu and sub-panels that display options for Output and Color Management.

Output settings are primarily used to prepare image files for prepress. However, the Labels button can be used to automatically add the image file title to the print margin, a convenient feature for Hard Proofing. Corner Crop Mark can be handy when printing pages that will be trimmed for artist's books or portfolios.

You may want to experiment with Background and Border. Use Background to print a color around the image area (the printer's default margins are still in effect; the color will not automatically print to the paper's edge). The Border option is a convenient method for surrounding the image area with a simple black border. The Encoding pop-up under Output should be left in the default Binary setting.

FIGURE 6.8 To add the image file title to a Hard Proof: 1) Click on Labels under the Output menu; 2) Size the print so that the label appears in preview window; 3) The label, signified by a small gray field, always appears in the top print margin; if it does not appear when the Labels button is clicked on, you must reduce the image size to create a larger margin.

The important controls are in Color Management's sub-panels. The Print sub-panel has two buttons, Document and Proof. Click on Document for Hard Proofing; it will display the color or grayscale Working Space profile selected in Color Settings (Adobe RGB [1998] or Dot Gain 20%, for example).

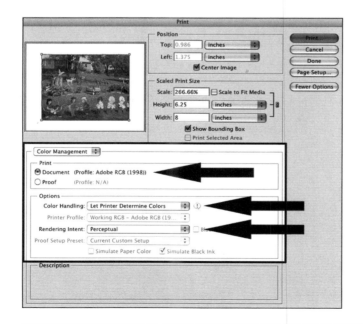

FIGURE 6.9 The Hard Proof printing path in Photoshop CS2 uses Print⋯⋗Document and Options⋯⋗Let Printer Determine Colors (and the Rendering Intent programmed into Color Settings). These choices will be combined with others made in the print driver in the next step.

PHOTOGRAPHER'S GUIDE TO THE DIGITAL DARKROOM

The Color Handling and Rendering Intent menus are under the Options sub-panel. These menus instruct Photoshop how the image file should be sent to the printer driver. For Hard Proofing, select Let Printer Determine Colors from the Color Handling menu. This will cause all the other options, except Rendering Intent, to gray-out. The default choice in Rendering Intent is the Intent programmed in Color Settings.

These settings program Photoshop to let the print driver color manage the print. The image file will be sent to the driver tagged with the Working Space profile selected in Color Settings. Click the Print button and the image file will be sent to the print driver.

THE OEM PRINT PANEL

The Print panel will present three menus: Printer, Presets, and Copies & Pages. Work from the top down. Select a printer and keep Presets on Standard. The important print driver controls are hidden in the Copies & Pages menu. We'll use Print Settings and the Color Management controls (Windows users should click the Properties button to access print-driver options) from this menu.

Select Print Settings from the Copies & Pages menu, and the panel configuration will change (access these panels in the correct sequence: Print Settings first, then Color Management).

Use the Media Type menu to select a paper. This is an important step. It instructs the OEM print driver "black box" to use a factory default print profile (the printer doesn't "know" what paper you're printing with; it simply maps the image file input values to the default print profile's output values based on the selection made in the Print panel).

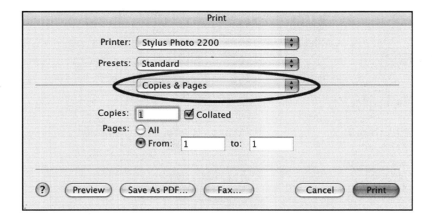

FIGURE **6.10** **The Print panel has three menus, along with other options that aren't used for Hard Proofing. Select the printer from the Printer menu, keep Presets on Standard, and use the Copies & Pages menu to navigate through the last two steps in the Hard Proof printing path: Print Settings and Color Management.**

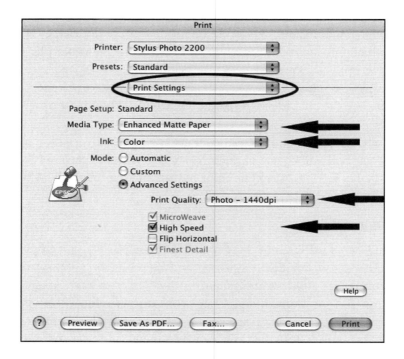

FIGURE 6.11 In Print Settings, select a paper, ink, and the Advanced Settings mode. Select a printing resolution (1440 dpi is ideal) and click on High Speed. Next, select Color Management from the Copies & Pages menu.

The Media Type selection has a substantial impact on how image file information is translated into ink on paper. Several important "behind the scenes" changes take place when a selection is made from the Media Type menu:

- Print resolution options, selected in the Print Quality, are determined.
- The default profile instructs the printer how to limit the amount of ink that is used by the print driver. Ink limiting is an important factor; it affects color gamut, saturation, and gamma. As we'll see, some OEM print drivers provide limited control over ink limits (RIPs often include extensive ink-limiting control).
- Most important, the default print profile instructs the print driver how to translate image input values into print output values.

Select Color in the Ink menu. Select Advanced Settings to activate the Print Quality menu and choose a printing resolution from the choices made available by the default print profile. I typically use a mid-range setting for Hard Proofs (this may be listed as "Fine" or "Photo"). Click on High Speed (to instruct the printer to print bidirectionally; the stochastic screening is created as the head moves in both directions across the width of the paper).

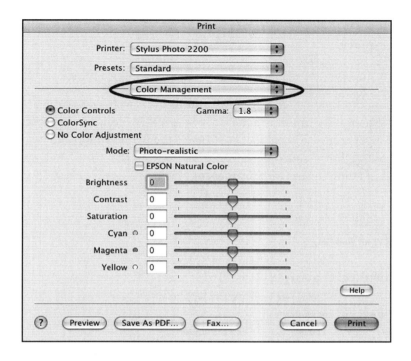

FIGURE 6.12 In Color Management, select Color Controls for Hard Proofing. Notice the color controls that allow using the print driver to edit the output values of the print.

If the nozzles are clean and the head aligned, microbanding at medium print resolution setting shouldn't be an issue. (Microbanding will look like there are black or white lines in the print.) If there is evidence of banding, run the nozzle check in Printer Utilities. If the printed pattern is good, try printing again with the same or higher resolution, but click off High Speed. You'll notice that higher resolution settings automatically activate MicroWeave and Finest Detail.

With Print Settings configured properly, return to the Copies & Pages menu and select Color Management. For Hard Proofing, select Color Controls and leave all options in their default setting. Note that the layout and control labels can vary by printer model; our example is the Epson 2200.

You may occasionally need to make a print that is not color managed by either Photoshop or the OEM print driver. For example, to author custom print profiles (an option that we'll discuss in later chapters), you'll need to print test targets that are not color managed. The same is true when profiling a scanner.

To print without color management, first select Document in Print with Preview's Print sub-panel and No Color Management from the Color Handling menu in the Options sub-panel. Click

Print to move to the Print panel. Under Color Management in the Copies & Pages menu, select No Color Management.

Load paper in the printer and click Print in the lower right corner. Depending on the computer and printer, and the size of the image file, it can take a few seconds or much longer to process the file. You'll hear the printer hardware begin its preliminary routine for advancing the paper and setting the print head. Pixels are in the process of being turned into droplets of ink.

The Hard Proof Workflow

Step #1: Prepare an image file for printing.
- Do not size or sharpen for Hard Proofing.

Step #2: Print with Preview
- Check paper size and orientation.
- Check image size/scaling.
- Click on More Options and select Color Management.
- Select Document in the Print sub-panel.
- In the Options sub-panel, select Let Printer Determine Colors from the Color Handling menu.
- Click Print.

Step #3: Print Driver Software
- Select Printer (and load paper).
- Keep Presets at Standard.
- Click on the Copies & Pages pop-up menu and select Print Settings.
- Choose paper in Media Type.
- Select Color.
- Select Mode: Advanced.
- Select a medium resolution setting in Print Quality and click on High Speed.
- Return to the Copies & Pages menu and select Color Management.
- Click on Color Controls. Do not use the gamma or the color adjustment controls.
- Load paper into the printer.
- Click Print.

EVALUATING THE HARD PROOF

The Hard Proof should *resemble* the image on a calibrated and profiled display (be sure to evaluate it under an accurate viewing light).

Upon careful inspection, an OEM Hard Proof may appear a bit dark overall. Detail and texture, especially in the lower tonal values (shadow areas), may be lost. This is especially common when printing with an office inkjet printer. It reflects a gamma bias in the default print profiles used by the print driver. These profiles are intended to produce vivid and saturated colors, but often at the expense of accuracy.

The performance of OEM print drivers can vary considerably. The gamma bias of an office inkjet printer can be relatively severe to the trained eye. Older inkjet printers, the Epson 1280, for example, exhibit more gamma bias than newer models. The latest Epson UltraChrome K3 machines have demonstrably less gamma bias (and, coupled with Epson's ICC printing profiles, these machines perform well with the Print Profile workflow outlined in the next chapter).

> Hard proofs, like wet-darkroom proof prints, are not precious objects; they are tools used to teach us photography. If you have more than one inkjet printer, make Hard Proofs with both and study the differences. Pin them up on a viewing wall and observe your reaction as it changes over time.
>
> Hole-punch Hard Proofs and keep them in a notebook. Take the notebook with you when traveling. Share the prints with friends and colleagues and think about their reaction to the images. Mark them up, making notations about intended changes, approaches or techniques to try, or the ink/paper you want to use for a final print.

FINE TUNING THE HARD PROOF

Return to Print with Preview to fine-tune the Hard Proof. Check the settings, duplicating those used for the first Hard Proof (particularly the selections in the Print and Options sub-panels). Click the Print button to move to the Print Panel and select Print Settings from the Copies & Pages menu. Configure the settings as before.

Select Color Management to access the Gamma and Advanced Settings sliders we ignored before. If the Hard Proof is a bit dark or light overall, make changes with the Gamma setting or the Brightness and Contrast sliders. The Brightness slider controls density (how dark or light overall the print will be). This is analogous to reducing or increasing the amount of exposure when making a wet-darkroom print. The Contrast slider, by comparison, affects the image similarly to changing paper grades or using contrast printing filters in the wet darkroom.

The Gamma setting affects both density and contrast. The default Gamma setting is 1.8; choosing 1.5, if available, produces a lighter print, 2.2 a darker one. Experiment with all the controls, but remember to annotate the Hard Proofs with setting information to avoid confusion. The Gamma and Brightness/Contrast

controls can be combined, but I do not recommend mixing them. It will be harder to diagnose the effect on the print.

It is good darkroom practice, wet or digital, to determine the proper density and color balance of a print before changing the contrast. Altering print density or color balance always affects the apparent contrast of an image. It is much easier to fine-tune contrast after determining the proper density and color balance.

The color balance of the Hard Proof can be modified using the Cyan, Magenta, and Yellow adjustment sliders. They will not alter the Master file; the edits occur after the image has left Photoshop and is being processed by the driver. This guarantees that the Master file is unaffected by the Hard Proof workflow.

Fine-tuning a print through the Print panel is problematic. The print driver does not include a live preview. Changes cannot be evaluated until another print is made. Several iterations may be necessary, adjusting the options in the Color Management panel, before achieving the desired print. This is very similar to the "print and evaluate" process that photographers use in the wet darkroom. It is useful to become familiar with these controls but, as you'll discover in the next chapters, there are printing workflows that are more accurate and useful for producing finished prints.

If you experiment with Advanced Settings and find a combination that works well, it can be saved for future use. Click on Presets and select Save. Give the settings an easily remembered name. Saved settings are loaded by navigating through Presets. You may discover that one combination of Advanced Settings works for one category of images, like landscapes, and another for portraits. You can save as many combinations as required (be sure to name them accordingly).

Some printers offer additional control by providing a method to alter the ink limit of the default print profile. If the color rendering of the Hard Proof is accurate, but the image is a bit dark (or, less often, light) overall, adjusting the ink limit can be a useful method for improving print quality. You'll need to explore the OEM print driver to see if ink limiting is provided. The Epson 2200, for example, provides a Color Density control in the Ink Configuration panel under the Copies & Pages menu. The Epson 4000's Color Density control is hidden in the Paper Configuration panel under Copies & Pages.

FIGURE **6.14** An inkjet printer may provide limited control of ink limits through the OEM print driver. Epson's Color Density control provides global ink limiting; you may need to search the driver's menu carefully to locate all the options.

It is also possible to use Photoshop to edit the Master file instead of using the print driver. There are two advantages: edits are immediately viewed on-screen, and the controls are much more powerful. When using Photoshop to edit Hard Proofs, do not make any other changes in the workflow, including the print driver Advanced Settings. It is a bad policy to "edit an edit" on an image file. It can lead to quality issues that are difficult to diagnose or correct.

Do not save the Master file with any of the changes or adjustments made in Photoshop. Instead, save the edited file as a Working or Print file (see chapter 3 for details). Master files must be protected from repeated changes.

Hard Proofing with the driver's color management may work well for the printing you want to do. If so, the same workflow can be used to produce finished prints. There is one caveat: image edits, either in Photoshop or by Advance Settings adjustments in the driver, are accurate only for the paper used for the Hard Proof. To make finished prints on a different paper, the process must be repeated.

Color Printing on the OEM Path, Part II: The Print Profile Workflow

One advantage to the Hard Proof workflow outlined in the last chapter is that we can see exactly how the printer behaves and how image information is transformed from the display to paper. It also makes the image tangible; a print can be held, evaluated, and used outside the constraints of a computer system. Lastly, the Hard Proof workflow relies on Photoshop's Working Space profiles instead of a print profile to identify the image file's input values. *This avoids any issues related to inaccurate print profiles.*

In a color managed workflow, two profiles are used when an image file moves from one device to another: a source profile and a destination profile. We can use either the Working Space profile or print profiles as destination profiles when printing; they both contain information the print driver uses to translate an image file into ink on paper. Accurately mapping input values to output values is a core color management concept in the digital darkroom.

The source profile for a Hard Proof is the Working Space profile selected in Photoshop's Color Settings (for example, either Adobe RGB [1998] for color images or 20% Dot Gain for grayscale). The destination profile is a factory default profile locked away in the black box/OEM print driver; its selection is determined in Print Settings (a combination of the Media Type and Print Quality menus).

The *Print Profile* workflow differs from the Hard Proof in two important ways: a print profile replaces the Working Space profile and Photoshop is programmed to color manage the print process instead of the OEM print driver. In this workflow, the "black box" profiles embedded in the OEM print driver are not used.

To move beyond the Hard Proof into the Print Profile workflow, it is necessary to know which print profiles are available on your computer. You can search the computer's hard drive for print profiles, but it is more convenient to check in Photoshop. For example, open an image file and navigate to either the Assign Profile or Convert to Profile panels located under the Edit menu. Use the Profile menu in either panel to scroll through all the profiles Photoshop has found on your system.

Alternatively, the same profile list can be accessed through the Proof Setup panel (View⋯⟩Proof Setup⋯⟩Custom). We'll use Proof Setup in the next chapter when discussing Photoshop's ability to *soft proof* image files for printing.

Regardless of the Photoshop panel you access to inventory print profiles, *be sure to cancel out of the panel(s)*. You don't want to mistakenly change or alter the Master File in any way.

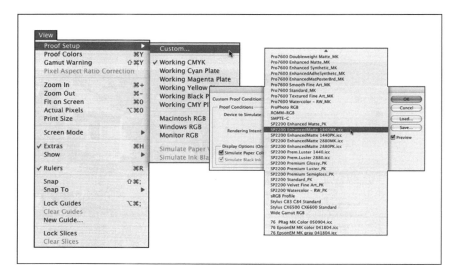

FIGURE 7.1 Photoshop's Proof Setup Profile menu can be used to determine the print profiles installed on your system. We'll investigate Proof Setup for *soft proofing* in the next chapter.

The Print Profile Workflow

Duplicate and open a Master File, preferably one that has already been Hard Proofed using the print workflow outlined in the last chapter. We'll make two Photoshop edits to the image before navigating to Print with Preview; the file will be sized (Image>Image Size) and sharpened (Filter>Sharpen>Unsharp Mask). As a rule, size the image file first and then sharpen it for printing. Sharpening an image is specific to content and print size; over-sharpening or repeated sharpening can lead to artifacts in the print.

The Hard Proof workflow took advantage of the scaling options available in Print with Preview. Using the Print Profile workflow, we'll use Photoshop's Image

FIGURE 7.2 Photoshop's Image Size panel offers a more sophisticated approach to sizing images compared to the scaling features in Print with Preview.

Size feature. It's a more powerful method for scaling images and you'll want to master the options available in this panel. Image Size allows complete control over the physical dimensions of the print; the resolution (measured in pixels per inch, or ppi), and any interpolation that may be necessary (see chapter 3 for more information on Photoshop's interpolation options).

After sizing the file, use the Unsharp Mask filter to sharpen it for printing. I prefer to standardize the Radius slider at 0.9 pixels and the Threshold between 5 and 10 levels. I then adjust the top slider—Amount—for the effect I'm after. Monitor these edits in the live preview window. I prefer relatively subtle sharpening for most images; used too liberally, Unsharp masking will tend to create odd halos around dark areas. With experience you'll also learn that over sharpening a file has the unfortunate tendency to increase the apparent contrast of the image (both on-screen and in the print).

Unsharp masking, by the way, is a technique originally used in the wet darkroom to control the contrast of an image and incidentally increase the illusion of sharpness. The terminology has been adapted to Photoshop.

When the image file is sized and sharpened, launch Print with Preview. It's always a good idea to check the thumbnail for the correct paper size and orientation. If necessary, click on Page Setup to make any changes. Be sure that More Options is clicked on to access the Color Management sub-panels.

In the Print sub-panel, keep Document clicked on (it should show the default Working Space programmed in Color Settings). In the Option sub-panel, click

Unsharp Mask

OK

Cancel

☑ Preview

100%

Amount: 100 %

Radius: 0.9 pixels

Threshold: 5 levels

FIGURE 7.3 **Photoshop's Unsharp Mask filter is powerful tool for improving the apparent sharpness of an inkjet print. There are also many third-party software plug-ins that extend this control considerably.**

on the Color Handling menu and select Let Photoshop Determine Colors. You'll notice that the Printer Profile menu becomes available when this selection is made. Click on the Printer Profile menu and scroll to the print profile you intend to use (this menu, by the way, also lists all the profiles Photoshop has found on the computer). Keep Rendering Intent on the default selection (the choice programmed in Color Settings) and Black Point Compensation clicked on.

Using this configuration, Photoshop will send the image file to the print driver tagged with the print profile rather than the Working Space profile used for Hard Proofing. You've substituted one profile for another—a print profile for a default Working Space profile. This changes the way image input values are mapped to the printer. You've also instructed Photoshop to color manage the printing process rather than the OEM print driver.

Click on Print and move to the OEM Print panel. Select the printer, keep Presets on Standard, and choose Print Settings from the Copies & Pages menu. Select the correct paper from the Menu Type menu, choose Color, and click on Advanced. Select the highest resolution setting available. Turn off High Speed; this instructs the printer to lay down droplets of ink on one direction only (a technique that with some printers may improve print quality). If you find that turning off High Speed does not make a noticeable difference, this option can be used regularly and printing will be quicker.

Navigate to Color Management through the Copies & Pages menu and select No Color Management. The print driver's color management controls will disappear. The print driver software has been programmed to allow Photoshop to color manage the print. This is necessary to compliment the selections made in Print with Preview.

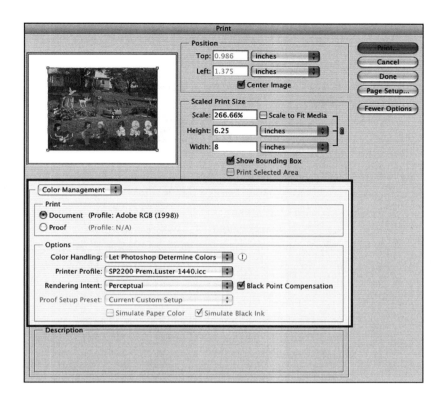

FIGURE 7.4 The Print Profile workflow uses Print┄┅Document (showing the color Working Space selected in Photoshop Color Settings) and Options┄┅Let Photoshop Determine Colors. The print profile is selected from the Printer Profile menu. Use the default Rendering Intent and Black Point Compensation.

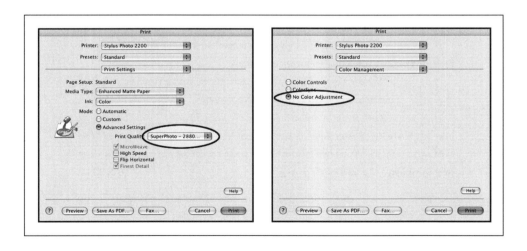

FIGURE 7.5 You may want to try a higher printing resolution in Print Settings with High Speed clicked off (many photographers cannot perceive a noticeable difference between 1440 and 2880, particularly on matte papers). More importantly, when using a print profile, click on No Color Adjustment under Color Management. This instructs the print driver to allow Photoshop to control the printing.

Step #1: Open a Master File in Photoshop (preferably one already Hard Proofed) and make two image edits:

- Use Image Size (Image···⊹Image Size) to scale the image for printing.
- Use Unsharp Mask (Filter···⊹Sharpen···⊹Unsharp Mask) to sharp the image file for printing.

Step #2: Launch and program Print with Preview:

- Make sure the More Options button is clicked on and use the preview to inspect image size and orientation. If necessary, use the Page Setup panel to make adjustments before continuing.
- Under Color Management select Document in the Print sub-panel.
- In the Options sub-panel select Let Photoshop Determine Colors from the Color Handling menu.
- From the Printer Profile menu select an appropriate print profile.
- Do not change the Rendering Intent (it should show the selection made in Color Settings) and make sure that the Black Point Compensation button is clicked on.
- Click the Print button to move the image file from Photoshop to the OEM print driver.

Step #3: Configure the Print panel:

- Select the correct printer and keep presets on the default Standard selection.
- Click on the Copies & Pages menu and navigate to Print Settings.
- Select the correct paper in the Media Type menu, leave Color in the default Color setting, and click Advanced under Mode.
- Select an appropriate printing resolution from the Print Quality menu.

Step #4: Configure the Color Management panel:

- Navigate to the Color Management panel, through the Copies & Pages menu, and select No Color Management.
- Click the Print button.

Step #5: Since the Master File has been edited (it was sized and sharpened before sending to Print with Preview) decide if you want to save a copy as a Print File. *Do not save the Master File with edits!*

Evaluating the Print Profile Print

If the selected print profile is accurate and you've followed the configuration steps in Print with Preview and the OEM print driver panels correctly, the print-to-

screen match should improve compared to the Hard Proof (perhaps dramatically). It will depend on the accuracy of the print profile.

If print quality is better this path can be used to make Hard Proofs (completely bypassing the print driver's Advanced Settings adjustment options; a good thing). Incidentally, if you do elect to use the Print Profile workflow for Hard Proofing it's possible to skip the sizing and sharpening steps to save time. Simply use the scaling features in Print with Preview (typically, Hard Proof prints are relatively small and sharpening should not be an important consideration).

If the print is better but still not as accurate as you wish, go back to the image in Photoshop and make any necessary edits. By working on a duplicate of the Master File, any possibility for making a better print can be explored. It's also a good idea to make image edits using adjustment Layers. You can explore any image editing option, knowing that the adjustment Layer can be deleted without altering the image file. Check the histogram while editing (especially with 8-bit files) to monitor the effect of edits on the general health of the image.

It's also possible the Print Profile workflow will produce results about the same quality or worse than the Hard Proof workflow, depending on the accuracy of the print profile used. As mentioned earlier, you'll likely have trouble with generic office printer profiles. However, the default profiles that ship with photo inkjet printers should perform well.

Other factors being equal, accurate print profiles will out-perform the Working Space profile used in the Hard Proof workflow. Accurate print profiles are necessary to fully exploit the Print Profile workflow, including the soft proofing process we'll examine in the next chapter. Where can you get better profiles? There are several options:

- Some inkjet printer manufacturers supply profiles through their Web sites.
- Some paper and ink vendors provide free profiles for their papers. Check Web sites to see if profiles are available for downloading. Free profiles are obviously worth investigating but they may or may not be more accurate than the default print profiles supplied with photo inkjet printers.
- Custom ICC profiles can be purchased. You may be able to locate a local source for custom profiles, but excellent resources are on the Internet (check the Resources appendix for more details). There are two options when purchasing a custom profile: purchase a ready-made profile or have one authored for your specific printer/ink set/paper combination. Ready-mades are less expensive and should outperform the default profiles that came with the printer. Because they are tailored to a specific printer, custom profiles are more expensive but should be more accurate. Having custom profiles made can be an excellent way to improve the accuracy of your workflow. The cost is reasonable, but a profile is required for each paper you want to print with.

FIGURE 7.6 Free print profiles can be found on the Web. Pictured are the download pages from the Epson and MIS Web sites. Be sure to select the correct computer platform when downloading profiles.

- You can author custom profiles by investing in, and learning to use, a profile authoring kit. If you want to use several printers or print on a wide range of papers or other media, investing in a profiling kit can be a good idea. Custom ICC profiles can be authored for anything that will transport through the printer. These kits use a spectrophotometer that can also author accurate display profiles (and there may be modules to author profiles for other digital devices like cameras, scanners and projectors).

Having accurate print profiles to work with—either purchased or self-authored—raises an interesting question: is your current printer worth an investment in custom profiles?

The cost of purchasing profiles will be reasonable if you print on just a few papers with a single inkjet printer. If you want to print on a variety of papers, perhaps use more than one printer, or if having the freedom to experiment is important it may be prudent to invest in a better printer first.

The last two options for working with custom print profiles (preferably ICC profiles) can dramatically improve printing quality, especially when linearization of the printer is included in the process. You'll recall that linearization is a calibration procedure. Ideally, an inkjet printer is linearized and accurate ICC print profiles are authored on the linearized printer. This the same logic we apply to calibrating and profiling displays.

Calibrating a printer is an important variable in the digital darkroom because the linearization of a printer changes over time. This can happen in subtle ways: for

PHOTOGRAPHER'S GUIDE TO THE DIGITAL DARKROOM

example. when replacing inks or using paper from different production runs. More commonly, printer linearization fails as the machine is used and ages (just like a display). Using a non-linearized printer will result in differences between an image on-screen and the print; the relationship between the image file input values and the printer's output values is altered by the non-linear state of the machine. Linearizing the printer removes this variable.

How important this may be, for the work you want to do, is ultimately an aesthetic decision. The process for calibrating a printer is more complicated and expensive than a display. Print profile authoring kits do not include a linearization function because it's based on authoring a curve, or LUT, that is used by the print driver. This data cannot be included in the profile. To linearize and author custom print profiles you'll have to purchase professional profiling software that includes linearization *and* use a third party RIP to drive the printer instead of the OEM print driver.

Fortunately, each successive generation of inkjet printers tend to demonstrate less print gamma bias out of the box. This is a good thing. Gamma bias is an indicator of the printer's non-linear state. As printer gamma bias decreases, the need to linearize a printer becomes less urgent. You can use the Hard Proof workflow to judge this. The procedure outlined in the tutorial Testing an Inkjet Printer, which includes a grayscale ramp, will help you evaluate the separation of tonal values in the printed image. If possible, use the tutorial procedure on more than one printer; critical evaluation of the differences will improve your ability to judge a printer's performance.

You'll recall from the last chapter that the OEM print driver for some printers includes an ink limiting control. The print driver for the Epson 2200, for example, provides access to a Color Density control through the Ink Configuration panel found under the Copies & Pages menu (the less expensive Epson C-series printers do not include an Ink Configuration option).

Ink limiting with an OEM print driver will not linearize a printer—the adjustment is global, affecting the ink output of each ink channel equally—but it's a useful feature for improving printer performance if you don't want to invest in the additional software and hardware necessary to perform linearization. If you determine that prints made with canned profiles are a bit dark overall (a common issue), make a series of test prints reducing the Color Density setting in 10% increments. The Color Density control can also be used to increase the amount of ink being used; if the prints are too light increase the setting in 10% increments.

Do the test prints using either the Hard Proof or Print Profile workflow; use the workflow that has produced the best print, as evaluated carefully under the viewing light. If you've purchased a calibration/profiling kit, like the EyeOne or Pulse, the spectrophotometer can be used to take accurate density readings from test prints. This provides objective information that can be correlated with your impression of the prints under a viewing light.

If you find an ink limit setting that generates a better print, saved it through the Presets>Save As menu. Remember to load the settings when printing in the future.

If you find that using ink limiting improves printer performance, run the test procedure for each paper you want to print with.

The good news is that the more often you do this—follow a testing procedure and carefully evaluate the results—the more informed your judgment becomes. This is analogous to the practical testing that wet darkroom photographer's have always done with film, papers and process chemistry. The advantage is in training your eye to make critical judgments, with or without the aid of specialized software and hardware.

Moving Ahead

You've mastered two basic and useful approaches for printing color images on the OEM path. The first approach, Hard Proofing, uses a Photoshop Working Space profile attached to the image file and the print driver to color manage the printing. It is simple, quick, and can produce very usable prints. The Print Profile workflow uses print profiles and allows Photoshop to color manage the print. This workflow can produce better prints, but it depends solely on the quality of the profile.

With experience, you'll identify the printing workflow that works best. Many bad prints are made by wandering through the choices and options presented by Photoshop and the print driver software. If you do experiment with these controls and options, be sure to keep careful notes. My suggestion is to spend time printing on the two OEM paths outlined in this chapter and the last. You'll establish reliable workflows that can be built upon.

There is an additional printing path available when using the OEM print driver. You may have seen a ColorSync option listed in the Copies & Pages panel. ColorSync can also be used to pull a Hard Proof that is virtually identical to using Color Controls. However, you will not have access to the Gamma and Advanced Settings in the Color Controls panel for fine-tuning.

On some printers choosing ColorSync from the Copies & Pages menu presents a different set of options found in the Quartz Filter pop-up menu. You'll find a grayscale option (do not confuse "grayscale" with "black/white" in this menu; choosing black/white produces a bit mapped print containing only black and white values), sepia and other special effect settings.

You may want to experiment with these options. However, I do not recommend this printing path for producing final prints. Turning the printing process over to ColorSync is a bit like using a point-and-shoot camera or an SLR on program mode; you sacrifice control for convenience. In the future, as the technique for inkjet printing becomes increasingly transparent, print workflows like ColorSync may play an important role in the digital darkroom.

The guiding principle in the digital darkroom is to preserve and protect the information stored in the image file pixels. You never want to use a printing workflow that damages or compromises the Master File. To produce beautiful prints, image file information must flow to the printer as accurately as possible. Working with accurate ICC display and print profiles and using sound color management policies is the best way to guarantee success.

In the next chapter we'll integrate Photoshop's soft proofing feature and examine options for working off the OEM path as we continue to explore the important roles that color management and ICC profiles play in the digital darkroom.

CHAPTER **8**

Advanced Color Printing

You now have a quick and reliable method for Hard Proofing image files and know how to select and use a print profile in Print with Preview. The next step is to continue investigating the Print Profile workflow to better understand the important role accurate print profiles can play in the digital darkroom.

The best method for exploiting the Print Profile path is Photoshop's soft proofing options, found in Photoshop's Proof Setup (View>Proof Setup>Custom). We'll first explore these features on the OEM path and then, later in this chapter, examine options for using the Print Profile workflow for printing color off the OEM path.

The Soft Proof

Soft proofing instructs Photoshop to simulate the print on-screen, introducing a form of *digital previsualization* into the printing workflow. Ansel Adams, in developing the Zone System, advocated previsualization as the key to controlling film and print tonalities. In practice, previsualization includes taking meter readings and mentally translating the data into a finished print before an exposure is made, a valuable technique in both the wet darkroom and the digital darkroom. Soft proofing in Photoshop extends this concept dramatically. It allows photographers to preview an image on-screen *as if it were ink on paper.*

Soft proofing is not a substitute for a Hard Proof; it is a powerful complementary tool that can improve image editing and printing accuracy. Soft Proofing does not alter the file in any way; instead, image values are simulated as print values on-screen. To accomplish this, Photoshop applies the print profile selected in Proof Setup's Customize Proof Condition panel (View>Proof Setup>Custom>Customize Proof Condition) to the image, temporarily replacing the Working Space profile with a print profile.

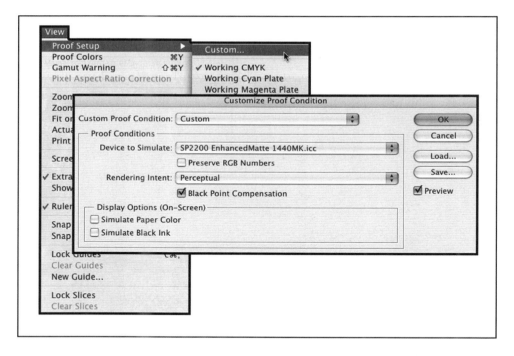

FIGURE 8.1 To soft proof an image file in Photoshop, open the Proof Setup's Customize Proof Condition panel. Locate the print profile you wish to use in the Device to Simulate menu. Be sure to leave the Preview button on the right edge clicked on.

Proof Setup

Like Print with Preview, Proof Setup's Customize Proof Condition is an important Photoshop panel. The choices made in Customize Proof Condition can have a significant influence on the way an image file is displayed; this, in turn, can influence how the image is edited and printed (the choices made in Customize Proof Condition change how Print with Preview is used).

Duplicate and open a color Master file in Photoshop, preferably an image already Hard Proofed. Navigate to Photoshop's Proof Setup and launch the Customize Proof Condition panel. The Proof Conditions sub-panel includes two pop-up menus: Device to Simulate and Rendering Intent. For the moment, leave Rendering Intent in its default selection (the one programmed in Color Settings).

Click on the Device to Simulate menu and select an appropriate print profile. The on-screen image may change, perhaps significantly. You may notice alterations in color, density, and contrast. The on-screen image is now *soft proofed*; it is a simulation of the printer/ink/paper combination represented by the print profile.

Make sure the Black Point Compensation button is clicked on: it instructs Photoshop to map the black point of the image file to the paper/ink combination identified by the selected print profile (duplicating the procedure used in Color Setting). This is the digital darkroom equivalent of making a wet-darkroom proper proof (where minimum film density is exposed to produce print black). This change may not be obvious on-screen, but if Black Point Compensation is not selected, the print's shadow values may not accurately match the on-screen image.

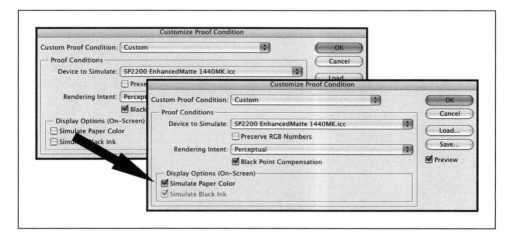

FIGURE **8.2** **The Simulate Paper White and Simulate Ink Black options in the Customize Proof Condition** panel can be useful for visualizing a finished print if the print profile is an accurate ICC profile. In this example, the selected print profile is not ICC, and the Ink Black option is not available (the necessary information is not in the profile).

Under Display Options, you'll find Simulate Paper Color and Simulate Black Ink. They are not available when a generic print profile is used (an office inkjet print profile, for example), or a display, camera, or scanner profile is accidentally selected. They *are* available when an ICC print profile is chosen.

Clicking on Simulate Paper Color automatically turns the Ink Black option on, but Simulate Ink Black can be used independently. These settings are designed to simulate the perceptual difference between viewing an image on-screen by transmitted light versus viewing a print with reflected light. This is a difficult phenomenon to simulate and using these options can initially seem confusing.

There is a trick to using Simulate Paper Color with an ICC profile. Do not look at the screen when clicking it on; instead, avert your gaze for a few seconds and then examine the image. When clicking on Simulate Paper Color, the image is often rendered with less contrast (prints have less contrast than displays), and our subjective experience is that the image appears "washed out" and dull. Allowing your vision to adjust, by glancing away from the screen, helps to normalize the view.

Conversely, you can to turn Simulate Paper Color on and off. Your vision will modulate between the two (a technique analogous to using Polaroid film to visualize an image). Experiment with these techniques to determine if either is helpful.

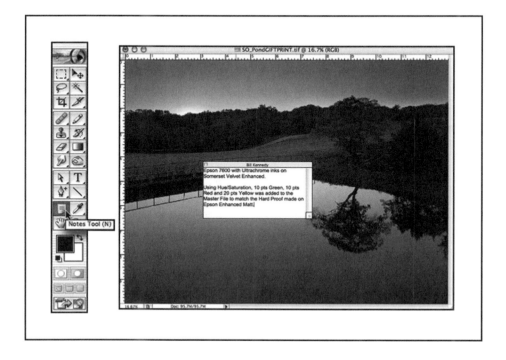

FIGURE 8.3 The Notes Tool makes it possible to leave valuable information where it's most useful, with the image file. Add as many notes as you like; they will not print with the file.

Be consistent in applying print profiles and options in the Customize Proof Conditions panel. As you experiment with settings, it is a good idea to keep notes. An old-fashioned "analog" paper pad and pencil are powerful tools in the digital darkroom. I keep a notebook for digital printing and make a habit of annotating Hard Proofs and working prints with settings. There is also a terrific feature in Photoshop, the Notes Tools, which can be used for tracking image information.

When selected from Photoshop's tool bar, Notes places a small text file (a virtual "sticky note") on top of the image. All the information about the file, which might be useful later, can be recorded. As many notes can be added to an image as necessary or deleted at any time. They will stay attached to the image as long as desired (but will not print). When using Photoshop's Full Screen Mode, which places the image file against a gray background, notes can be dragged to the background to aid in editing.

Soft proofing isn't infallible. A color print profile is only accurate for a specific combination of printer/ink/paper, and it must be authored correctly (preferably to ICC standards for a linearized printer). Change any variable and the results may suffer, sometimes dramatically. Also, the options in Print with Preview and the print driver software must be configured properly. Soft proofing affects only the simulation of the image file's on-screen image. It does not change the pixel information in the file, nor does it automate the printing process.

Beyond Proof Setup

You'll find Gamut Warning under the View menu. Gamut Warning is designed to complement and extend soft proofing. When a print profile is selected for soft proofing, Photoshop simulates its gamut or color space. Often the print profile cannot reproduce all the color information contained in the image file. It is common for the

FIGURE 8.4 **Gamut Warning is found under the View menu. It works with the soft-proofing choices made in Proof Setup to indicate image file color information that cannot be replicated by the printer.**

displayed image to contain information that cannot be accurately reproduced by the printer/ink/paper combination selected. You'll want to know this before making edits or attempting a final print.

With Gamut Warning activated, portions of the on-screen image may be grayed out (gray is the default color; it can be changed in Photoshop>Preferences). The grayed areas represent image color information that is *out of gamut* for the print profile. The color information exists in the image but cannot be reproduced by the selected printer/ink/paper combination.

If you activate Gamut Warning, and there are no grayed areas in the image, Photoshop is indicating that the image file gamut can be faithfully reproduced by the print profile selected in Proof Setup. None of the image file input values fall outside of the profile's output values, and the image gamut does not require editing to "fit" on the print.

"Out of gamut" color is an issue that artists in many disciplines must deal with. Photographers shooting transparency film struggle in the wet darkroom to make prints that replicate the color in their film originals, using inter-negatives or direct-positive printing processes (Ilfochrome or R-4, for example). Press operators struggle to get the images produced by ink on paper to match film originals and prints.

A painter faces the same issue when trying to simulate oil paint on canvas with a screen print, for example. Often, many small compromises must be carefully made—a great deal of craftsmanship must be dedicated to the task—to produce a print that does justice to the original image.

Soft proofing, combined with skillful Photoshop editing, simplifies this problem by providing artists with a powerful took kit, allowing them to accurately translate color information as faithfully as possible from one medium to another.

Use Gamut Warning to edit the color information in an image file to match the selected print profile and Rendering Intent. This can be done using Levels or Curves, or any editing option found under Image>Adjustments. I find Hue/Saturation, Color Balance, and Selective Color to be especially useful for editing out-of-gamut color information.

Hue/Saturation allows individual colors to be isolated and edited. Color Balance presents a different method for editing color: it treats shadow, mid-tone, and highlight information independently. Selective Color extends this concept one step further, by allowing you to edit within the individual colors of an image file. You can, for example, select Red in the pop-up menu, and then edit all other colors that compose Red in the image file.

These are powerful techniques, providing ample evidence of how image control in the digital darkroom far exceeds that of traditional methods in the wet darkroom. You can experiment with edits by creating adjustment layers (Layer>New Adjustment Layer). Editing on layers preserves the pixel integrity of the original file.

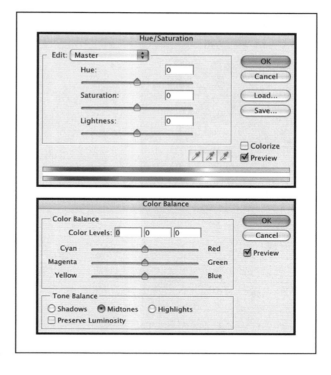

Gamut Warning can be used to select an appropriate print profile (leave it turned on while loading different print profiles in Proof Setup and watch the gamut warning change). You may discover that one paper is better for an image than another.

It can also be used to determine if changing the Rendering Intent between Perceptual and Relative Colorimetric is a good idea. Perceptual Intent was programmed in Photoshop's Color Settings in chapter 5, a good first choice for desktop inkjet printing. Using Gamut Warning, you may discover that Relative Colorimetric sometimes reduces out-of-gamut color. If so, assign Relative Colorimetric Intent to the image in the Proof Setup panel along with the print profile (this will not change Color Settings; Perceptual is still the default Intent).

Over time you may discover that Relative Colorimetric is a better choice for your printing workflows. If so, Relative Colorimetric can become the default Rendering Intent; simply select it the Photoshop's Color Settings instead of Perceptual. As mentioned in chapter 5, all Rendering Intents can be used in the digital darkroom, but Perceptual and Relative Colorimetric are the most useful.

Soft Proofing and the Print Profile Workflow

Soft proofing and Gamut Warning are a powerful combination; they enhance accuracy and make printing workflows more efficient. As you learn to use them, your understanding of how color management works in the digital darkroom will deepen.

The next step is to prepare the image file for printing using the print profile selected for soft proofing. Follow the print profile printing workflow outlined in the last chapter and make a print.

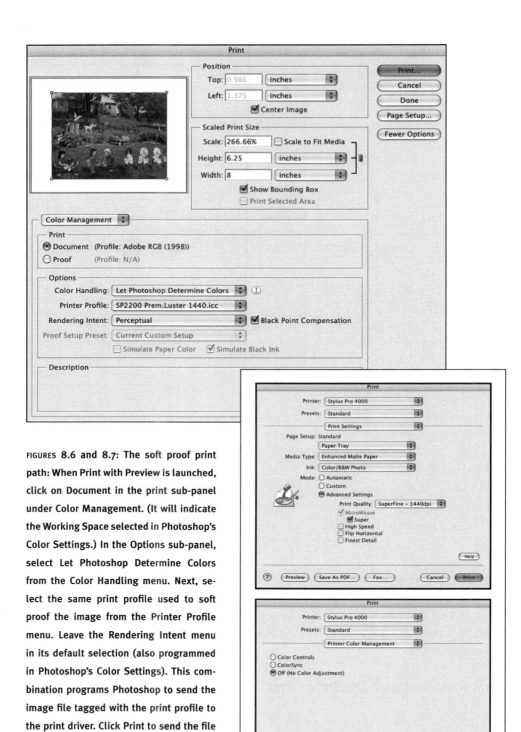

FIGURES **8.6** and **8.7:** The soft proof print path: When Print with Preview is launched, click on Document in the print sub-panel under Color Management. (It will indicate the Working Space selected in Photoshop's Color Settings.) In the Options sub-panel, select Let Photoshop Determine Colors from the Color Handling menu. Next, select the same print profile used to soft proof the image from the Printer Profile menu. Leave the Rendering Intent menu in its default selection (also programmed in Photoshop's Color Settings). This combination programs Photoshop to send the image file tagged with the print profile to the print driver. Click Print to send the file to the print driver. Next, configure Print Settings and Color Management. By clicking on No color Adjustment, you program the print driver to allow Photoshop to color manage the print.

If you soft proofed with an accurate ICC print profile and properly programmed Print with Preview and the OEM print driver settings, the print should be a good match to the on-screen image. The next step is to leave the objective world of Photoshop and print-driver settings and concentrate on the print under a viewing light.

What is your first impression? Are the overall density, contrast, and color balance of the print what you expected? How does it compare to the on-screen image? It should be very close. If there are obvious problems, check the workflow.

Soft Proof Trouble Shooting

- Is the custom display profile loaded under System Preferences?
- Are the color settings in Photoshop configured properly?
- Did you check the general health and well being of the image file with the histogram?
- Do you have an accurate ICC print profile for the printer/ink set/paper combination you used to make the print?
- Was this profile loaded properly in Proof Setup's Customize Proof Condition panel?
- Did you configure Print with Preview properly?
- Did you configure the print driver software properly?
- Is the printer working properly (do you need to use the Print Utilities)?

I sometimes discover issues with the first print that, when I look closely at the on-screen image, are actually there. I simply missed them. The process is the same as working in the wet darkroom. I'm pleasantly surprised to "get it right" on the first print, although the success rate in a color-managed digital darkroom is much higher than in the wet darkroom.

Printing Off the OEM Path

Once mastered, soft proofing and the Print Profile workflow is a technique that both improves working on the OEM path and encourages working off it. Different papers, ink sets, and printer software can be used, provided you have accurate print profiles to work with.

There are many paper choices and, as we'll see in the next chapter, changing ink sets introduces the quadtone option for grayscale printing. Replacing the OEM print driver with Raster Image Processor (RIP) software can dramatically improve print quality and provide useful productivity enhancements. Papers are usually the first step off the OEM path.

PAPERS OFF THE PATH

The paper choices available for inkjet printing are almost overwhelming, but they tend to fall into two categories: those that mimic the look and feel of contemporary wet-darkroom papers, and art papers used by painters, illustrators, and photographers working with alternative processes.

Mimics typically include glossy, semigloss, luster, and matte papers. Some simulate wet-darkroom RC paper; others are designed to evoke the look and feel of traditional fiber paper. As mentioned in chapter 1, dye ink sets are currently better for replicating the look of a wet-darkroom print on glossy and semigloss surfaces. All the papers in the mimic category are coated for inkjet printing.

Artist papers vary widely in surface texture and base tint, ranging from very rough to very smooth, and from bright white to cream and beyond. They work well with both dye ink and pigment ink sets (although pigments enjoy better longevity ratings). This category subdivides into papers that are coated specifically for inkjet printing and uncoated stock.

Coatings can play an important role in the performance of ink-and-paper combinations, particularly those matched by the manufacturer. Some coatings include optical brighteners (OBs), similar to those used in many wet-darkroom papers. They absorb yellow and reflect a higher percentage of blue light, producing a tint perceived as "bright white." However, OBs have a tendency to fade over time, causing a color shift (especially noticeable in the base tint of the paper). Some coatings are designed to swell on contact with moisture, allowing the inks to penetrate the top surface. In effect, the inks become encapsulated into the coating. This approach is designed to enhance the longevity of prints, particularly those made with dye inks.

Uncoated papers, especially those with medium to heavy surface texture, may produce prints that on careful inspection appear soft and less sharp than the same image printed on coated stock. This has to do with a phenomenon called "dot gain," a term borrowed from the prepress industry. Liquid ink spreads when applied to a surface. On uncoated stock, the spread, or dot gain, increases because the ink has a higher tendency to soak into the paper fibers. Sharpness decreases as each droplet of ink diffuses into the paper. This can produce a beautiful effect for some images.

Other paper considerations include weight and size. The weight of a paper is measured two ways: the actual thickness of the stock and its physical weight (measured in grams per centimeter). Inkjet printers vary in their ability to transport and print on heavy papers; printers featuring a straight-through paper feed generally handle heavy stock better than paper feeds that bend the paper. When checking for printer profiles earlier, you may have noticed a watercolor paper. Epson photo printers, for example, may include print profiles for several watercolor papers (these should transport through a printer without problems).

To learn more about papers, I recommend *Coming Into Focus*, edited by John Barnier and published by Chronicle Books, 2000 (particularly chapter 21: Paper, written by W. Russell Young III); and *Digital Book Design and Publishing*, by Douglas Holleley and published by Clarellen and Cary Graphic Arts Press, 2000

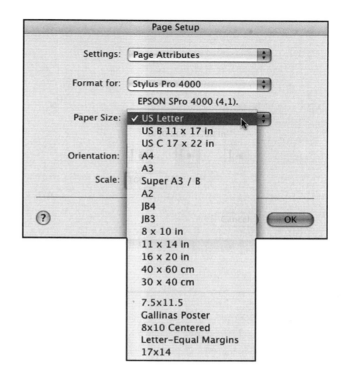

FIGURE **8.7** **The Paper Size menu is located in Page Setup.** Those listed at the bottom are custom paper sizes created through the Settings menu.

(chapter 10: Printing Substrates and Materials). You'll find these books especially helpful for printing on traditional artist papers and also for generating ideas for handmade books and alternative printing processes (both of which can be combined with, and integrated into, inkjet printing). Norman Koren's Web site (*www.normakoren.com*) includes an annotated list of inkjet papers and a list of vendors that supply print profiles for the papers they sell). See the Resource appendix for more information.

You may have noticed in the Print Size menu in Print Setup that inkjet papers are not the same sizes as papers traditionally used in the wet darkroom. Typically, inkjet stock is sold in 4 × 6, 8.5 × 11, 13 × 17, 13 × 19, and larger sizes. Some of the default paper sizes are European (A3, Super A3/B, or B, for example). Check the Paper Sizes sidebar to translate these choices into inches. There are also selections for envelope, index cards, and many more, depending on the printer. Some printers also use roll paper.

A6	4.1 x 5.8 inches
A4	8.3 x 11.7 inches
A3	11.7 x 16.5 inches
Super	B13 x 19 inches
B size	11 x 17 inches
C size	17 x 22 inches
Letter	8.5 x 11 inches
Legal	8.5 x 14 inches
Panoramic	8.3 x 22.5 inches
Banner	16.5 inches x 49 feet

Choosing a paper is an important aesthetic choice touching on a number of issues in the digital darkroom. One of the most important is gamut. Paper is simply another device that holds information, and some have a larger gamut than others. To make it more interesting, the paper gamut can change with different ink sets. Typically, coated papers have a larger gamut than uncoated papers, and glossy papers have a larger gamut than others.

Photographers interested in replicating the look and feel of wet-darkroom prints are often concerned with two things: 1) duplicating the surface of silver-gelatin papers; and 2) duplicating the Dmax (maximum black) of silver-gelatin papers with a particular paper-and-ink set combination. A high-gloss wet-darkroom paper may have a Dmax approaching 2.0–2.2. Some glossy inkjet paper-and-ink-set combinations, especially dyes, exceed the Dmax of wet-darkroom prints, but many fall in the 1.6–1.7 range.

Inkjet density values, including Dmax and Dmin, can be measured with a reflection densitometer or the spectrophotometer used to build profiles. You'll need software that allows LAB readings with a spectrophotometer (the L channel reading can be converted to logarithmic density numbers).

You don't need to be a mathematician to do this. Bruce Lindbloom thoughtfully provides a calculator for converting L to log values on his Web site (*www.brucelindbloom.com*).

Experiment with non-OEM papers by using the profiles installed on your system. You may find a profile that produces a good print (expect to do some tweaking in Photoshop). It can be helpful to try several Media Type selections in the print driver to adjust how much ink is laid down. This will affect the color gamut. Remember, some manufacturers and vendors supply profiles for their papers (Lysonic, Pictorico, Red River, Crane, and Calumet Photo's Brilliant inkjet papers, for example). These profiles may be more useful that a default. Eventually, if you enjoy using a variety of papers, accurate ICC print profiles are a must.

Many photographers have noted that inkjet prints tend to be more fragile than the prints made in the wet darkroom. Photographers should treat any final print—wet or digital—with care. How prints are handled, stored, and used are important issues. Pigment inks, especially on artist papers that have a soft surface (cold press rather than hot press), are more susceptible to buffing and scratching.

Some photographers routinely coat their inkjet prints to create a more durable surface and, hopefully, to add an ultraviolet (UV) barrier that impedes ink fading (UV glazing is also recommended for framing and display). You can check for inkjet aerosol sprays, the easiest coating method to experiment with, from the ink vendor listed in the Resource appendix. Sprays and coatings are also a frequent topic on Internet groups dedicated to inkjet printing and the digital darkroom.

INK OFF THE PATH

There are many reasons to consider third-party ink sets (some aesthetic and others purely practical). Let's outline the practical reasons first, and then examine some of the aesthetic issues.

You may find that third-party ink sets are less expensive than OEM inks. This is especially true when using a continuous inking system (CIS). A CIS replaces the OEM cartridges with a system that feeds bottled ink to the print head through plastic tubing. After the initial purchase, a CIS can dramatically reduce ink cost. I recommend using ink in cartridges before making the investment in a CIS. Changing inks in a CIS is messy, at best. Follow the instructions for setup and usage carefully. Using these systems could void the printer's warranty (if the usage is detectable). An alternative to CIS is third-party ink cartridges that can be refilled with bulk ink.

There are third-party inks designed to match OEM ink sets (using these may or may not work with OEM print profiles) and others that are significantly different. Do not be tempted by cheap ink. Using it can become a color-management nightmare, and there may be serious archival issues. Bad ink on good paper is not only a waste of money, but, more importantly, time and effort. There are a vast number of third-party ink vendors (a quick Google search will prove the point); currently, those that cater to photographers include Lyson, InkjetMall, Media Street, MIS Associates, Inkjet Art, and Inkjet Goodies.

There are at least two aesthetic reasons to use third-party ink. First, you may want to change from dye ink to pigment ink (or vice versa). Be forewarned that inexpensive printers designed for dye inks may develop clogging issues when using pigment ink. Pigment ink has a higher viscosity than dye ink, and the print head may not function properly or may need frequent cleaning.

FIGURE 8.8 This chart, taken from a Media Street technical bulletin, illustrates the gamut of three inks sets. The large elliptical shape represents the LAB color space. The black outline is Media Street's Generations G-Chrome inks; the white outline represents Epson UltraChrome inks; the medium gray outline is Lyson's Cave Paint inks.

Black = Generations G-Chrome
Yellow = Epson Ultrachrome
Red = Lyson Cave Paint

If you are contemplating changing inks, purchase a set of cleaning cartridges for the printer (see the tutorial, Printer Utilities for more information on cleaning cartridges). Use these to flush the old ink from the print head before introducing the new ink set. This is critical when using a larger printer, where ink is transported from cartridges to the print head via plastic tubing (as opposed to the smaller printers where ink cartridges sit on top of the print head). You must flush these tubes before changing inks (recommended even if the vendor says it is not necessary).

Gamut is the second aesthetic reason to change inks for color printing. Some third-party manufacturers claim a larger-than-OEM gamut for their inks. Other factors being equal, ink sets with a larger gamut make image editing (using an ICC print profile, soft proofing, and gamut warning) a bit easier and potentially less destructive to the image. This can be judged by eye but empirical proof is better.

RIPS AND PRINTING COLOR OFF THE PATH

RIPs can be a valuable alternative to an OEM driver, but there are additional expense and another application to learn. RIPs perform the same basic functions as OEM print drivers—they manage the hardware behavior of the printer and control how image-file information is transformed into ink—but they can vastly improve both.

RIPs may also include any number of workflow features that can improve the efficiency of printing compared to OEM print drivers. Depending on the RIP (and they vary widely) there will be a number of features that can improve workflow productivity:

- The RIP may allow optimized positioning of more than one image file on the paper. This can save paper and boost the "throughput" of the printer (printing more images in the same amount of time).
- Some RIPs may also allow each image file to be individually color managed. This allows printing color and grayscale images simultaneously, or printing color images tagged with different profiles. You cannot duplicate this feature in Photoshop.
- The RIP may include a "hot folder" or "job folder" feature allowing multiple print jobs to be ranked, ordered, or stored for future printing.

Some of the workflow features of a RIP can be simulated, to a point, in Photoshop. For example, a new document can be created in Photoshop for gang printing (see the tutorial, Testing an Inkjet Printer for details on this procedure), or you can use the Picture Package feature (File>Automate>Picture Package) for making multiples of the same images. These Photoshop options cannot duplicate the convenience of a professional RIP, but they are free and useful alternatives.

RIPs can also improve print quality by doing a better job of converting image-file information to the droplets of ink that form the dither pattern on a print—the stochastic screen mentioned earlier. When a color or grayscale file is sent to a RIP,

the conversion of information is similar to what takes place in an OEM print driver: the file information is converted into a proprietary CMYK color space and sent to the appropriate ink channels. RIP software can allow direct control over this step, whereas OEM drivers do not.

You'll recall, from chapter 4, that calibration in the digital darkroom is a process of using software to control hardware. We calibrate hardware (a display, for example) to known standards, and build a profile that accurately describes the color space of the device. Linearization is the calibration process for inkjet printers, and it improves, sometimes dramatically, the quality of the profiles built for the printer. The result is a more accurate print, one that comes as close as possible to matching the on-screen image.

As noted earlier, OEM drivers are generally biased to produce saturated, vivid colors. This bias varies by printer, with newer inkjet printers providing a more linearized response than older models. You can also adjust the image in Photoshop to compensate for the OEM driver bias (making Levels or Curves adjustments, for example), but the effectiveness of this is limited compared to what can be accomplished with a linearized printer, accurate ICC print profiles, and a RIP. We'll return to each of these issues in chapter 9.

Grayscale Printing on the OEM Path

You might assume that printing grayscale images in the digital darkroom would be relatively easy. In practice, printing grayscale images with the same accuracy as color requires extra care. By the way, you've probably noticed that in the digital darkroom the traditional black/white print is called a *grayscale* print. This terminology reflects Photoshop's eight image modes, where black/white is an image composed of just two levels of information—black and white—similar to high-contrast lithograph images. A Photoshop grayscale image, by comparison, is composed of as many levels of information as the file bit depth provides. It is the digital darkroom equivalent of a traditional black/white print.

There are several reasons why grayscale printing can be more challenging than color. First, grayscale files have one-third the information of an RGB file, emphasizing the need for careful image edits in Photoshop (many experienced photographers realize that Photoshop technique is to the digital darkroom what Zone System technique is to the wet darkroom).

Secondly, OEM inkjet printers use color ink sets. These inks must be precisely mixed to simulate neutral gray tonalities; and this, unfortunately, isn't yet a strength of OEM print driver software. One alternative is to replace the color ink sets with quadtone inks. Quadtone inks are a matched set of gray inks ranging from a dense black to progressively lighter shades.

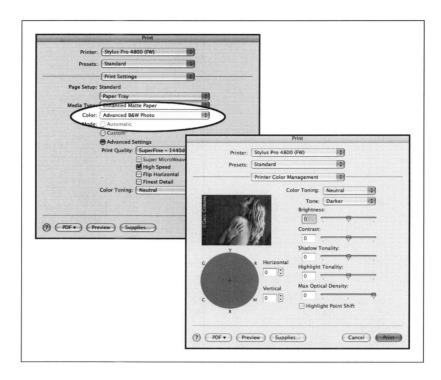

FIGURE 9.1 The Epson K3 Ultrachrome printers have an improved grayscale printing option, Advanced Black & White Photo, located in the Print panel's Color menu.

Currently there are no OEM quadtone printers, but the most recent offerings by Hewlett Packard and Epson offer "quasi-quadtone" options that improve grayscale printing. The Epson 2200, 4000, and 7600 UltraChrome printers use either Photo Black, for glossy papers, or Matte Black, for other papers, along with Light Black ink.

The latest Epson UltraChrome K3 models, the 2400 and 4800, do not allow Photo Black and Matte Black inks to be loaded into the machine simultaneously (you must choose which ink to install). They include an additional, very light, black ink called Light Light Black.

This three-black-ink configuration is designed to work with a new print driver feature, Advanced Black & White Photo (ABW). ABW brings to the OEM printing path several features that previously required a third-party RIP. RGB and grayscale images can be made using the same printer and media, and the Printer Color Management panel accessed through ABW allows neutral and tinted printing. Unfortunately, there is no live preview (when you find settings that work well, be sure to save them through the Presets menu).

Hewlett Packard also offers several inkjet printers that are designed to use dedicated black and gray dye inks. These inks are designed to work on a limited range of HP media, however, and there may be archival issues when printing on non-OEM media.

PHOTOGRAPHER'S GUIDE TO THE DIGITAL DARKROOM

Another solution, often coupled with using quadtone inks, is to replace the OEM print driver with a RIP. Both alternatives address many of the grayscale printing issues outlined in this chapter, but they require leaving the OEM path. We'll examine them in detail in the next chapter.

We'll begin by adapting the color printing workflows outlined in chapters 6 and 7 to printing grayscale on the OEM path. We want to know what can be accomplished by printing grayscale with OEM ink sets, papers, and print-driver software. For many photographers, fine-tuning the OEM printing path will produce the grayscale prints they're looking for. One advantage for printing grayscale is the ability to use color to easily produce the equivalent of toned wet-darkroom prints. We'll examine non-OEM options in the next chapter for those seeking more control.

Grayscale Issues

Before printing grayscale images, there are a few predictable issues to define. Many photographers feel that producing *neutral* grayscale images with color ink sets is the "final frontier" of the digital darkroom. The difficulty begins with defining *neutral*. Often, when photographers refer to a neutral print, they are describing the look and feel of the silver-gelatin prints they've made in the wet darkroom.

Neutral is a moving but predictable target in the wet darkroom. Every combination of enlarging paper and print developer will produce a unique image tint. There are warm and cold papers, warm and cold developers, and many ways to alter the image color of a black/white print through processing and toning. Even the stop bath, fixer, and the quality of the wash water can have subtle effects on image color. Because the color tint of a black/white print can have considerable emotional impact, wet-darkroom photographers often devote much time and energy to producing a color tint they like.

The "neutral" issue in the digital darkroom is complicated by comparison. An OEM inkjet printer uses color ink (from 4 to 8 inks with current printers) to produce shades of gray. This often results in a grayscale print that may exhibit one or more color problems.

First, there may be *color shifts* within the tonal structure of the image. When color ink sets are used for grayscale printing, the OEM print driver partitions the file information into the various ink channels. Partitioning information requires transition points. OEM drivers are designed to create transitional points for color images—not grayscale ones—so, typically, color shifts are most noticeable at these transitions. You may, for example, see a magenta or a green shift as dark tonalities merge into middle tonalities, and again when middle tonalities merge into lighter image areas. This is most noticeable when printing a grayscale ramp (see the tutorial, Testing an Ink Printer).

The exact color shift is the product of the print driver and ink set, but it is also influenced by paper choice. Some combinations produce more noticeable (and

objectionable) color shifts than others. A best-case scenario is when a color shift mimics the "split-tone" look achieved in the wet darkroom.

Secondly, even if color shifts are minimal, there may be a noticeable *color cast*. Color cast is an overall tint, ranging from cool to warm. Again, the exact color cast is the product of the printer, ink set, and paper used. Change any variable and the color cast will likely change, sometimes significantly. This may or may not be an issue, depending on the printing you want to do. We'll revisit color cast later in this chapter, when we examine the black-ink-only (BIO) printing path.

Lastly, the color problems associated with grayscale printing are exacerbated by a visual-perception phenomenon called *metamerism*. Metamerism is the tendency for some colors to noticeably shift hue under different light sources. Two colors may appear identical under one light source, for example, but very different under another. Metamerism explains why a grayscale print can appear neutral under one light source, say tungsten, but not under another (fluorescent or daylight, for example).

This can be a deep source of frustration for photographers making prints for sale or exhibition. Often, if an ink-set-and-paper combination is prone to metamerism, the effect is less noticeable with a color print. The much wider range of color in the print, coupled with the eye's tendency to auto-correct what we see, effectively camouflages the problem. Not so with grayscale printing, where shifts in color can be very noticeable when seen against gray tonalities.

Neither color cast nor metamerism should be limiting factors in Hard Proofing grayscale images, at least initially. You'll want to concentrate on establishing a grayscale printing workflow based on density, contrast, and tonality control. By printing images, you can identify any color-related issues. As we move through this chapter and the next, we'll examine many grayscale print paths and discuss options for dealing with color shift, color cast, and metamerism. Any of these paths can then be adapted to a Hard Proofing workflow.

Grayscale Image Files

Grayscale printing in the wet darkroom is a model of simplicity (there's nothing like 175 years of technological evolution for working the kinks out of a system). Photographers traditionally decide before exposure if an image is going to be color or black/white and then choose a film aimed at that target. A color image can be converted to a black/white print in the wet darkroom, but the options are limited and quality is a serious issue. By comparison, the grayscale path in the digital darkroom presents more choice (a lot more choice). We'll examine the grayscale options for working with a digital camera first, then for working with a scanner.

A digital camera may offer a grayscale capture option. When selected, the original RGB exposure information will be converted by the camera's software into a grayscale file. There are two problems with this approach.

First, choosing in-camera grayscale with most digital cameras eliminates the option for Raw capture. (A few cameras currently offer grayscale capture that preserves the Raw information; this is an excellent option, as it allows previewing grayscale on the camera's LCD screen, but the Raw information is preserved for post-processing.)

Second, the conversion of RGB information to grayscale is arbitrary: an algorithm in the camera software determines the conversion. It is the RGB-to-grayscale equivalent of program mode for exposure (sacrificing control for convenience).

Many photographers shooting digitally find that a Raw RGB image file provides the best path for grayscale printing. A Raw file preserves all the information stored in the image pixels (including bit depth). This makes it much easier to edit density and contrast in Photoshop, while still preserving the integrity of the histogram (more image information equates to more control and less problems with print quality). An excellent resource on Raw processing is Bruce Fraser's *Camera Raw with Adobe Photoshop CS2* (Peachpit Press, 2005).

The color information in a Raw capture offers greatly enhanced control over the tonal relationships in a grayscale image. In traditional black/white photography, tonal relationships are determined by the exposure and development of the film. Filters can be used during exposure to manipulate tonal values (using a yellow, orange, or red filter to progressively darken a blue sky, for example), but the options for altering tonal relationships during printing are severely restricted compared to processing color image files in the digital darkroom.

While the argument for Raw capture with digital cameras is compelling, there are three workflow issues to consider:

In-camera memory. Raw files are large, limiting the number of images that can be stored on a given memory card.

In-camera processing speed. It takes more time for a digital camera to buffer, process, and write Raw files to memory.

Post-processing. It takes more time to process Raw image files after downloading them from a camera.

The Raw image workflow also applies to scanning color prints or film for grayscale printing (see chapter 3 and tutorials for details on the SSPP scanning workflow). This is only true when scanning color originals, however. There is little advantage in producing an RGB file from black/white negatives. However, if your scanner offers an LAB scan mode, there is one exception worth trying.

Make identical scans in grayscale and LAB. Open both in Photoshop and compare the grayscale file to the Luminance channel image in LAB. Compare the image on screen and also the histograms. Depending on the scanner software, and the

FIGURE 9.2 The Type menu in the ScanWizard Pro 7 application offers a variety of scanning modes including LAB. Note, however, that with this software you can make a 16-bit RGB scan but only an 8-bit LAB scan.

Job:	RGB Colors
	RGB Colors (48–bit)
	Gray Scale
Input Profile:	Gray Scale (16–bit)
	CMYK Colors
Type:	✓ Lab Colors
Resolution:	Web/Internet Colors
	256 Colors [Default]
	256 Colors [Custom]
Frame:	Line Art
Output:	B&W Diffusion
Scaling:	100.0 % 11.8 MB
Transform:	F 0˚
Category:	None
D-Range:	Full Range
W&B Points:	No Correction
Gradation:	No Correction
Color Cast:	No Correction
Saturation:	No Correction
Selective:	No Correction
Tone Curve:	No Correction
Filter:	None
Descreen:	None
	Default

algorithm it uses to convert the raw RGB data from the sensor into grayscale, there may be a noticeable difference. You can decide which approach works best. If you prefer the LAB version, select the Luminance channel and convert it to grayscale (the other two channels are discarded and the file size is reduced proportionally).

When scanning a black/white print, you must decide if retaining the color information in the print is important. If the print is aged, hand colored, or toned, for example, and retaining that information is important, scan the print in RGB and finesse the color in Photoshop. File size can become an issue, however. A 1200 dpi RGB scan in 16-bit from an 8" × 10" color print will result in a file that will be almost 660 megabytes. If file size is an issue, determine the largest print size you'll need and size the scan with the scanner software accordingly. In general, it is better to use only the necessary print size and retain the 16-bit depth.

Hard Proof from a Grayscale Master File

You'll recall that Dot Gain 20% was the recommended grayscale Working Space in Photoshop's Color Settings. If Photoshop detects a profile mismatch when an image file is opened, the Embedded Profile Mismatch panel appears (you programmed this to happen in Color Settings; see chapter 5 for details). Choose Convert to Dot Gain 20% and click OK.

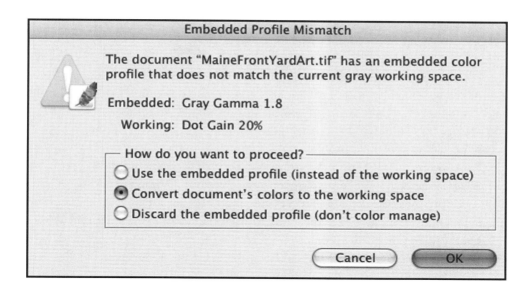

FIGURE 9.3 Photoshop's Embedded Profile Mismatch panel will automatically launch if you open an image file tagged with a profile that does not match the choices made in Color Settings. Unless you are working with someone else's file and do not want to alter it, choose Convert.

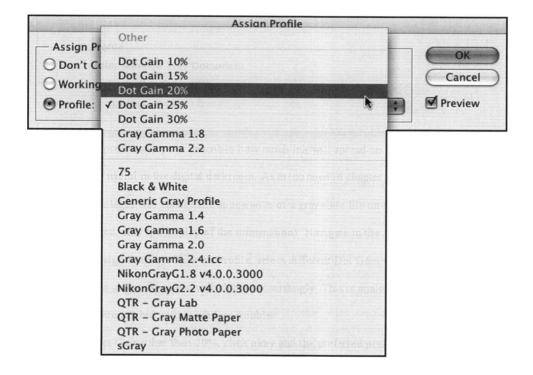

FIGURE 9.4 Use the Assign Profile panel to experiment with different Dot Gain settings (a convenient way to visualize the image as darker or lighter).

Dot Gain can be very useful in the digital darkroom. As mentioned in chapter 5, selecting different Dot Gain percentages will change the appearance of a grayscale file on-screen (the file information is not changed, only the display of the information). Navigate to the Assign Profile panel (Edit>Assign Profile). Click on Profile, select different Dot Gain settings from the pop-up menu, and the on-screen image will change accordingly. This is analogous to making test prints in the wet darkroom, but with much less trouble.

If you prefer a Dot Gain other than 20%, click OK, and the preferred profile will be assigned to the file. Assigning a profile does not change Photoshop's Color Settings. You'll want to keep Color Settings standardized for now. It also doesn't change the image. It only alters the simulation of the file information on-screen

If you prefer a different Dot Gain for an image, the Dot Gain can be saved with the file when it is closed, or the file can be converted (Edit>Convert to Profile). You may want to indicate this in the title of the saved file. We'll return to Dot Gain later, after pulling a Hard Proof, and see how it can be used to tailor the match between an on-screen image and the print.

After experimenting with Dot Gain, the next step is to make a Hard Proof using the same workflow outlined in chapter 6. Briefly, this is a two-step process. First, navigate to Print with Preview, make the appropriate selections, and click Print to move the image file to the print driver. Second, make appropriate selections in the print driver. Every setting in Print with Preview and the printer driver is important!

Grayscale Hard Proof Workflow

Step #1: Print with Preview
- Check paper size and orientation.
- Check image size/scaling.
- Click on More Options and select Color Management.
- Select Document in the Print sub-panel.
- Select Let Printer Determine Colors in the Options sub-panel.
- Click Print.

Step #2: Print Driver Software
- Select Printer (and load paper).
- Keep Presets at Standard.
- Click on the Copies & Pages pop-up menu and select Print Settings.
- Choose paper in Media Type.
- Select Color (or Black if you want to print BIO).
- Select Mode: Advanced.
- Select a medium resolution setting in Print Quality and click on High Speed.

- Return to the Copies & Pages menu and select Color Management.
- Click on Color Controls. Do not use the Gamma or the color adjustment controls.
- Load paper into the printer.
- Click Print.

Grayscale Hard Proof from an RGB Master File

Next, we'll concentrate on grayscale Hard Proofs using color Master files that must be converted to grayscale. Color to grayscale conversion is one of the most important steps in the grayscale workflow and there are many options.

The quick and easy way to produce a grayscale Hard Proof from a color Master file is to let the print-driver software manage the conversion. With the Master file open in Photoshop, navigate to Print with Preview. Follow the same procedure for making a color Hard Proof but with one exception: under Print Settings in the Copies & Pages menu select Black from the Ink menu. This instructs the print driver to use black ink only (BIO).

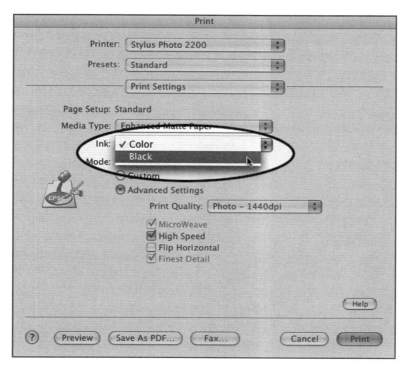

FIGURE 9.5 The Ink menu under Print Settings in the Print panel allows for black ink only (BIO) printing; a workflow that uses the OEM print driver to produce a grayscale Hard Proof from an image file.

The print driver conversion is predictable, useful, and—best of all—temporary. It does not alter the Master file in any way (the conversion occurs after the image file is sent to the print driver software). Later, when making a finished print from the file, grayscale conversion can be finessed in Photoshop.

Simple techniques, like BIO for Hard Proofing color Master files, can increase productivity. This is similar, in effect, to the routine many photographers adopt for making proof prints in the wet darkroom. The general idea is to work as efficiently as possible without sacrificing control or predictability.

There are two disadvantages to Hard Proofing with BIO. First, you can only compare the print to the RGB image on-screen. This is helpful but somewhat limiting. Secondly, this print path will camouflage any color-shift issues that may arise later if color ink sets are used to print grayscale. We'll examine the BIO print path in more detail at the end of this chapter.

Photoshop Color to Grayscale Conversion Techniques

There are many Photoshop options for converting color information into grayscale. You'll have a choice between conversions that retain color information and conversions that discard it. Retaining color information results in larger files but

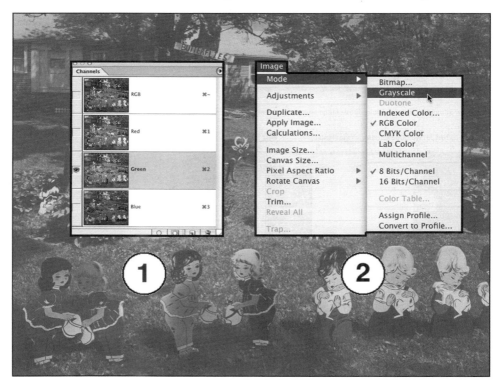

FIGURE 9.6 Select an individual RGB channel and convert it to grayscale.

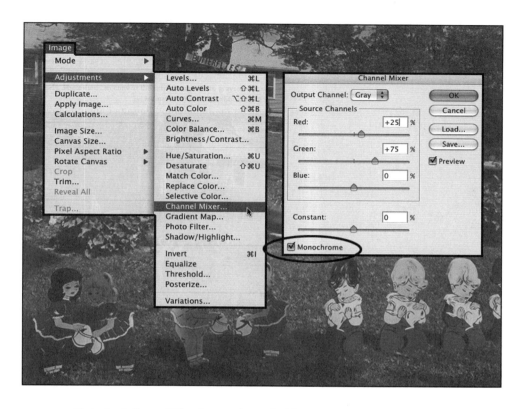

FIGURE 9.7 Photoshop's Channel Mixer is a popular method for translating color image files into grayscale. Make sure the Monochrome button is clicked on and try to keep the total percentages close to 100% to avoid unnecessary editing of the pixel information.

allows more workflow flexibility. If you choose a permanent conversion option, be absolutely certain that you're working with a duplicate Master file.

We'll begin by summarizing a few of the standard techniques that discard color information. You can, for example, select one channel from an RGB image file (Window>Channels) and convert it to grayscale (Image>Mode>Grayscale). Conversely, Photoshop can convert the entire image file to grayscale (it will use a predetermined percentage of the information in each channel, much like the process that occurs in a digital camera).

You may want to compare these options. Try a conversion, and then use the History palette to go back and try another approach (in Photoshop, Command + z backs up one step, also convenient). There are third-party Photoshop plug-ins (some designed to mimic the tonal qualities of traditional black/white films) that you may want to experiment with.

Many photographers prefer using the Channel Mixer to tailor grayscale conversions (Image>Adjustment>Channel Mixer). It allows custom mixing from the RGB channels (click on the monochrome button at the bottom of the panel). When using this technique, in the image title bar, you'll see that the image file is still in RGB

FIGURE 9.8 **Use Photoshop's Adjustment Layers to convert color information to grayscale. This preserves the underlying file and makes it possible to revisit the conversion as long as the layer exists.**

mode. However, because monochrome was selected in Channel Mixer, the color information is no longer accessible for editing. You may wish to make additional image edits, including contrast or density adjustments, and permanently convert the image to grayscale (thereby reducing the file size).

The same control is accomplished by creating an Adjustment Layer, which will preserve the color information in the file. In the Layers palette, click on the Create New Fill or Adjustment Layer icon on the bottom tool bar (the half-black/half-white circle) and select Channel Mixer from the menu.

Similarly, a color file can be desaturated using a Hue/Saturation adjustment layer. With the Edit menu set on Master, move the Saturation slider to −100. Select individual colors from the menu and make adjustments using the Lightness slider. You'll have access to all the color information in the file. For experienced black/white photographers this can be an epiphany. You'll have complete control over tonal values *and their relationships*. Most importantly, the information in the original image file is not altered. You can use Photoshop's Save As command (File>Save As) to permanently save the new grayscale image; then simply close the color Master file without alteration.

If you use Adjustment Layers for color to grayscale conversion, and decide to permanently convert the image to grayscale, be sure to flatten the layers first (Layers>Flatten Image). If you navigate directly to Image>Mode>Grayscale, Photoshop will ask if you want to flatten layers before converting. Click Flatten to preserve the layer effects. If you convert without flattening, Photoshop will ignore the layers and convert the original color image via the default grayscale conversion. The work you did with layers will be ignored.

There are other advantages to the conversion technique that uses Adjustment Layers. You can trash or create a new Layer at any time. You can create different types of adjustment layers (Selective Color or Photo Filter, for example). You can also experiment with the layer modes available in the menu. Lastly, the image file can be saved with layers (allowing you to stop and start again). Use Photoshop's Save As command and substitute "Working" for "Master" in the file name. Complete the conversion of the color image file to grayscale and make a Hard Proof.

Evaluating the Hard Proof

Carefully examine the Hard Proof under the viewing light. How close is the match between print and the on-screen image? Are there density or contrast differences? You'll also want to look for evidence of color shifts, color cast, and metamerism (which may or may not be objectionable). Annotate and number the Hard Proof. Indicate how the print was processed; make notations about what you see and, perhaps, any questions to refer to later.

If there is an objectionable color shift or color cast, the first step is to print with another paper. These issues will vary by printer, ink set, and paper combination. Changing paper is the easiest variable to experiment with. It is worth the cost of a few packages to see if one type produces a better print. If the color cast is not too extreme, it can be adjusted through the print driver's Color Management controls (see chapter 6 for details on this procedure). Print-driver controls are not as useful for dealing with color shifts.

Metamerism is a more difficult problem. Changing papers may help, but the problem is probably the ink set. Metamerism is a fact of life: it occurs naturally and cannot be completely eliminated in any printing system (wet or digital darkroom). Some ink sets demonstrate less metamerism than others. This will require changing printers—to use an OEM ink set that does not produce noticeable metamerism—or using third-party ink in an existing printer. This will take some experimentation, and you may want to explore other options in this chapter first.

It is not unusual to see density and contrast differences—caused by the print driver's gamma bias—between the print and the on-screen image. You can partially compensate for the gamma bias by using the Brightness and Contrast sliders in the print panel's Advanced Settings, but these controls are crude compared to the range of options available in Photoshop.

With OEM print drivers that include an ink-limit control, it is also possible to improve print density and contrast by altering the amount of ink the printer lays down. You'll not find this option on all printers, however. When using such driver adjustments, you're programming the printer to modify the amount of ink used in each ink channel. These adjustments work for both grayscale Master files and color Master files that have been converted to grayscale. While this workflow can produce surprisingly good prints and is useful for Hard Proofing, there is a limit to how much can be accomplished with the print driver. These controls are not as sophisticated as those available in Photoshop, and you do not have a live preview.

Grayscale Printing on the OEM Path

We'll use Photoshop to improve grayscale print quality on the OEM path. Duplicate and open a Master file that has been grayscale Hard Proofed (choose a representative image that has plentiful shadow and highlight detail). Place the Hard Proof under the viewing light. The first step is to improve the match between the on-screen image and print. This can be accomplished in two ways, with Dot Gain or Curves. We'll examine Dot Gain first.

Open Color Settings (Edit>Color Settings), click on the gray Working Space menu and select different Dot Gain settings to see if one is a closer match (this is the same technique you used earlier through the Assign Profile panel). Lower the Dot Gain percentage and the image will become progressively lighter. Raising the percentage makes the image darker.

The image file is not changing when you select different Dot Gain percentages, only the simulation of the image on-screen. Each Dot Gain setting is a different grayscale working space profile that is applied to the image. The histogram will be exactly the same regardless of the Dot Gain setting used. Don't worry about an exact match: we'll tweak the selection in the next step.

Having selected a Dot Gain, navigate to Custom Dot Gain in the same menu. Use the Dot Gain sub-panel to tailor the on-screen image to the print. Notice the two small editing points on the curve: one in the lower left corner (corresponding to print white) and another in the upper right corner (print black). You can click and drag these settings, or create additional editing points by clicking anywhere on the curve or grid. Experiment, making small adjustments, and watch the image change. You can return the curve to its default setting by holding down the Option key to change the Cancel button to Reset.

When the Dot Gain curve matches the on-screen image to the print, name it appropriately (include the printer, ink set if non-OEM, and paper in the title) and click OK. The custom Dot Gain is now the default gray working space profile. You can build Custom Dot Gain settings for as many combinations of printer/ink/paper combinations as necessary.

The advantage of this technique is that the image file information is not changed

PHOTOGRAPHER'S GUIDE TO THE DIGITAL DARKROOM

FIGURE 9.9 Use Photoshop's Custom Dot Gain in Color Settings to build a gray working space profile that customizes an on-screen image to the grayscale Hard Proof. For more information on this approach, see Paul Roark's tutorial.

in any way. You've profiled how Photoshop displays the image on-screen. It is an excellent method for working accurately with grayscale images (Paul Roark uses an extension of this technique in his tutorial, Using Curves).

It can also be used as a quick method for previewing the conversion of a color Master file to grayscale. Simply navigate to Image>Mode>Assign Profile and select the custom Dot Gain setting from the Profile menu (make sure the Preview button is clicked on). Use any of the default Dot Gain settings, or a custom Dot Gain if you've authored one.

The same method can be used with Photoshop's Curves. With a grayscale image on-screen, navigate to the Layers palette and create a Curves Adjustment Layer. You'll have a gray channel curve that can be edited like the Dot Gain curve.

The Curves panel has a larger tool kit than Dot Gain. You can, for example, switch the position of the black and white points by clicking on the tonal ramp under the bottom edge of the curve; or use the black point, mid-point, and white point eyedroppers to sample image areas. There is also an option for creating a freehand curve by clicking on the small pencil icon (I do not recommend this). Similarly, don't use the Auto or Options buttons.

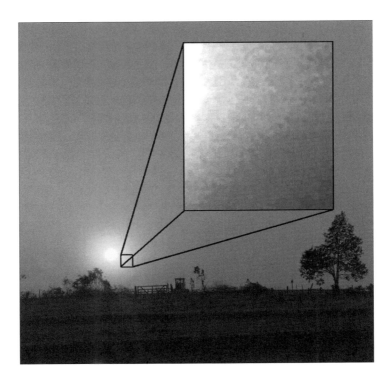

FIGURE 9.10 Contouring, often called *posterization*, is most noticeable in areas of smooth, continuous to-
nality. It can be a real problem when 8-bit files must be heavily edited.

When you're satisfied, click Save. Name the curve appropriately in the Save pan-
el. The curve will be saved as a Photoshop .acv file. The saved curve can be applied
to other files by clicking on the Load button in a Curves panel. You may want to
create a new folder through the Save panel to store .acv files. This will make naviga-
tion easier in the future.

The Custom Dot Gain and Curves approaches are useful for improving the
match between an on-screen image and the print. Both work by altering the rela-
tionship between the image file's input values and new output values created by the
Custom Dot Gain or Curves. My preference is Dot Gain: it changes only the display
of the image and does not alter the file information. This is a critical difference,
especially when working with 8-bit image files. Applying a Curve to an image file
changes the pixel distribution in the image file, increasing the potential for *contour-
ing* (see chapter 5 for more details on contouring).

Contouring is more likely to happen in 8-bit rather than 16-bit files. It is most
obvious in areas of continuous tonality, like a blue sky or a smooth wall. In severe
cases, it can affect the look of an entire image. The skin tonality in a portrait can
become chalky and rough, for example. Contouring tends to be less obvious in
areas of an image that have lots of detail and texture.

When using the Curves approach, always work on a duplicate of the Master file.
If a Curve is applied and the image is saved, the effect is permanent. If you open

this file and apply a second Curve, for a different paper or ink set, the image file is changed again. The integrity of the image file will be damaged.

With an accurate print-to-screen match, the image file can be edited with confidence. Using the numerous selection tools and technique available in Photoshop, it is possible to recreate and extend all the image controls used in the wet darkroom. You'll have more control over density, overall and local contrast, and dodging and burning.

There is a metamerism work-around using Photoshop's Custom Dot Gain or Curves technique that can be used on the OEM printing path. It doesn't completely eliminate metamerism, but can reduce it to a less objectionable level. Best of all, this workflow uses Photoshop and Print panel controls and does not require special equipment or software.

Begin by making a Hard Proof from a grayscale Master file. Then, without making any changes to the image file or settings used in Print with Preview, make a second print. This time, in the Color Management panel of the print driver, select Mode···⁞Photo-realistic and move the Cyan, Magenta, and Yellow sliders all the way to the left. You're instructing the driver to reduce the use of these inks, limiting them as much as possible. You can save these settings (Presets···⁞Save As) for convenience.

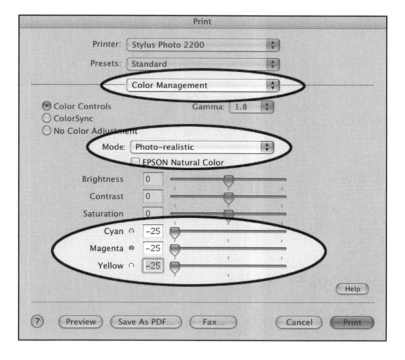

FIGURE 9.11 The metamerism work-around uses the controls available in Photoshop and the OEM print driver to reduce the amount of color ink used to make a grayscale print.

If the correction curve is accurate, the prints made using this workflow should match the density and contrast of the original Hard Proof and produce a grayscale print that demonstrates less metamerism than the original Hard Proof.

Grayscale Work-Arounds

There are two OEM methods I routinely use to manage the color-shift and color-cast issues in grayscale printing. The first colorizes the grayscale image to camouflage the fact that a neutral print cannot be made. Done properly, the result is analogous to toning a print in the wet darkroom. This is accomplished by converting the image to Duotone (Image>Mode>Duotone) or to RGB (Image>Mode>RGB).

The Duotone panel presents many options for adding color to a grayscale image. There are Monotone, Duotone, Tritone, and Quadtone default selections. Begin with the presets installed in Photoshop (Image>Mode>Duotone>Load). These selections are easily modified by clicking on the Curve symbol or the Ink symbol. The possibilities are almost endless. Once a Duotone setting is applied, the file can be converted to RGB, making it possible to edit the image as an RGB file. The best reason to convert a duotone file to RGB is that ICC print profiles are then available for soft proofing.

A grayscale file can also be converted directly into RGB (Image>Mode>RGB) enabling soft proofing. When converting from grayscale to RGB, the appearance of the on-screen image will not change, but the file size will triple. Instead of a single grayscale channel, the file is now composed of three duplicate channels. You can add color to the image through all the options available in Image>Adjustments, or better, by creating Adjustment Layers in the Layers palette.

When replicating the look of a traditional black/white toned print, a little color goes a long way. Begin by experimenting with small changes to the gamma setting in Levels. Using gamma instead of the white or black point adjustments is a more conservative approach to colorizing a grayscale image. It helps create an overall colorization that minimizes color shifts. If you've done split toning in the wet darkroom, and want to mimic that effect, try making level adjustments with the black point and/or white point.

The Black-Ink-Only Option

One work-around for grayscale printing is the black-ink-only option (BIO). If the image file is healthy, it's possible to make beautiful Hard Proof and finished prints using BIO.

There are several considerations, however. Because the print is composed of black ink only, the printer's dither pattern can be noticeable, particularly in the light gray areas of the image. This may not be a problem if the print is viewed at a normal dis-

tance. (Under a loupe, the dither pattern is easily seen.) For some viewers, the inkjet dither mimics the grain pattern in wet darkroom prints. For others, the droplets of black ink produce a coarseness that is objectionable. This is more noticeable with older inkjet printers having a larger droplet size, or if the image is made on a glossy paper (matte and textured papers will, to a degree, obscure the dither pattern).

Essentially, the BIO dot pattern is an aesthetic issue. If a BIO grayscale print looks and feels the way you want it to, the workflow is easy to master. You'll want to make sure that image files are processed on a calibrated and profiled display, use the Dot Gain technique outlined earlier, and learn to tailor output by constructing curves that correct for the OEM print driver's gamma bias.

BIO has the advantage of working with the OEM print driver, thereby avoiding the expense and complication of using a third-party RIP to drive the printer. BIO photographers often experiment with non-OEM black inks and papers until they find a combination that works best. This is an inviting way to venture off the OEM path.

BIO eliminates the color-shift issue associated with printing grayscale using color ink sets, but it does not eliminate color cast or metamerism. Instead, BIO tends to minimize these issues. You'll discover that specific combinations of black ink and paper result in prints that may or may not be neutral. I've found that printing BIO on an inexpensive Epson C-86 produces grayscale prints that are more neutral than those produced on the Epson 4000 (which, to my eye, produces a warmer "neutral" print). The difference is in the ink sets. The UltraChrome pigment black ink in the 4000, by itself, produces a warmer color cast than the ColorBrite pigment ink used by the C86.

The most serious limitation to printing BIO is that the full capability of the printer isn't being exploited. Since image information is literally the "stuff" that makes fine prints possible, other approaches have been developed to take full advantage of complete ink sets. We'll examine those options in the next chapter.

CHAPTER 10

Advanced Grayscale Printing

P rinting grayscale photographs off the OEM path is one of the most proactive areas in the digital darkroom. There are many options and printing paths to consider, ranging from simple "plug and play" solutions to involved approaches offering considerable control over grayscale printing. There are two organizing principle for this chapter: the printer doesn't change, but everything else is open to experimentation; and the combination of color management with reliable workflows makes this experimentation profitable.

We'll focus on the variables that, for many photographers, define grayscale printing off the OEM path: quadtone inks and RIP software. These are often combined, but there are several quadtone print solutions that work with the OEM print driver. If you elect to replace the OEM driver with a third-party RIP, there are several that support grayscale-only printing, and others that support both grayscale and color.

All the RIPs mentioned in this chapter install default printing profiles or curves that provide convenient, "out-of-the-box" printing solutions. They also support the authoring of custom printing profiles or curves, and we'll examine why, for some photographers, investing in the equipment to do this can be a good idea.

It should be emphasized that digital darkroom skill sets and workflows are inherently agnostic; they are not tied to one manufacturer or vendor. That said, grayscale printing off the OEM path includes many approaches and solutions supported by individuals and third-party companies. We'll examine how these options work and also compare them (often referring to specific products, manufacturers, vendors, and suppliers).

Introduction to Quadtone Printing

Printing quadtone begins by replacing the printer's OEM inks with a matched grayscale ink set that varies in density from black to light gray. Both dye- and pigment-based quadtone ink sets are available (see the Resource appendix for quadtone ink vendors). Typically, you can choose between purchasing inks in cartridges, which may be refillable, or using bulk ink with a CIS. You may want to experiment with cartridges first—it's time-consuming, more expensive, and relatively difficult to switch inks in a CIS.

If the printer has more than four ink channels (perhaps its a six-, seven-, or eight-ink machine), the printing path is still referred to as "quadtone." Depending on the approach or the vendor, the extra channels usually have duplicate inks or inks that contain a small amount of tint color.

Tinted inks can be used to modify the color cast of the print, usually ranging from a deep sepia or brown tone effect to a light selenium or colder tone. Extra ink channels also allow for non-ink coatings to be used. These coatings, especially when printing with pigment inks on glossy papers, provide a work-around to the bronzing issue (visit the MIS Associates Web site, *www.inksupply.com,* for more details).

Future developments with non-ink coatings, using extra channels in an inkjet printer, may open new possibilities beyond eliminating, or minimizing, the bronzing issue. Coatings can add a UV-protective layer to extend print life and also provide a welcomed measure of protection against surface scratching and abrasion. Eventually, this may lead to interesting aesthetic options similar to the varnish coatings used on offset presses to enhance photographic book reproduction.

A desktop printer must be dedicated to quadtone inks. Some photographers maintain two printers—one for color, another for quadtone. When converting a new printer to quadtone, it is a good idea to first install the OEM ink set, use the printer utilities to test the machine's mechanical performance, and make a set of test prints (see the tutorial, Testing an Inkjet Printer). If the printer performs properly, use cleaning carts to flush the OEM ink from the print head and then install the quadtone ink set. Cleaning carts can be ordered from the same vendors that sell quadtone inks. Follow the installation instructions carefully, as the procedure will vary by printer.

Clogging can be an issue when using third-party inks with some machines. The orifices of the printer head must remain clean for ink to flow properly. Clogging can be caused by ink viscosity, dust, minute flaking from paper, and from residual ink drying in the orifice. Third-party dye ink, which generally has lower viscosity, tends to clog less than pigment ink.

When changing inks, particularly from dye to pigment, be sure to use cleaning carts to flush the print head and keep the inks from commingling. It is also a good

idea to monitor the printer's performance by running the printer utilities nozzle check and using cleaning cycles when necessary. If you experience persistent clogging issues, contact the ink vendor for instructions and assistance.

Quadtone Ink and the OEM Print Driver

Quadtone printing solutions fall into two categories: those that use the OEM print-driver software, and those that work in combination with a third-party RIP. We'll examine the OEM solutions first. These are easy to implement and relatively inexpensive. We'll then turn our attention to RIPs, which range from shareware to feature-intensive commercial applications.

Similar to printing with black ink only (BIO), printing with quadtones minimizes undesirable color shifts and metamerism. Unlike BIO, printing with quadtones exploits a printer's full potential by using at least four inks instead of one. This improves tonal gradation and minimizes obvious ink dotting, which can be particularly noticeable in the lightest tonal areas of a print. Quadtone printing also allows a significantly larger choice of print color casts.

Many photographers use quadtone ink sets with the Curves printing path, an approach that has been extensively explored by Paul Roark (*www.paulroark.com*) and others. This technique uses a set of curves (which can be authored in Photoshop or any graphic editing application that supports curves) to translate grayscale image values into RGB values in Photoshop; these values are then sent to the OEM driver. To explore this printing path, you'll need to use curve sets produced by someone else or learn to build your own. Curves authored by Roark for MIS inks are available free from their Web site, *www.inksupply.com.*

GO TO···⟩Tutorial···⟩Using Curves, by Paul Roark

"EZ" PRINTING

A part of MIS Associates' UltraTone ink family, EZN (neutral) and EZW (warm) are pigment inks designed to be a "plug and play" quadtone printing solution. They do not require dedicated software. Image files, either grayscale or RGB, can be processed through Photoshop's Print with Preview panel to the OEM print driver when using these inks.

In addition to the neutral and warm inks (which can be mixed and matched to produce different print color casts) there are two black inks. Eboni black is designed for matte papers; Photo black is for glossy and semigloss papers. EZ inks can be switched by running a cleaning cycle or two to flush the printer head after switching carts (it isn't necessary to use cleaning carts between ink changes).

The disadvantage of EZ is the lack of print profiles and the limited number of printers supported (currently including the 8.5-inch Epson C80 series—82, 84, and 86—and the 13-inch 1280). The absence of print profiles eliminates Photoshop's soft proofing feature for previewing print density, contrast, and color cast. MIS provides tutorials on printing (including paper recommendations).

I recommend the Hard Proof printing path, outlined in chapter 6, for this ink set. Prints will show the print driver gamma bias, which can be addressed with the print driver controls or the Photoshop Dot Grain or Curve procedures outlined in chapters 6 and 8. This workflow can produce excellent prints and is a good introduction to quadtone printing.

PIEZOGRAPHY

The original PiezographyBW system, sold through InkjetMall (*www.inkjetmall. com*), combines proprietary software that works with the OEM print driver and a matched set of quadtone inks. The software installs as a Photoshop plug-in, rather than a stand-alone application. Image files are exported (File>Export) to the printer instead of using the Print with Preview or Print commands. The results, compared to the standard OEM print driver, are prints with increased resolution and a demonstrably more linearized tonal scale.

Unfortunately, these improvements have a tendency to reveal mechanical issues that may be hidden by the dither and gamma bias of the OEM print driver. On machines prone to it, banding can become glaringly obvious with the PiezographyBW software. Having a good machine, and keeping the head clean and aligned, is very important to maintaining high-quality output with this approach.

Currently, several versions of the Piezo plug-in for Apple and Windows computers and dedicated quadtone inks are sold on *www.BWGuys.com*. MIS also markets quadtone inks designed for this approach. It is likely that new RIPs using Photoshop's plug-in architecture will be available in the future.

InkjetMall has replaced PiezographyBW with PiezographyBW ICC, a grayscale printing solution using modified ICC profiles (we'll examine another grayscale ICC approach used by the ColorBurst RIP in a moment). The PiezographyBW ICC approach does not use a plug-in or RIP. Instead, proprietary profiles are purchased from InkjetMall and installed for the printer, PiezoTone ink set, and paper combination you wish to use. The advantage of PiezographyBW ICC is the ability to soft proof grayscale images as easily and accurately as RGB images. The workflow, which takes good advantage of the OEM print driver, is virtually identical to using ICC profiles with a color inkjet printer.

You don't need to purchase and master new software or learn how to build profiles or curves with PiezographyBW ICC. Currently, only Epson printers and PiezoTone inks are supported. Profiles must be purchased for each printing combination. InkjetMall's iQuad option is more expensive, but the authoring process incorporates linearization. Because InkjetMall's ICC profile authoring is proprietary, it is not possible to build and integrate your own ICC profiles.

Lastly InkjetMall has recently announced another option for quadtone printing, Piezography Neutral K7. This approach will expand the number of matched inks from the original four to seven (requiring the use of a seven-ink printer). Interestingly, K7 has been designed to work with the QuadTone RIP application, an inexpensive grayscale RIP that we'll examine in a moment.

Quadtone Printing and RIPs

The basic job of a RIP is to out-perform OEM print drivers. This can include the ability to work with alternative inks (including quadtone), printing profiles, or curves for non-OEM papers, vastly improved ink limiting, and the ability to use printer-linearization curves. Driving a printer with a RIP also changes the stochastic screening method (each RIP uses a proprietary formula for placing the minute droplets of ink on paper).

Among the currently available desktop RIP applications, several are specifically intended for grayscale-only printing, whereas others support both grayscale and color printing. Some RIPs use *print curves* to translate pixel information into droplets of ink. There are other RIPs that can use *print profiles* in addition to print curves. The main difference, however, is how printer linearization is achieved.

A linearized printer using an accurate print profile should be capable of maintaining a one-to-one relationship between image file input values and the output values that become ink on paper. It should replicate a 5-percent image density as a 5-percent ink density, for example. It should not demonstrate the gamma bias inherent in OEM print drivers.

Linearizing a printer requires the creation of a curve or look-up table (LUT) that adjusts image input values to the printer. This is most accurately done when ink limits can be set prior to the linearization. Profiles are then authored for the linearized machine. When an image file is processed through the RIP, both the profile instructions and the linearization file are used to translate image input values into droplets of ink.

Grayscale RIPs linearize the printing curves instead of the machine; the printing curves are edited to account for the printer's nonlinear state. The first two RIPs we'll examine, Quadtone RIP (QTR) and Bowhaus IJC/OPM, are grayscale print RIPs that install default print curves for quadtone and Epson's UltraChrome inks and include a method for linearizing those curves.

If UltraChrome inks are used with QTR or Bowhaus, the OEM print driver can be used to print color and the RIP to print grayscale. Using a grayscale print RIP with color inks, rather than quadtone inks, requires printing curves that are precisely authored to avoid the printing issues we've identified: uncontrolled color shifts, unpredictable color cast, and increased metamerism. Poorly authored curves can also contribute to contouring (especially when working with 8-bit files).

ImagePrint, ColorBurst, and StudioPrint are desktop RIPs patterned after, and in some cases adapted from, commercial prepress RIPs. They introduce the use of printing profiles in addition to curves. They print both color and grayscale using color inks (OEM or third party), or they can be used with quadtone inks for dedicated grayscale printing.

As we compare RIP software, let's distinguish between the basic *function* of a RIP—to transform the pixel information in an image file into droplets of ink—and workflow *features* that may be built into the application. We initially made this distinction in chapter 6 when discussing OEM print drivers. Because functionality and features are typically changed as new versions of applications are released, the version for each RIP will be indicated in the section heading.

QUADTONE RIP VERSION 2.1

QuadTone RIP is shareware and available for a modest $50 fee. Authored by Roy Harrington (*www.harrington.com*), QTR is currently available for Apple's Mac OS 9/X and PC Windows XP. QTR incorporates the freeware GNU Ghostscript

FIGURE **10.1** The QuadTone RIP control panel with default settings.

FIGURE 10.2 Using QRT begins by selecting a printer and QuadTone RIP from the Copies & Pages menu. Printing curves are selected (and blended if desired), resolution is set (1440 is recommended), and the job is sent to the printer.

for CUPS print-driver software, which allows the RIP to work in concert with the OEM print-driver controls. Follow the installation instructions carefully. If you are using an Apple computer, consider upgrading the operating system to at least Mac OS 10.3 to take advantage of the unified installation package.

Unlike most RIPs, QTR is not a stand-alone application. It is accessed through Photoshop's Print with Preview or Print commands. This allows QTR to process image files through the Print panel of any software that supports graphic files, including Microsoft Word and Adobe InDesign.

In the Print panel, select the appropriate printer and QuadTone RIP in the Copies & Pages menu. The QTR panel is well organized and easily navigated. You'll notice two Curve menus. QTR incorporates a blending feature that allows two printing curves, with different color casts, to be mixed (we'll see other examples of this in the Bowhaus and ImagePrint RIPs).

When using an Epson 4000, an additional Black Ink menu will appear above the Resolution menu, allowing a choice between Epson's Matte Black and Photo Black inks. The default printing curves are authored for 1440 dpi. The Ink Limit and Gamma Adjustment menus are useful for altering the density and contrast of a print. Ink limiting restricts the flow of ink in all channels; the effect is progressively lighter or darker prints (similar in effect to adding or subtract exposure to a print in the wet darkroom). Ink Limit is an enhanced version of the ink limiting controls

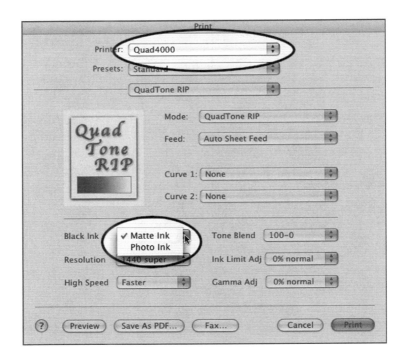

found in some OEM print drivers (see chapter 6 for details on OEM ink limiting).

The Gamma Adjustment affects the overall contrast of the print (similar in effect to changing paper grades or printing filters in the wet darkroom; or when making a gamma adjustment in Photoshop Levels or Curves). Ink Limit and Gamma Adjustment can be used to tailor an existing print curve for another paper with similar characteristics (avoiding the need to author a new curve). Combinations can be saved through the Presets menu.

The Print panel does not have a live preview of the applied curve, blended curves, or any adjustments made with Ink Limit or Gamma Adjustment. As when using the OEM print driver adjustments, you must print and adjust to determine the best settings. It may require several iterations to find preferred combinations.

Photoshop's Print with Preview panel provides an easy workflow to Hard Proof the choices made in the QuadTone RIP panel. Navigate to Print with Preview and click the Page Setup button. Select a paper size for the Hard Proof stock and the correct orientation. Click OK to return to Print with Preview. In the Scaled Print Size sub-panel, click the Scale to Fit Media button. Click Print to return to the Print panel and QuadTone RIP.

You can make as many QRT Hard Proofs as necessary without altering the original image file. Save the combinations through Presets and click the Cancel button instead of Print in the bottom

QTR provides a method for building and linearizing curves, but the procedure, particularly for a novice or a photographer not interested in a "nuts and bolts" approach, may be unfortunately opaque. There are several steps and the documentation is fragmented. Lastly, technical support is informal. Roy Harrington graciously provides an e-mail address (roy@harrington.com) for questions, and he is a generous contributor to DigitalBlackandWhiteThePrint@yahoogroups.com (an excellent source of information). Because QTR is built on open source code, and encourages experimentation, the application constantly evolves. The Yahoo group is the best way to stay informed.

BOWHAUS IJC/OPM VERSION 1.2.2

Bowhaus IJC/OPM (*www.bowhaus.com*), like QTR, is built on the Gimp-Print open source print driver. It is two stand-alone applications that work together, Ink Jet Control (IJC) and Open Print Maker (OPM). You do not access IJC/OPM through Photoshop's Print with Preview. Instead, you'll open the image file in OPM.

OPM is the RIP, used to send image files to the printer. IJC is used to modify default print curves, build custom printing curves for inks and papers not included, and linearize curves. The supplied curves include ones for Lyson, MIS, and Epson UltraChrome inks on a range of papers.

The Lyson Daylight Darkroom kit includes IJC (repackaged as Profile Creator) and OPM (Print Pro applications). The kit includes the RIP, Lyson Digital Darkroom quadtone dye inks in cartridges or in bulk with an included CIS, and a set of cleaning cartridges. The printing curves are built for the Daylight Darkroom inks supplied with the kit and Lyson papers. To use the Lyson inks with alternative papers, new curves must be created with Profile Creator (IJC).

The OPM interface, like QTR, is a model of simplicity. When launched, a printer selection panel appears. Choose a printer and click OK. The main panel includes a preview area and sub-panels. Color and grayscale image files can be opened (File>Open Image) or "dragged and dropped" into the preview area.

When printing a color image file through OPM you cannot exercise any control over the conversion of color information to grayscale. However, the ability to drag and drop RGB files into OPM makes Hard Proofing color images through OPM easy and convenient.

FIGURE 10.4 When Bowhaus OPM is launched, you will be asked to select a connected printer before the main Control panel appears.

The Size and Position sub-panel includes a Paper Size menu and controls for orientation, scaling, and centering the image. There is also a Fit To Page option that works well for Hard Proofing. The Position options are especially convenient for controlling print margins. OPM is completely independent of the OEM print driver; the default printing margins that produce off-centered prints when using the OEM driver are eliminated.

As with QTR, OPM includes the option of blending two print curves. Blender can be used when pulling Hard Proofs, by the way, with either grayscale or color image

FIGURE 10.5 Clicking the Edit button in OPM will launch Inkjet Control (IJC), which is composed of two panels. Ink Tweaks includes a well-designed visual interface that shows which channels, and how much ink, are being used by the printing curve selected in OPM. The Linearization panel allows densitometric data to be used to modify printing curves of a specific printer.

PHOTOGRAPHER'S GUIDE TO THE DIGITAL DARKROOM

files. The Edit button links OPM to the Inkjet Control application used to build and linearize curves. IJC's visual interface significantly improves the process of linearization and of authoring and/or editing print curves. The current documentation for using IJC is cloudy; however, Bowhaus has posted helpful tutorials at *www.bowhaus. com/contributors/contributor.htm*. Check this link periodically for updates.

The Print Gamma, Exposure, and Contrast sliders work similarly to the OEM print driver controls but with a live preview. This is a significant time-saver for pulling Hard Proofs. The last sub-panel includes the Print and Exit buttons, and a Quality/Speed adjustment. Select Quality for fine printing; Speed is useful when Hard Proofing.

IMAGEPRINT RIP VERSION 6

ImagePrint RIP, produced by ColorByte Software, is a stand-alone application that installs a large number of default ICC color profiles and non-ICC grayscale profiles (called "recipes") for Epson's UltraChrome ink. There are profiles for prints viewed under different light sources (a metamerism work-around). Color-Byte maintains a Web-based profile repository from which additional profiles can be downloaded. The purchase of an ImagePrint license, or extended service agreement, includes a time-limited profiling service.

FIGURE 10.6 The ImagePrint application interface.

FIGURE 10.7 ImagePrint Templates panel, a useful feature for studios providing picture packages to clients.

ImagePrint is an unusually "feature rich" application and the interface is well organized. There are options for printing multiples or gang printing separate image files concurrently. Photographers doing volume printing or editions will find these features useful. A Templates feature provides an automated printing path for pictures packages (multiple prints of different sizes), which can be advantageous for portrait or special event photographers.

ImagePrint can independently process image files in a ganged print, allowing files tagged with different profiles to be printed on the same sheet. It is also possible to print a profiled grayscale image containing image areas that are tagged with a color profile (the Colorize BW feature).

Of special interest to black/white photographers, the Tint Picker is designed to work with Epson's UltraChrome inks. Similar in effect to the curves-blending feature found in QRT and Bowhaus OPM, the Tint control adjusts print color cast with a live preview.

FIGURE 10.8 The ImagePrint Tint Picker works like the QTR and Bowhaus curve-blending controls to produce toned grayscale prints.

ImagePrint users will find the new Epson 4800's Advanced Black & White Photo very similar in function to the Tint Picker.

ImagePrint does not incorporate a provision for linearizing the printer. This exclusion makes the application relatively easy to learn and convenient to use. However, the default color profiles and grayscale recipes are not, by definition, linearized for your printer. You must balance convenience against the level of control you wish to exercise over the printing process.

ImagePrint does have an ink-limiting option (Correction>Color>Ink Limit), but using Ink Limit involves authoring a new profile (after ink limits are set) or invalidating a default profile (the ink-limited profile can be used to print, but it will no longer be as accurate for soft proofing).

ImagePrint installs an extensive and easily read PDF manual, and offers an excellent Web-based tutorial. Photographers new to RIPs will find these resources especially useful.

COLORBURST VERSION 3.8.1

ColorBurst, like ImagePrint, is a stand-alone RIP application. The default ICC profiles are built for printing color and grayscale with Epson Ultrachrome inks. It can be used with OEM or alternative inks by authoring or having custom profiles made.

ColorBurst is available in two versions, XPhoto and XProof. Both are PostScript enabled to allow printing with full text and graphic support (if you want to pro-

FIGURE 10.9 The ColorBurst interface.

duce prints with text or artist books, for example). The XProof version includes the Pantone Color Library (for design projects or prepress proofing).

A "lite" version of ColorBurst is currently sold as an option with the Epson 4000 printer. It can be used as a stand-alone application or accessed through Photoshop's Print with Preview, simplifying the printing path. Follow the set-up directions carefully and configure the printing path outlined in the documentation.

Unlike ImagePrint, which uses a proprietary "recipe" to build grayscale profiles, ColorBurst supplies modified ICC profiles for grayscale printing. ColorBurst does not use printing curves or recipes. This allows the full use of Photoshop's softproofing features. Compared to ImagePrint, ColorBurst does not have a comparable range of workflow features; instead, it provides an elegant and professional level of access to all the factors controlling how each ink channel of the printer behaves.

One example is the Environment feature ColorBurst uses to group a linearization file with a printing profile. When an Environment is loaded in the RIP, both

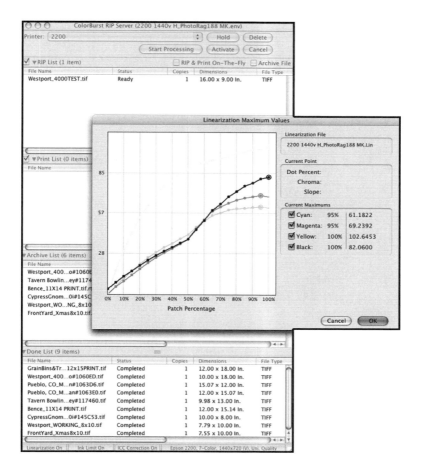

Figure contents:

ColorBurst RIP Server (2200 1440v H_PhotoRag188 MK.env)

Printer: 2200 — Hold — Delete

Start Processing — Activate — Cancel

RIP List (1 item) RIP & Print On-The-Fly Archive File

File Name	Status	Copies	Dimensions	File Type
Westport_4000TEST.tif	Ready	1	16.00 x 9.00 In.	TIFF

Linearization Maximum Values

Linearization File
2200 1440v H_PhotoRag188 MK.Lin

Current Point
Dot Percent:
Chroma:
Slope:

Current Maximums
Cyan:	95%	61.1822
Magenta:	95%	69.2392
Yellow:	100%	102.6453
Black:	100%	82.0600

Print List (0 items)
File Name

Patch Percentage (0% 10% 20% 30% 40% 50% 60% 70% 80% 90% 100%)

Cancel — OK

Archive List (6 items)
File Name
Westport_400...o#1060E
Tavern Bowlin...ey#1174
Bence_11X14 PRINT.tif.r
CypressGnom...0i#145C
Westport_WO...NG_8x10
FrontYard_Xmas8x10.tif

Done List (9 items)

File Name	Status	Copies	Dimensions	File Type
GrainBins&Tr...12x1SPRINT.tif	Completed	1	12.00 x 18.00 In.	TIFF
Westport_400...o#1060ED.tif	Completed	1	10.00 x 18.00 In.	TIFF
Pueblo, CO_M...n#1063D6.tif	Completed	1	15.07 x 12.00 In.	TIFF
Pueblo, CO_M...an#1063E0.tif	Completed	1	12.00 x 15.07 In.	TIFF
Tavern Bowlin...ey#117460.tif	Completed	1	9.98 x 13.00 In.	TIFF
Bence_11X14 PRINT.tif	Completed	1	12.00 x 15.14 In.	TIFF
CypressGnom...0i#145C53.tif	Completed	1	10.00 x 8.00 In.	TIFF
Westport_WORKING_8x10.tif	Completed	1	7.79 x 10.00 In.	TIFF
FrontYard_Xmas8x10.tif	Completed	1	7.55 x 10.00 In.	TIFF

Linearization On | Ink Limit On | ICC Correction On | Epson 2200, 7-Color, 1440x720 (V), Uni, Quality

FIGURE 10.10 ColorBurst incorporates the ability to re-linearized a printer at any time. The linearization file is grouped into an Environment with the appropriate print profile.

files are used to guarantee the best possible match between the on-screen image and print. With ColorBurst the printer can be relinearized at any time. The new linearization file is simply grouped with the profile in the Environment. This design provides a high level of control over an inkjet printer, an approach also used by StudioPrint.

STUDIOPRINT VERSION 11.0.4.2

Like ColorBurst, StudioPrint allows full control over all the variables that contribute to print quality. It is only available for Windows computers (check availability for your Windows operating system at *www.ergosoft.com*).

StudioPrint can be used with a wide range of inkjet printers, from desktop machines to medium- and large-format printers used in professional print shops and labs. This includes Encad, Hewlett Packard, Mimaki, Roland, and others. You can install default print profiles for Epson UltraChrome inks, but the versatility of

FIGURE 10.11 The StudioPrint application interface.

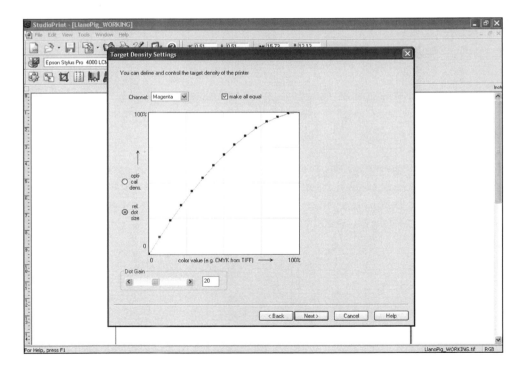

FIGURE 10.12 StudioPrint provides a complete compliment of controls for all variables in inkjet printing including ink limiting, linearization, and working with custom print profiles and curves.

this application extends to working with many printer/ink/paper combinations.

The on-board calibration features include ink limiting, linearization of the printer for working with print profiles, and building accurate printing curves for quadtone ink sets. This will allow as many quadtone inks to be loaded as there are available channels in the printer. With an Epson 7600, for example, it is possible to load InkjetMall's Carbon Sepia and Selenium ink sets, or MIS UltraTone inks, and author linearized print curves for any combination of ink channels.

Like ImagePrint, StudioPrint also incorporates a number of productivity features, including a professional set of layout tools (position, crop, scale, and tiling, for example). StudioPrint does not include templates for picture packages.

Taking Control

MIS EZ, the Roark curves print path (which can be adapted to any quadtone ink set), and PiezographyBW ICC are quadtone print solutions that work with the printer's OEM driver. A printer must be dedicated to quadtone inks, but with EZ and PiezographyBW there are no additional software applications to learn. This is also true of the Roark curves print path, provided curves authored by others are used (or you author them by eye). To do a proper job of building print curves, however, either a densitometer or spectrophotometer (and software) are needed.

EZ and Roark's print curves are less expensive to implement than PiezographyBW ICC, which requires purchasing ICC profiles in addition to ink. (However, using ICC print profiles on a calibrated and profiled display may result in incremental ink and paper savings over the life of the printer.)

The main advantage to these three solutions is relative simplicity. Easy implementation allows you to concentrate on learning skill sets, including Photoshop, while producing high-quality grayscale prints.

To exercise more control, you'll want to consider replacing the OEM driver with a RIP. When comparing RIPs it is useful to consider their performance on two levels: what can be accomplished with the default profiles or curves included in the installation package and what is required to author custom curves/profiles or perform printer linearization.

QTR and Bowhaus are grayscale print RIPs designed to work with either Epson UltraChrome or quadtone inks. They are relatively inexpensive to implement, and their default grayscale print quality can be a substantial improvement over the OEM driver's grayscale. They also incorporate methods for adapting default printing curves, authoring new curves, and linearizing curves (though they vary in how these are done).

This level of control does require time and attention, however. You'll need to learn more than just the application interface, and a densitometer or spectrophotometer is needed to do a proper job.

RIPs like ImagePrint, ColorBurst, and StudioPrint are the next step when you desire more control or workflow features. More expensive than grayscale RIPs, these applications share a common characteristic: they can produce excellent color and grayscale prints from color ink sets. This is a considerable advantage for many photographers. Increased productivity can quickly offset the higher initial cost.

With the current technology, print workflows that incorporate ink limiting, linearization, and the authoring of custom print profiles provide the highest level of control in the digital darkroom. These workflows require not only a RIP, but also additional hardware/software to author linearization curves and printing profiles. You'll need to learn skill sets for each piece of the puzzle added to the picture.

Alternatively, you can elect to use the OEM print driver, with or without OEM ink or papers, and explore other methods for exercising control over printing. You have a degree of control over ink limits, for example, through the choices available in the Media Type menu and, perhaps, through the various OEM print-driver panels available for the printer. Lastly, the non-linear performance of the OEM driver can be partially corrected by careful image edits in Photoshop. Despite inherent limitations, these options, used intelligently, can produce excellent prints.

Ultimately, the control you'll need is dictated by the prints you wish to make. This has been true since the birth of photography. Each successive technology presents challenges and rewards, and it is the photographer's privilege to determine what is necessary and valuable.

FIGURE 10.13 Nicephore Niépce, *View from his Window at Le Gras.* ca. 1827. Heliograph. Gernsheim Collection, Humanities Research Center, University of Texas, Austin.

As inkjet technology continues to advance, working in the digital darkroom will become increasingly transparent, and skill sets will become increasingly easy to master. Photographers will innovate techniques and create workflows, looking for solutions and methods to exploit the technology's creative potential.

Using the public forums available through the Internet, and applications like PDF and QuickTime to make information portable, photographers can share their knowledge, opinions, and images. As the Internet accelerates the development of the digital darkroom, it is interesting to note its role in the unprecedented revival of "alternative processes," including those used by artists since the birth of photography: the daguerreotype, tintype, salted prints, cyanotype, and many more. The digital darkroom is yet another alternative for photographers seeking an appropriate technique to give voice to their aesthetic ambitions.

It would seem the distant, almost imaginary horizon seen from Niépce's window in 1827 is ultimately less a document about place, and more an invitation to the journey (as all good photographs are).

Comparison Chart for Grayscale Printing Solutions

Prepared by Scott Martin, *www.on-sight.com*

Pros	Cons	Cost	Options
Workflow: OEM print driver with OEM ink and paper			
• Easy to learn. • Smooth dot pattern and tonal gradations.	• Uses all ink, leading to metamerism issues.	• No additional costs unless custom profiles are purchased or self-authored.	• Vast. Any inkjet printer can be used. • Photo inkjets recommended over office inkjets.
Workflow: OEM print driver using black ink only (BIO)			
• Easy to learn. • Fewer color-related issues. • Can be a good "aesthetic fit" for your work.	• Obvious dot pattern (will vary by printer). • Tonal gradation less smooth. • Less ability to resolve fine image detail.	• No additional costs.	• See above. • BIO well suited to third-party black inks and papers. • Photo inkjets recommended over office inkjets.

Pros	Cons	Cost	Options

Workflow: OEM print driver with quadtone inks

Pros	Cons	Cost	Options
• Extremely smooth dot pattern and tonal gradation. • Consistent print color cast. • Metamerism less than with OEM ink.	• Dedicated printer required. • Concern for same ink availability over the long term. • More clogging issues than OEM. • Less flexibility for modifying print color cast.	• Moderate to high. • CIS may be desirable. • Calibration and profiling kit if self-authoring custom print profiles.	• See Resource appendix for a listing of quadtone ink vendors.

Workflow: Grayscale RIP with quadtone inks

Pros	Cons	Cost	Options
• Extremely smooth dot pattern and tonal gradation. • Consistent print color casts.	• Dedicated printer required. • RIP must be purchased and learning curve mastered. • More clogging issues than OEM. • Generally poor documentation.	• Moderate to high. • CIS may be desirable. • Calibration and profiling kit if self-authoring custom print profiles.	• QTR and Bowhaus. • See Resource appendix for quadtone ink and RIP vendors.

Workflow: Professional RIP with quadtone inks

Pros	Cons	Cost	Options
• Excellent dot pattern. • Excellent tonal gradation. • Ease of use and learning curve (documentation better than grayscale RIPs). • Workflow features.	• Dedicated printer required. • Concern for same ink availability over the long term. • More clogging issues than OEM. • Less flexibility for modifying print color cast.	• High by comparison. RIP cost an issue with small printers. • CIS may be desirable. • Calibration and profiling kit if self-authoring custom print profiles.	• ImagePrint, StudioPrint, ColorBurst.

Pros	Cons	Cost	Options
Workflow: Professional RIP with OEM inks			
• Easy to use. • Excellent dot pattern. • Excellent tonal gradation.	• Print color cast can vary by print. • Color and grayscale from same printer/ink. • Clogging issues reduced.	• RIP must be purchased and learning curve mastered. • Moderate. RIP cost will vary by printer size and PostScript capability. • CIS may be desirable.	• Calibration and profiling kit if self-authoring custom print profiles. • ImagePrint, StudioPrint, ColorBurst.

APPENDIX: RESOURCES

Alternative and Hybrid Processes

- *www.bostick-sullivan.com*
- *www.photoformulary.com*
- *www.danburkholder.com*
- *Making Digital Negatives for Contact Printing*, by Dan Burkholder (Bladed Iris Press, 1999)
- *www.precisiondigitalnegatives.com* (eBook by Mark Nelson)
- *The Book of Alternative Process*, by Christopher James (Thomson Delmar Learning, 2001)
- *Coming into Focus: A Step-by-Step Guide to Alternative Photographic Printing Processes*, edited by John Barnier (Chronicle Books, 2000)

Color Management

- *Understanding Color Management*, by Abhay Sharma (Thomson Delmar Learning, 2003)
- *Real World Color Management*, by Bruce Fraser, et al. (Peachpit Press, 2004)
- *Color Management for Photographers: Hands on Techniques for Photoshop Users*, by Andrew Rodney (Focal Press, 2005)

Consulting

- Andrew Rodney (*www.digitaldog.net*)
- Jim Rich (*www.ecolortools.com*)
- Graphic Intelligence Agency (*www.gia.com*)
- Scott Martin (*www.on-sight.com*)

Digital Cameras

- *www.dpreview.com*—This site contains detailed equipment reviews and an excellent set of short tutorials by Vincent Bockeart
- *www.123di.com*
- *www.luminous-landscape.com*
- *www.smartshooter.com* (Will Crocket)
- *Real World Camera Raw with Adobe Photoshop CS2*, by Bruce Fraser (Peachpit Press, 2005)
- *www.dcresource.com*

Film, Print, and Removable Media Storage and Archiving Supplies

- *www.lightimpressionsdirect.com*
- *www.calumetphoto.com*
- *www.bhphoto.com*

Film-Based Photography

- *The Zone VI Manual*, by Fred Picker (Amphoto Books, 1974)
- *The Camera*, by Ansel Adams (Bulfinch, 1995)
- *The Negative*, by Ansel Adams (Bulfinch, 1995)
- *The Print*, by Ansel Adams (Bulfinch, 1995)
- *Polaroid Land Photography* (out of print), by Ansel Adams (Morgan & Morgan, 1963)
- *Beyond Basic Photography*, by Henry Horenstein (Little, Brown, 1977)
- *The Elements of Black and White Printing*, second edition, by Carson Graves (Focal Press, 2001)
- *The Zone System for 35mm Photographers*, second edition, by Carson Graves (Focal Press, 1996)

Fine Art Printing Services

- *www.westcoastimaging.com*
- *www.coneeditions.com*
- *www.dugal.com*
- *www.nasheditions.com*
- *www.blackpointeditions.com*
- *www.k2press.com*
- *www.custom-digital.com*
- *http://deanimaging.com*

OEM and Non-OEM Inks

- *www.inkjetmall.com* (Cone Editions)
- *www.inksupply.com* (MIS)
- *www.inkjetgoodies.com*
- *www.lyson.com*
- *www.inkjetart.com*
- *www.mediastreet.com*
- www.atlex.com

Non-OEM Papers and other Media

- *www.inkjetmall.com*
- *www.inksupply.com* (MIS)
- *www.inkjetgoodies.com*
- *www.shadesofpaper.com*
- *www.lyson.com*
- *www.atlex.com*
- *www.pictorico.com*
- *www.normankoren.com*
- *www.digitalartsupplies.com*

Perception and Color Theory

- *www.cie.co.at/cie/*—Homepage for the International Commission on Illumination.
- *www.color.org*—Homepage for the International Color Consortium
- *http://dpfwiw.com/*

- *Vision and Art: The Biology of Seeing*, by Margaret Livingstone (Harry N. Abrams, 2002)

Photoshop Technique

- *www.digitaldog.net* (Andrew Rodney)
- *www.russellbrown.com* (Russell Brown)
- *The Photoshop CS2 Book for Digital Photographers*, by Scott Kelby (New Riders Press, 2005)
- *Going Digital, The Practice and Vision of Digital Artists*, by Joseph Nalven and J.D. Jarvis (Course Technology PTR, 2005)
- *Photoshop CS2 Workflow, The Digital Photographer's Guide*, by Tim Grey (Sybex, 2005)
- *www.tinytutorials.com* (Dan Burkholder)

Printing Profiles (free)

Note: There are now many Internet sites that offer free printing profiles. Check the sites for the papers, printers, and inks you wish to use.

- *www.inkjetart.com*
- *www.crane.com/museo*
- *www.epson.com*

Printer Hardware

- *www.Epson.com*
- *www.Canon.com*
- *www.HewlettPackard.com*

Printer Software (RIPs)

- *www.colorbytesoftware.com* (ImagePrint)
- *www.colorburstrip.com* (ColorBurst)
- *www.ergosoftus.com/studioprint* (StudioPrint)
- *www.bowhaus.com* (IJC/OPM)
- *http://harrington.com/QuadToneRIP.html* and *www.quadtonerip.com* (Quad-Tone)

Scanner Hardware

- *www.Epson.com*
- *www.Canon.com*
- *www.HewlettPackard.com*
- *www.Microtek.com*
- *www.Imacon.com*
- *www.umax.com*

Scanning Services

- *www.nancyscans.com*
- *www.westcoastimaging.com*
- *www.coneeditions.com*

Scanning Software and Supplies

- *www.hamrick.com*—Information on VueScan
- *www.silverfast.com*—Information on Silverfast
- *www.aztek.com* (Kami scanning fluid)
- *www.stouffer.net*
- *www.darkroom-innovations.com*
- *www.photoformulary.com*

Self -Publishing

- *Digital Book Design and Publishing*, Douglas Holleley
- *www.adobe.com/epaper/ebooks/ebookmall/main.html*
- *www.apple.com/au/quicktime/mac.html*
- *www my100books.com*
- *www.fastbackbooks.com*
- *www.asukabook.com*
- *www.mypublisher.com*
- *www.apple.com/ilife/iphoto/books/prices.html*

Wet Darkroom Practice

- *The Print,* by Ansel Adams (Bulfinch, 1995)
- *Examples: The Making of 40 Photographs,* by Ansel Adams (Bulfinch, 1989)
- *Beyond the Zone System,* by Phil Davis (Focal Press, 1998)
- *The Elements of Black-and-White Printing,* by Carson Graves (Focal Press, 2001)
- *Zone System for 35mm Photographers,* by Carson Graves (Focal Press, 1996)

Workshops and Training

- The Santa Fe Workshops (*www.santafeworkshops.com*)
- The Maine Photographic Workshops (*www.mpw.com*)
- The Palm Beach Workshops (*www.palmbeachworkshops.com*)
- Anderson Ranch (*www.andersonranch.com*)
- Software Cinema (*www.softwarecinema.com*)
- Graphic Intelligence Agency (*www.gia.com*)
- Cone Editions (*www.coneeditions.com* or *www.inkjetmall.com*)
- *www.d-65.com/workshops.html*
- *www.k2press.com*

APPENDIX: THE JONES PLOT

by Robert Zolla, Eastman Kodak Company

Making a photograph is all about controlling light. Whether the process is the conventional silver-halide system in a darkroom, an entirely digital system, or a hybrid of the two, the fundamental principals of controlling light are the same.

Objects in a scene reflect light toward our eyes and our cameras. Through the aperture and the shutter, the camera and lens control the amount of light that reaches a recording medium (film or an electronic sensor). Information recorded is somehow used to generate a finished photograph. That photograph, in turn, controls how light is reflected from a source of illumination back to our eyes. It is this reflected light that our brain interprets as a representation of the original scene. The relationship between the reflected light from the original scene and the reflected light from the photograph determines the look or "tone scale" of the photograph.

Depending upon the photographic system, various functions within the system contribute to the photograph's tone scale. How these functions interact can be complex, but a graphical tool can help us understand these interactions. That tool is called a Jones Plot.

The Jones Plot is a four-quadrant graph that shows us the characteristics of the subsystems within our photographic system and how they affect each other. This tool is a very powerful one, for we can use it to determine how our photographic system will respond. If we know the behavior of the capture medium, any intermediate processes and the print medium, we can use the Jones Plot to determine the tone scale of our photographic system. This knowledge can come from sources such as manufacturers' data sheets and specifications, or we can empirically mea-

sure it for our particular media. It can explain why (or more importantly, why not) our system gives us good-looking prints. If the results are not to our liking, it can help us to determine where the problem lies and suggest how we might correct it. First, we'll look at a Jones Plot one quadrant at a time for a traditional silver-halide black-and-white system. Then, we'll see how we can use the Jones Plot to understand fully digital and hybrid systems.

The Silver-Halide System

Figure A1 is a Jones Plot for a typical black-and-white silver-halide photograph. It contains four quadrants, each representing a fundamental step, or phase, of a photographic system. Quadrant I shows the relationship between scene brightness and exposure; quadrant II is the characteristic curve (DlogE plot) of a typical negative film; quadrant III is the characteristic curve of a typical enlarging paper; and quadrant IV shows the relationship between the original scene brightness values and the densities of the final print.

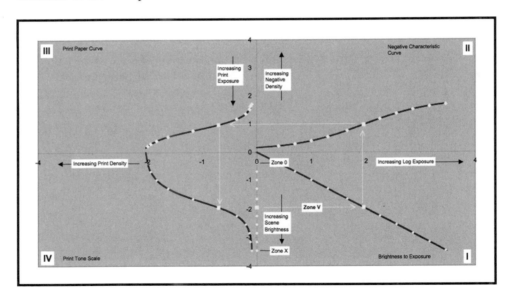

FIGURE A1 The Jones Plot for a typical B/W silver-halide system

The plot in quadrant IV is often referred to as the print tone scale, and this is what we're after. Our objective is to determine how the system will reproduce the scene we want to capture. Let's look at each quadrant in turn, and then look at how an image maps through the total system.

Quadrant I – Scene Brightness to Exposure

Quadrant I of the Jones Plot shows the relationship between the brightness in various parts of a scene and the logarithm of the exposure that they would produce on the negative film. For clarity, Figure A2 highlights this quadrant.

The input to our photographic system is scene brightness. This is shown on the Y-axis in zones from Zone 0 through Zone X. Each zone change represents a one-stop change in exposure, or a doubling or halving of exposure depending upon the direction of change. The X-axis is the logarithm of the exposure. Since the logarithm of 2 is 0.3, each Zone step along the Y-axis produces a change in log exposure of 0.3 along the X-axis. This linear relationship produces the straight line shown in quadrant I with a slope of 0.3 log E per Zone (or 0.3 log E per stop).

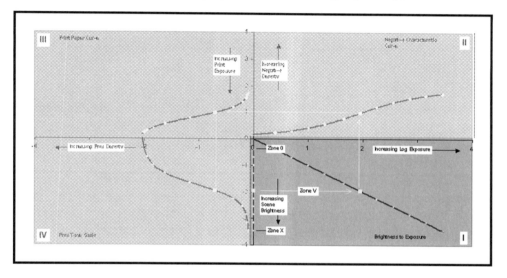

FIGURE A2 **Quadrant I.**

Quadrant II – The Negative Characteristic Curve

Quadrant II shows the resulting negative density as a function of the logarithm of exposure. For clarity, Figure A3 highlights this quadrant. This is the familiar DlogE curve for film. The shape of this curve varies significantly depending upon the emulsion formulation and the development process.

Good photographers know the importance of careful developer selection, formulation, temperature control, agitation, and timing in processing negatives, as each of these factors directly impacts the shape of the film curve. The input to the film is the logarithm of exposure and is shown along the X-axis. The output of the film, shown along the Y-axis, are the densities that result from the exposures it receives in the camera.

These densities are measured with an instrument called a densitometer and are a convenient way of representing how much light can pass through the negative when we print it. We will look more closely at density in a moment, but for now, it is sufficient to know that increasing density blocks more light. Notice that the resulting curve is not at all linear. Only the middle portion of the curve is straight. It has decidedly curved lower and upper portions, referred to as the toe and shoulder, respectively.

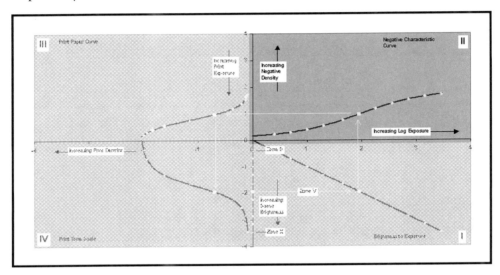

FIGURE A3 Quadrant II.

Quadrant III – The Paper Characteristic Curve

In Quadrant III we see the characteristic curve of a typical grade 2 photographic paper. For clarity, Figure A4 highlights this quadrant. Though less familiar to some, this curve for the paper is analogous to the DlogE curve for a film. It shows the relationship between the logarithm of the exposure it receives in printing and the resulting reflection density produced in development.

Again, we'll look more closely at reflection density in a minute, but for now, it is sufficient to know that large reflection densities reflect less light to our eye (are darker) than small densities. The input to the paper is the logarithm of exposure and is plotted along the Y-axis.

Notice that in this quadrant, *increasing exposure* is plotted as going *toward* the X-axis instead of away from it. The reason for this will become apparent soon, but for now, just remember the direction is opposite from what we're accustomed to. The output of the paper is its reflection density and is plotted along the X-axis. Again, this curve is nonlinear. Notice too that the slope of the straight-line portion of the paper curve is very steep compared to that of the negative.

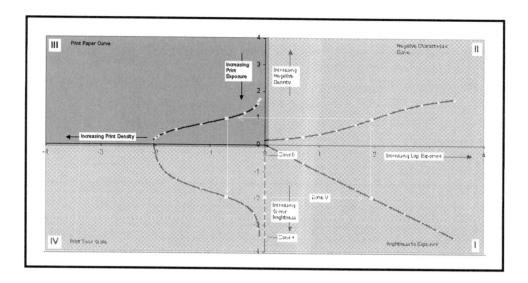

FIGURE A4 Quadrant III.

Quadrant IV – The Print Tone Scale

Quadrant IV shows us the relationship between the brightness values of the original scene and the corresponding densities in the finished photographic print. This is the tone scale of our complete photographic system and this is what we're after. As before, Figure A5 highlights this quadrant. The brightness values of the scene or Zones are shown along the Y-axis and the corresponding print densities are shown along the X-axis.

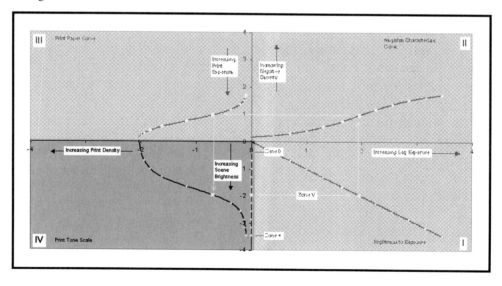

FIGURE A5 Quadrant IV.

The final print does not reproduce the scene in a linear fashion. It is the *shape* of this curve that determines the *look* of our print. And, it is the shape of curves of each component in our system—that is, in quadrants I, II, and III—that determines the shape of the curve in quadrant IV. Changing any one or all of these curves modifies how our system reproduces the scene we're trying to capture and reproduce.

Now, let's look at how each piece of the system contributes to the image tone scale by mapping, through the Jones Plot, a scene we want to photograph to the finished print.

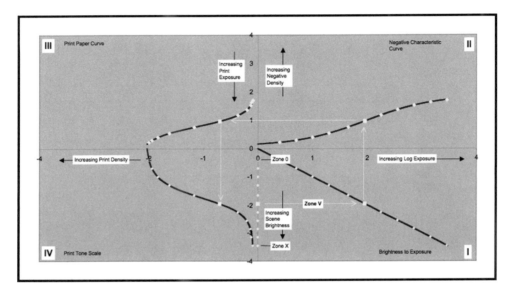

FIGURE A6

In Figure A6, we see points on the Y-axis representing the brightness of all of the zones from Zone 0 through Zone X in a scene that we want to photograph. We'll map a point in our hypothetical scene through our photographic system that we want to place at Zone V in our print.

The same procedure can be applied to any point, but for the sake of simplicity we'll only look at Zone V. This point is located on the Y-axis of Quadrant I. By drawing a horizontal line through the Zone V point, we find that the line intersects the line in Quadrant I relating scene brightness to the logarithm of exposure. Next we draw a vertical line through this intersection point. Where the vertical line crosses the X-axis tells us the logarithm of the exposure that the film will receive. This vertical line also intersects the negative characteristic curve in Quadrant II.

If we now draw a horizontal line through the point of intersection on the negative characteristic curve, where it intersects the Y-axis tells us what density the negative will have. What we've just done is determine the negative's density for a properly exposed Zone V tone. Notice that as we cross over from Quadrant II to

Quadrant III of the Jones Plot, the Y-axis now represents print exposure. Notice, too, that the direction of increasing print exposure is opposite that of increasing negative density.

Let's take a moment to see why this is so. When we print a negative, we place it between a light source and the print paper. This is true whether we're making an enlargement or a contact print. The negative *modulates* the printing light, varying the paper's exposure on a point-by-point basis inversely proportional to the negative's density. Areas of low density on the negative produce areas of high exposure on the print paper, and vice versa. Even more important is that the relationship between the film density and the print exposure is logarithmic.

Density is defined as the logarithm of one divided by the transmission of the film. A transmission of 1 means that 100% of the light incident onto the file will pass through it. A transmission of .01 means that only 1% of the incident light will pass through the film, and so forth.

Mathematically, this can be written as:

(1) $D = Log \, 1/T$ where: D = density T = transmission

Likewise, due to the nature of logarithms, we can rewrite this equation as:

(2) $D = -LogT$

Pay particular attention to the minus sign in equation 2. What these equations are really telling us is that the negative's densities control the light passing through it in a logarithmic manner, and thus control the print paper exposure in a logarithmic manner. The minus sign tells us that as negative density goes up, print exposure goes down. That's why in the Jones Plot increasing negative density and increasing print exposure go in opposite directions along the Y-axis shared by quadrants II and III.

Going back to the Jones Plot, if we extend the horizontal line from the Zone V point on the negative density into Quadrant III, it intersects the paper DlogE curve. The point where the line intersects the curve is the density on the print for Zone V. Now, if we extend this vertical line into Quadrant IV and extend the horizontal line through the Zone V point along the Y-axis in Quadrant I, the point where these two lines intersect gives us the relationship between scene brightness and print density.

If we repeat this mapping process from Quadrant I to Quadrant IV for every brightness point between Zone 0 and Zone X, we create the curve in Quadrant IV. This curve tells us the relationship between the scene brightness and the print densities. This curve describes our photographic system's *tone scale*.

From the curve for our example system, we see that tones lying between Zones III and VI are reproduced proportional to the brightness of the original scene. Above Zone VI, the tonal separation is reduced or *compressed*, with very little tonal separation above Zone VII. Tonal separation is also compressed below Zone III, but not as severely as in the highlights. Our example photographic system will show good shadow separation and tonality, but the highlights will be compressed.

From this example we can see that the Jones Plot is a very powerful tool in understanding the behavior of a photographic system. Modifying the shape of any of

the curves in Quadrants I through III will alter the shape of the tone scale in Quadrant IV. *The Jones Plot gives us a way to predict the results of varying any of the parts of the system.* And, it works for digital and hybrid systems, too.

Digital and Hybrid Systems

There are analogs for the different quadrants in the silver-halide Jones Plot in the digital world as well. A silver-halide negative is a way of storing information about scene brightness. So is a digital image file from a digital camera. Both record information, only in different manners.

A negative records scene brightness in a two-dimensional (X-Y) physical map of deposits of metallic silver, or densities. A digital camera records the same brightness information in a two-dimensional array of numbers. In a negative, the *deposits of silver are proportional to the scene brightness.* In the digital image file, the *numbers are proportional to the scene brightness.* We can replace the film curve of density versus exposure in Quadrant II of the Jones plot with a digital camera curve of the number, or *code value,* versus exposure.

Likewise, an inkjet printer receives numbers or code values and deposits ink onto a piece of paper. These ink deposits create densities, just like the metallic-silver deposits do in photographic paper. We can measure these densities with a reflection densitometer and generate a curve of print density versus code value. This is the digital analog of a photographic paper's DlogE curve. We can generate a Jones Plot for our digital system, just as we did for the silver-halide system and learn how our system will reproduce the tones in a scene. If we use a computer to modify the code values anywhere along the way between scene capture and printing, we can use the Jones Plot to predict how these modifications will impact the final print.

Figure A7 is a Jones Plot for a hypothetical digital camera and inkjet printer system. The process for generating the tone scale of the finished print is the same as for the silver-halide plot. Notice the similarities between Figures A7 and A6! There are, however some very important differences to note. Where Quadrant II of the silver-halide plot shows the negative density as a function of exposure, Quadrant II in the digital plot shows code value as a function of exposure. And, Quadrant III of the digital plot, the code-value input to the printer has replaced print-paper exposure.

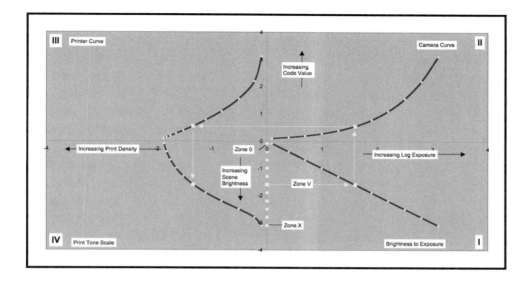

FIGURE A7 A Jones Plot for a digital system.

It is very interesting to note that the tone scale of this hypothetical digital system differs from the silver-halide system. Based on the shape of the tone-scale curve and the placement of the Zone V density in the print, this system would most likely produce unacceptable looking prints for the vast majority of images. But the good thing with a digital system is that we can use the computer to modify the relationship between the code values from the original image file and the code values sent to the printer.

In our Jones Plot, this would be the equivalent of modifying the camera-response curve in Quadrant II. We can even draw the tone scale curve we want and then work "backwards" to determine how to modify the shape of the camera curve to make the system behave as we would like.

Jones Plots can also be used with hybrid film/digital systems. Scanning a negative, for example, produces a data file that relates code values to film density, which ultimately relates code values to scene brightness. By replacing the curves in quadrants I and II with the appropriate curves, we can again determine the response of our photographic system.

I N D E X

H

hard drives, 4, 20
 recoveries, 49
Hard Proofs, 99–109
 color balance, 108
 color density, 108–109
 evaluating, 106–107
 grayscale, evaluating,
 157–158
 grayscale workflow,
 152–153
 labels on, 101
 of Master files,
 48, 150–154
 workflow, 106
Harrington, Roy, 172, 175
heliography, xiii
Histogram window, 24, 33, 95
Holleley, Douglas, 136
Hue/Saturation function,
 132–133
 grayscale conversion
 with, 156
hybrid processes, 189
 Jones Plot in, 202–203

I

ICC. *See* International Color
 Consortium
iLife, 17
image(s)
 assessment, 95–96
 continuous-tone, 41
 enlargement, 41
 evaluating, 52–53
 file size, 38–39
 information, 23
 processing, 46, 51
 size, 39
Image Size panel, 30, 39
ImagePrint RIP, 177–179
 advantages of, 184
information, 40–41
 archiving, 59–60
 management, 15–16
 pipes, 64–65
 preserving, 46
ink(s)
 color gamut of, 140
 DuraBrite, 7
 dye v. pigment,
 8–10, 139
 Epson UltraChrome,
 7, 9, 177–178, 183
 EZ, 169–170
 limiting, 109
 longevity of, 8
 non-OEM, 138–140, 191

OEM, 94, 191
 quadtone, 169–171, 186
 years, 8
inkjet density values, 138
InkjetMall, 170–171
International Color
 Consortium (ICC), 65
 history of, 74–75
 profiles, 73
interpolation, 39
iPhoto, 17–19
iWork, 19

J

Jones Plot, 195
 in hybrid processes,
 202–203
JPEG
 artifacts, 52–53
 compression, 52
 downsampling and, 38
 Fine mode, 52
 in Photoshop, 51
 to TIFF conversions, 48
 TIFF v., 52
Just-Normlicht, 12

K

kilobytes, 30
Kodak Photo CD, 58
Kodak Tri-X, 24
Koren, Norman, 136–137

L

LAB, 7
 color models and, 65
 grayscale and, 149
 history of, 66
 in Photoshop, 32, 67
labels, 17
 CD, 20
 on Hard Proofs, 101
levels, 34–36
lights, viewing, 3, 12–14
linearization, 70
 Bowhaus IJC/OPM and,
 176–177
 quadtone printing and,
 171
liquid crystal displays (LCDs),
 11
Luminous Landscape, 55
LUTs (look-up tables), 36
 organization of, 72
Lyson Daylight Darkroom, 175

M

Mac OS, 3
 display panel, 74
MAM-A, 20
Matrixes, 65
 organization of, 72
Maxwell, James Clerk, 28
McCelland, Deke, 19
Media Street, 139
Media Type menu, 104
megabytes, 30
megapixels, 36
memory, 10
metamerism, 148
 minimizing, 157
 work-around, 161–162
microbanding, 105
MIS Associates, 169–170
MIS EZ, 183
multi-sampling, 57

N

Nash Editions, x
negative characteristic curve,
 197–198
Niépce, Joseph Nicephore,
 ix, 184
 *Copy of Engraving of
 Cardinal d'Amboise,*
 xiii
noise, 28, 53
Notes Tool, 130–131

O

OEM
 color management,
 107–108
 gamma settings, 108
 inks, 94, 191
 paper, 94
 Print panel, 103–106
OEM path, xii, 93–94
 grayscale printing on,
 158–162
operating systems, 3, 14–15
 ICC profiles of, 73
optical brighteners (OBs), 136
optical density range,
 39, 54–58
optical resolution, 54
Ott-Light, 13–14
output devices, 72
outsourcing
 printing, 40
 scanning, 58–59
overexposure, 55–56

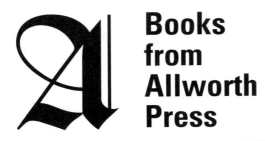

Books from Allworth Press

Allworth Press is an imprint of Allworth Communications, Inc. Selected titles are listed below.

Profitable Photography in the Digital Age: Strategies for Success
by *Dan Heller* (paperback, 6 × 9, 256 pages, $19.95)

Mastering the Basics of Photography
by *Susan McCartney* (paperback, 6¾ × 10, 192 pages, $19.95)

Photographic Lighting Simplified
by *Susan McCartney* (paperback, 6¾ × 9⅞, 176 pages, $19.95)

Photography—The Art of Composition
by *Bert Krages* (paperback, 7¾ × 9¼, 256 pages, $24.95)

The Photographer's Guide to Negotiating
by *Richard Weisgrau* (paperback, 6 × 9, 208 pages, $19.95)

The Real Business of Photography
by *Richard Weisgrau* (paperback, 6 × 9, 256 pages, $19.95)

Photography Your Way: A Guide to Career Satisfaction and Success, Second Edition
by *Chuck Delaney* (paperback, 6 × 9, 304 pages, $22.95)

ASMP Professional Business Practices in Photography, Sixth Edition
by *the American Society of Media Photographers* (paperback, 6¾ × 9⅞, 432 pages, $29.95)

Business and Legal Forms for Photographers, Third Edition
by *Tad Crawford* (paperback, with CD-ROM, 8½ × 11, 192 pages, $29.95)

How to Shoot Stock Photos That Sell, Third Edition
by *Michal Heron* (paperback, 8 × 10, 224 pages, $19.95)

Pricing Photography: The Complete Guide to Assessment and Stock Prices, Third Edition
by *Michal Heron and David MacTavish* (paperback, 11 × 8½, 160 pages, $24.95)